The World of William Glackens

VOLUME II

W9-BVQ-814

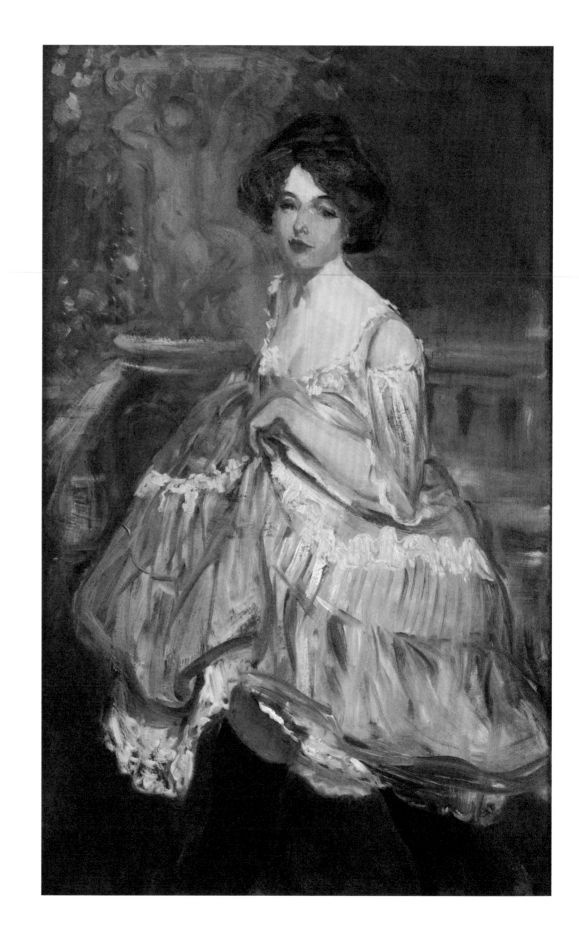

THE WORLD OF
William Glackens

VOLUME II

The C. Richard Hilker Art Lectures

Essays by

Judith A. Barter

Charles Brock

Teresa A. Carbone

Marc Simpson

New Perspectives on William Glackens

Essays by

Avis Berman

Carol Troyen

Sylvia Yount

Sansom Foundation, Inc.

This publication was organized by
Doris Palca with the help of:

Deborah Lyons, *Editor*
Thea Hetzner, *Copy Editor*
Diana Kamin, *Picture Researcher*

Printed by GHP Media
 West Haven, Connecticut
Stock: 100 lb. Mohawk Superfine
 Ultrawhite

Distributed by:
ARTBOOK/D.A.P.
75 Broad Street, Suite 630
New York, NY 10004

ISBN: 978-0-692-78480-8

FRONTISPIECE
William Glackens
Dancer in Blue, c. 1905
Oil on canvas
47 × 29 in. (118 × 74 cm)
NSU Art Museum Fort Lauderdale, FL;
Gift of the Sansom Foundation 92.43

Contents

Preface

The preface to Volume I of *The World of William Glackens: The C. Richard Hilker Art Lectures*, published in 2011, ended with a look forward to inaugurating a second series of lectures, and the eventual publication of a companion volume, and here we are. How rare, but very rewarding it is, to make such hopeful predictions and actually see them come to pass.

On behalf of the Board of Directors of the Sansom Foundation, I take great pride in introducing this publication, a compilation of essays comprising the second series of the C. Richard Hilker Art Lectures, all presented at the New-York Historical Society, with the addition of contributions from a symposium that took place at the Barnes Foundation in Philadelphia on November 8, 2014, in connection with the highly acclaimed exhibition *William Glackens*.

Neither volume of *The World of William Glackens* would have been possible without the generosity and foresight of Ira Glackens and his wife, Nancy. The establishment of the Sansom Foundation in 1956 under their guidance ensured that the legacy of Ira's father, artist William Glackens, would continue to contribute to the arts and to American culture.

C. Richard Hilker, who became president of the Sansom Foundation in 1990, carried on the Foundation's commitment to the arts, and the lecture series commemorates his leadership. Publishing the C. Richard Hilker lectures assures them the larger audience they deserve and makes this scholarly material available for future reference and research.

The lectures presented here were given by esteemed art historians, whose biographies appear on page 252. The range of subject matter represented attests to the many exciting possibilities for new scholarship that still exist in the field of American art.

Marc Simpson delivered his "Eakins in Paris" lecture in 2012, discussing Thomas Eakins's lasting relationship with Paris, where he began his artistic training, and where his captivating portrait of "Clara" now hangs in the Musée d'Orsay, the only Eakins painting to be found in a French public collection.

"Trompe l'oeil and Modernity," Judith A. Barter's lecture, followed in 2013. Dr. Barter expounded her theory that the revival of trompe l'oeil painting at the end of the nineteenth century led the way to American modernism, while exploring the connections these works had to contemporary people and events.

Teresa A. Carbone delivered the lecture "All About Eve? William Glackens's Audacious *Girl with Apple*" in 2014. Discussing this painting in the context of Manet's *Olympia* and other scandalous nudes, she elaborated on the impact the work had on the American art scene and the way it relates to the new roles women were undertaking in the era.

The final lecture in the Hilker series was "The Exhibition Game: Rockwell Kent and The Twelve," given by Charles Brock in 2015, in which he investigated the highly competitive art exhibition "game" as practiced in the art world in the early twentieth century, through an analysis of a pivotal 1911 exhibition organized by Kent.

The 2014 Barnes symposium "New Perspectives on William Glackens," which included lectures by Avis Berman, Carol Troyen, and Sylvia Yount, round out this volume and provide us with new insights into Glackens's art. The Sansom Foundation was honored to underwrite this event, which was presented in conjunction with the first major exhibition of the artist's work in over fifty years. I wish to thank our friends at the Barnes Foundation, whose cooperation made the publication of these thought-provoking and entertaining lectures possible. My thanks also to Avis Berman, who brilliantly curated *William Glackens* and wrote the introduction to the lectures from the symposium she organized. Her friendship and sage advice is deeply appreciated.

I hope the reader will share our excitement in being able to make this beautiful, profusely illustrated book a reality, and will find it an informative and enjoyable visit to the world and art of William Glackens.

Frank Buscaglia
PRESIDENT
SANSOM FOUNDATION, INC.
JANUARY 2017

Eakins in Paris

MARC SIMPSON

Lecture given on November 29, 2012

New-York Historical Society

New York City

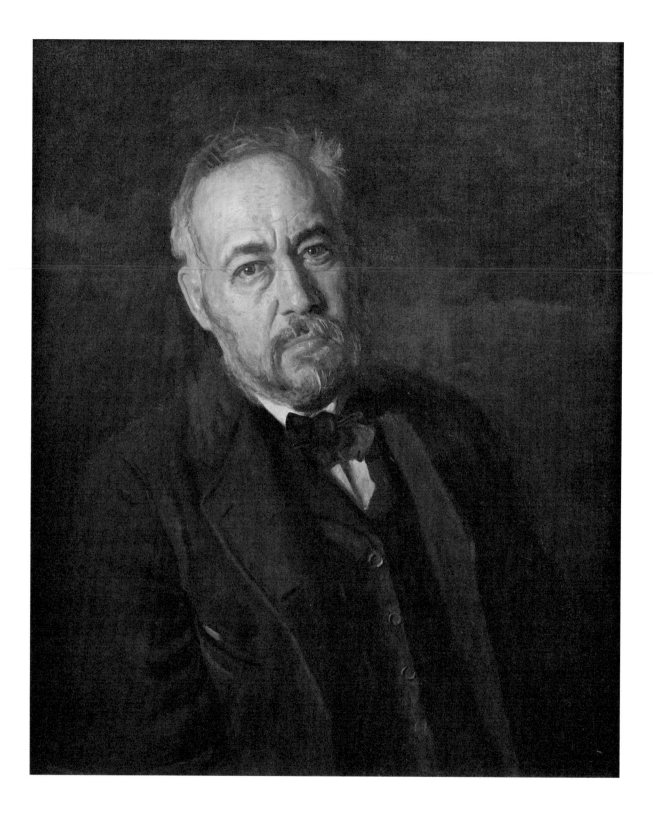

Eakins in Paris

MARC SIMPSON

"I was born July 25, 1844," Thomas Eakins declared in 1893 (Fig. 1). "My father's father was from the north of Ireland of the Scottish Irish. On my mother's side my blood is English and Hollandish. I was a pupil of Gérôme (also of Bonnat and Dumont, sculptor). I have taught in life classes, and lectured on anatomy continuously since 1873. I have painted many pictures and done a little sculpture. For the public I believe my life is all in my work."[1] That last rings with particular poignancy, since so much recent scholarship on the artist has focused on Eakins's inner, private self in conflict with cultural norms and expectations, prompting art historians to make retrospective diagnoses of his apparent psychological disorders and perceive various levels of sexual and behavioral deviance in his life and work. The simple fact that Eakins has been the subject of three large biographies since 2005—not to mention a number of more directed book-length studies focused on aspects of his life and career—gives witness to the hold that his life, in addition to his work, exerts on scholars.[2]

To be fair, Eakins's life story does invite an almost lurid fascination, akin to watching a horrific accident unfold in slow motion. It is virtually impossible to consider Eakins's career and not emphasize the vilification in his own day of what have come to be recognized as masterworks: *The Gross Clinic* of 1875 (Philadelphia Museum of Art) and *The Agnew Clinic* of 1889 (University of Pennsylvania, Philadelphia). Or not focus on the pedagogic and studio practices, based on the study of the human nude (including his own naked body—Figs. 2, 3), that prompted public outcry and ostracism in late nineteenth-century Philadelphia, culminating in his dismissal from the directorship of the Schools of the Pennsylvania Academy of the Fine Arts in 1886.

A biography of Eakins could easily carry the title *Tom Eakins: A Tragic Opera in Three Acts*; and the painter, at least at times, knew it.[3] Attend to his words from 1894, when he was asked again for the facts of his life: "I was born in Philadelphia July 25th, 1844. I had many instructors, the principal ones Gérôme, Dumont (sculptor), Bonnat.

Fig. 1
Thomas Eakins
Self-Portrait, 1902
Oil on canvas
30 × 25 in. (76.2 × 63.5 cm)
National Academy Museum, New York;
398-P

3

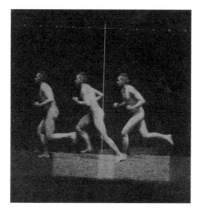

Fig. 2
Circle of Thomas Eakins
Motion Study: Thomas Eakins nude,
running to the left, 1885
Cyanotype
2½ × 2⁷⁄₁₆ in. (6.4 × 6.1 cm)
Pennsylvania Academy of the Fine Arts,
Philadelphia; Charles Bregler's Thomas
Eakins Collection, purchased with the
partial support of the Pew Memorial
Trust 1985.68.2.401

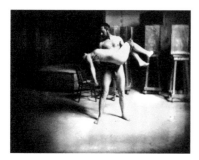

Fig. 3
Circle of Thomas Eakins
Thomas Eakins nude, holding nude
female in his arms, looking down, c. 1885
Dry-plate negative
4 × 5 in. (10.2 × 12.7 cm)
Pennsylvania Academy of the Fine Arts,
Philadelphia; Charles Bregler's Thomas
Eakins Collection, purchased with the
partial support of the Pew Memorial
Trust 1985.68.2.847

I taught in the Academy from the opening of the schools until I was turned out, a period much longer than I should have allowed myself to remain there. My honors are misunderstanding, persecution, & neglect, enhanced because unsought."[4]

Both these autobiographical statements repeat three facts. Two are his birthdate and his teaching career, both apt in the context. The third shared datum is not about family life, reputation, or art making but about his artistic training in France. This repetition and its specificity signal the pressing importance of France for Eakins a full quarter-century after the end of his schooling.

In many ways it could be said that throughout his life (and after), Eakins was, in some fashion, in Paris. Such a statement would be literally true, of course, only when he was living and breathing in that place. We would then have to note that Eakins was abroad just once during his seventy-two years, from 1866 to 1870. While he, indeed, spent most of that time in Paris (at the École des Beaux-Arts, studying with Jean-Léon Gérôme and Augustin Dumont, and during the summer of 1869 in the independent atelier of Léon Bonnat), that scarcely counts as a lifetime. It might then be asserted, metaphorically, that he was in Paris when his paintings were there, representing him. Even within this more flexible understanding of the phrase, we would have to acknowledge that Eakins put only ten paintings on public view in five different Parisian exhibitions from 1875 to 1900, and their cumulative stay, and thus this level of symbolic presence, was limited.[5] It is possible to make a case, however, that he was figuratively in Paris far more pervasively than this. The evidence for this claim is manifest in his sense of himself and his profession, and in his lifelong sense of tradition and manhood, as held against the standards established in France. We see this in his behavior, his defense of his practice, and especially, through his art, in certain of his genre works. It may be further asserted that today, by virtue of the wholly beautiful and inexplicably understudied portrait known as *Clara* (Fig. 23), now a part of the French national collection, Eakins could be said still to be in Paris. This last claim, whimsical though it may be, provides the opportunity both to consider a singularly handsome painting and to document a tale of exemplary museum collegiality and selflessness.

First, a bit of biography to augment what Eakins provided. At Philadelphia's Central High School he received an advanced, college-level education that included particular achievement in languages and mechanical drawing (Fig. 4). After graduation, Eakins worked with his father—the calligrapher and writing master Benjamin (1818–1899)—and then, in 1862, began studying figure drawing at the Pennsylvania Academy of the Fine Arts. His few extant drawings from the time (Fig. 5) show a marked talent for portraying weight and mass. His father having purchased a draft deferment for him—a middle-class

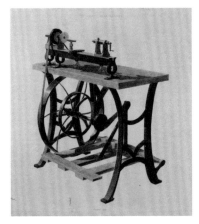

Fig. 4
Thomas Eakins
Perspective of Lathe, 1860
Ink and watercolor on paper
16⁵⁄₁₆ × 22 in. (41.4 × 55.9 cm)
Hirshhorn Museum and Sculpture
Garden, Smithsonian Institution,
Washington, DC; Gift of Joseph H.
Hirshhorn, 1966

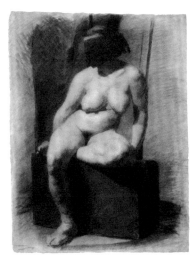

Fig. 5
Thomas Eakins
*Study of a Seated Nude Woman
Wearing a Mask*, 1863–66
Charcoal and crayon with stumping
on paper
24¼ × 18⅝ in. (61.6 × 47.3 cm)
Philadelphia Museum of Art; Gift of
Mrs. Thomas Eakins and Miss Mary
Adeline Williams, 1929 (1929-184-49)

privilege—Eakins was able to continue his schooling at the Academy and in anatomy classes at Jefferson Medical College throughout the years of the Civil War. In the fall of 1866, at the urging of his father,[6] he set out for France, intent on turning himself into a painter.[7]

During his years in Paris, Eakins wrote wonderful letters home filled with tales of his activities, his friendships, and his art. They convey Eakins's voice and manner, his winning charm, insecurities, and bravado; they detail as well the texture of a young man's life in Paris at the end of the Second Empire.[8]

Arriving in Paris on October 3, 1866, Eakins (Fig. 7) settled into the first of a series of lodgings and studios on the Left Bank near the Luxembourg Gardens.[9] After a month of fighting French bureaucracy and American consular indifference, displaying in the process guile and perseverance, he entered Gérôme's atelier at the École. After just six weeks, he was able to write: "I am comfortable here, and like Paris much more than I expected to when I left home."[10]

It was doubtless of help that he reached Paris with command of both spoken and written French.[11] He wrote home, in fact, that all he had accomplished early on was due to his tutor and family friend, Bertrand Gardel, "for he has introduced me to Mr. Lenoir [the secretary of the École, who was helpful in the complicated admission process] and the whole French people. I have yet to encounter my first real difficulty in making myself understood."[12] Of Gérôme's atelier he noted, "There is no one in all the studio who knows English, and I'm glad of it."[13]

His densely packed letters (Fig. 6) include details of his rented lodgings, his concert and circus visits, and, guardedly, politics.[14] These were, after all, years of unrest in the Second Empire, with censorship of the press and the mail, limited rights of public assembly, and great political discord bubbling beneath the glittering streetlights. More than this, he tells tales of his school life and friendships with his French colleagues, emphasizing fraternity-like hazing, athletics, and male-bonding rituals, including visits to a brothel (where he apparently did not indulge).[15] He also sent accounts of his expenses (his father supported him financially throughout his life), and he sought to assure his family that he was on track professionally. "I do not think I have overrated the advantages of the Imperial School," he reported in December 1866. "From 8 to 1 we have the living model. We have a palace to work in. We have casts from all the good antique and many modern statues. Twice a week our work is corrected by the best professors in the world."[16]

As this last hints, at the center of Eakins's enthusiasm for Paris and the École des Beaux-Arts was his admiration for his principal teacher, Jean-Léon Gérôme.[17] After he had received his first direct critique, Eakins wrote home: "His criticism seemed pretty rough, but after a moment's consideration, I was glad. I went out and bought Gerome's photograph that very night [Fig. 8].... He has a beautiful

Fig. 6
Thomas Eakins
Illustrated letter to his mother,
November 8–9, 1866
Thomas Eakins Letters, Archives of
American Art, Smithsonian Institution,
Washington, DC

Fig. 7
Frederick Gutekunst
Eakins at about age twenty-four, c. 1868
Albumen print on cream wove paper
$3^{9}/_{16}$ × 2¼ in. (9 × 5.7 cm)
Pennsylvania Academy of the Fine Arts,
Philadelphia; Gift of Gordon Hendricks
1971.22.1

Fig. 8
Charles Reutlinger
Jean-Léon Gérôme, c. 1867–68
Albumen carte-de-visite
Pennsylvania Academy of the Fine Arts,
Philadelphia, Archives

eye and a splendid head.... I am delighted with Gerome."[18] As the years of apprenticeship progressed, Eakins recorded that Gérôme was "very kind to me & has much patience because he knows I am trying to learn."[19]

He likewise wholeheartedly admired Gérôme's paintings. The *Ave Caesar! Morituri te salutant* (Fig. 9) prompted him to write:

> You wanted to know the Romans. There they are real. Gerome knows them. He knows all men.... He makes people as they were, as they are, their virtues their vices & the strongest characteristics of those he represents.... Look at Gerome's head again. It is like Shakespeares & Cervantes just as large but a great deal more beautiful.[20]

Yet it was not Gérôme's subject matter that Eakins wanted to emulate. The young Eakins had a philosophy in place that supported the study of nature with the triumvirate of "experience & memory & sense"; as he later wrote in the fall of 1869, "A teacher can do very little for a pupil & ... the greater the master, mostly the less he can say."[21] From Gérôme, however, Eakins learned the tools of the craft and to articulate his own truths.[22] He summarized his experiences on the eve of leaving France: "I feel now that my school days are at last over and sooner than I dared hope, what I have come to France for is accomplished.... I am as strong as any of Gerome's pupils, and I have nothing now to gain by remaining. What I have learned I could not have learned at home, for beginning Paris is the best place."[23] Eakins arrived home in Philadelphia on July 4, 1870, with some handsome studies (Fig. 10) and one clumsy painting from Spain. But he also had in hand the tools to become a great picture maker.

The truth of Eakins's claim can be seen in the first known work he did on his return. By putting *The Champion Single Sculls* (Fig. 11) on exhibition in Philadelphia in late April 1871, Eakins inaugurated his professional career. In finish and fullness, the American emulated his European master, showing specific individuals in particular conditions of light and atmosphere, characterizing a whole culture of middle-class life observed in detail. Yet the picture was not a success in Eakins's eyes. He never again showed it, and he wrote that putting it in strong light "ruined" it.[24] As he pondered its perceived weaknesses, he asked *en français*, "What is the practice of the best painters? Is there a conventional solution?"[25]

This seems almost a conversation carried on with another. Indeed, Eakins scribbled the questions next to a draft of a letter he sent to Gérôme in 1873, along with the gift of a now-lost watercolor of a rower. Eakins's draft ends—again, *en français*: "I feel that I will soon do much better. In this hope I invite your criticism if you see bad tendencies in my painting."[26] Gérôme accepted the watercolor with thanks, praising it, self-reflexively, as a fulfillment of Eakins's years of training: "I am indeed delighted that my counsels, however tardily applied, have at

last borne fruit. . . . Keep in touch, I beg of you, and consult me every time that you feel the need, for I am much interested in my pupils' work and in yours in particular."[27]

A year later, in May 1874, Eakins did precisely that, sending Gérôme two small paintings and a watercolor.[28] The watercolor, *John Biglin in a Single Scull*, now at Yale, was another gift. The oils, intended for exhibition, were two hunting scenes: *Starting Out After Rail* (Museum of Fine Arts, Boston) and, most likely, *The Artist and His Father Hunting Reed-Birds on the Cohansey Marshes* (Fig. 12).[29] Since the latter included a self-portrait taken from a staged photograph (Fig. 13), it seems a particularly apt envoi to his Parisian master. It is likely more than a coincidence, too, that its signature is the Latin inscription *Benjamini Eakins Filius Pinxit* (painted by the son of Benjamin Eakins)—for Gérôme used Latin inscriptions and titles throughout his oeuvre.

Gérôme responded to the three works with enthusiasm, giving the American his wholehearted approval:

I . . . see great progress; I give you my compliments and [encourage you to push further in this] serious direction, which assures you the future of a man of talent. . . . You have now in hand the means of your art, it is only a question of choice and taste. Your watercolor is entirely good and I am very pleased to have in the New World a pupil such as you who does me honor.[30]

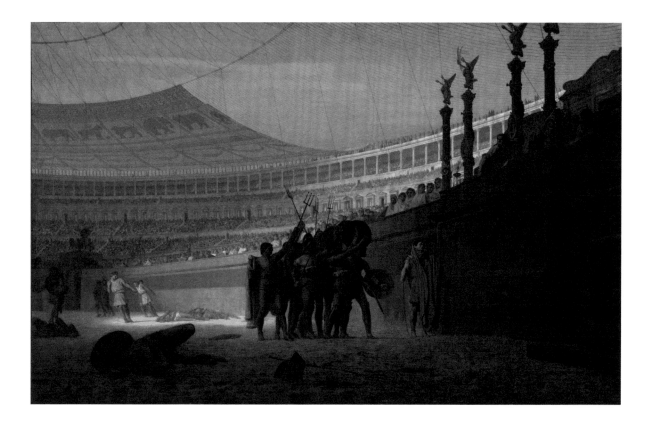

Months later Eakins was still bragging about this note to his friend, the writer and art critic Earl Shinn.[31]

Gérôme kept the watercolor and put the two oils in the commercial gallery owned by Adolphe Goupil, one of the leading art dealers and publishers of the era, with branches in Paris, London, New York, and elsewhere—who was also, conveniently, Gérôme's father-in-law. It is not clear if Eakins's paintings were seen by the Parisian public. Some sort of entrepreneurial enterprise was clearly under way, however, for the next year—1875—Eakins sent Gérôme four more oil paintings—a picture of a boat race, a scene of becalmed ships, and two unidentified bird-hunting scenes.[32] The plan was that the Frenchman would select one or more for the Salon and let Goupil have the others. The shipment, however, was delayed, and Gérôme "ordered the old ones [already] at Goupil's to be sent" to the Salon.[33] When the four new works arrived, he forwarded them to the London branch of Goupil, where the two hunting scenes were sold (they have not been seen since).[34]

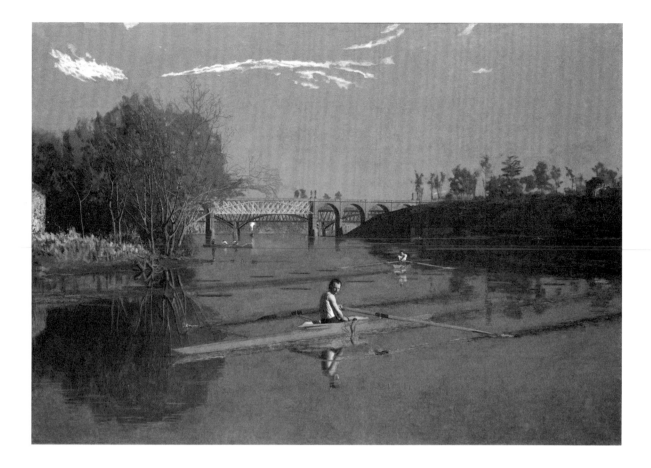

Fig. 11
Thomas Eakins
*The Champion Single Sculls
(Max Schmitt in a Single Scull)*, 1871
Oil on canvas
32¼ × 46¼ in. (81.9 × 117.5 cm)
The Metropolitan Museum of Art,
New York; Purchase, The Alfred N.
Punnett Endowment Fund and
George D. Pratt Gift, 1934 (34.92)

As for the two works in the Salon, even amid the thousands of pictures on view, and small though they are (just about two feet at the larger dimension), *The Artist and His Father* and *Starting Out After Rail* attracted reviewers from the Parisian press, all of whom emphasized the precise detail in both paintings. One, calling Eakins "a disciple of Gérôme," thought them "strange" and "exotic," "rendered like a photograph" with "truth of movement."[35] Another jested that the two canvases, "each showing two hunters in a boat, resemble so much photographic proofs washed over with local tints of watercolor, that one asks oneself if they are not specimens of some industrial process still unknown, which the inventor has maliciously sent to Paris . . . to frighten the French school."[36] Another, though, praised the pictures as being "well and vigorously painted."[37] This does not exactly jibe with the idea of the tinted photographs, reminding us that we must treat newspaper reviews of the nineteenth century—and today—with care. They are opinions refracted through sensibility and memory, never gospel.

So in 1875, thanks to Gérôme, Eakins had two oils well received in the Salon and two oils sold in London—a much stronger response than he had had to date in the United States (Eakins did not show an oil painting in New York until 1877). He wrote ecstatically of the whole

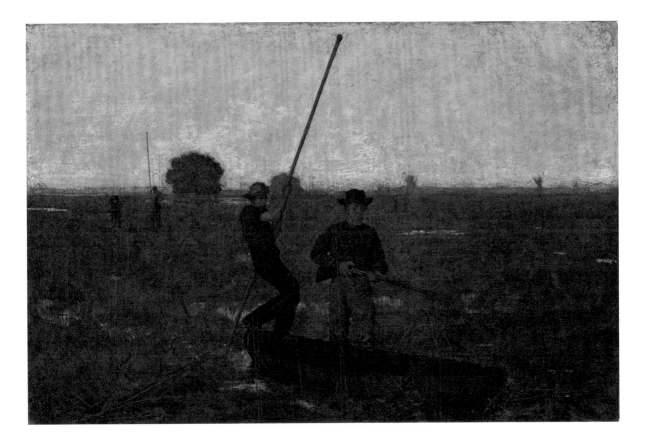

Fig. 12
Thomas Eakins
The Artist and His Father Hunting
Reed-Birds on the Cohansey Marshes,
c. 1874
Oil on canvas laid on composition board
17⅛ × 26½ in. (43.5 × 67.3 cm)
Virginia Museum of Fine Arts,
Richmond; Paul Mellon Collection
85.638

Fig. 13
Circle of Thomas Eakins
(possibly Henry Schreiber)
Thomas Eakins in Hunting Garb
(Study for The Artist and His Father
Hunting Reed-Birds on the Cohansey
Marshes), 1873
Albumen silver print, squared for transfer
2 × 2 in. (5.1 × 5.1 cm)
Philadelphia Museum of Art; Thomas
Eakins Research Collection, Gift of
Mrs. Elizabeth M. Howarth, 1984
(PDP-2243)

Salon/Goupil episode to Shinn, closing with the lines, "I wouldn't send you such a damned egotist letter but I feel good, and I know you will be pleased at my progress."[38]

It was in this time of success and promise that Eakins painted *The Chess Players* (Fig. 14).[39] In it he put the men who had been most instrumental in his reaching this culminating moment—standing at center, his father, who had encouraged him to go to Paris and supported him while there; to the left, Bertrand Gardel, his French tutor; and to the right, George Holmes, an artist and teacher. Holmes, too, had a tie to Eakins's time in Paris. He had asked the young man to describe to him the pictures that he was seeing in Paris. Striking a cautionary note to us all, Eakins wrote to his father: "Twice I commenced a letter to Mr Holmes about the Galleries of the Louvre & Luxembourg, but the pleasure in seeing a picture cannot be conveyed by writing & I find the attempt contemptible."[40] More to the point, while in Paris Eakins characterized both Gardel and Holmes as being "true & big men [who] have admitted me to their friendship."[41] So here in the foreground of this richly appointed parlor, Eakins portrayed the network of thoughtful Philadelphians who had made his Parisian experience possible.

In the picture's background, as is well known, is Gérôme, represented by the framed photogravure of the *Ave Caesar!* which Eakins had written of so intently from Paris. The water pipe to the left of the photogravure and the globe at the far right perhaps refer to the Frenchman's travels and enthusiasm for the Near East. Even more fundamentally, the subject and general disposition of the figures echo Gérôme's own *Draught Players* of 1859 (The Wallace Collection, London).[42] In addition, the fact that this painting is on wood—an unusual support for Eakins—seems a further technical bow to the Frenchman, who used panels often, especially for scenes of modern history. In the foreground, Eakins's signature, carefully inscribed in red on the drawer of the game table, does double homage: it is in Latin—like Gérôme's titles—and shows the same filial respect as the Salon hunting scene: *Benjamini. Eakins. Filius. Pinxit.* We know, moreover, that Eakins was thinking of his French master at this time, for he apparently wrote to him as he worked with the administration of the Pennsylvania Academy of the Fine Arts in developing the curriculum for the schools—letters that prompted Gérôme to answer: "To search the truth is the only reasonable way and other roads carry you to the abyss"—affirming Eakins's own dedication to the truth of observation and investigation.[43]

So the panel shows the man who taught him French, the man who sent him to France, the man with whom he communed about French art, and the Frenchman who taught him to paint. Eakins valued this scene of rationality, masculinity, and cosmopolitan pleasure, exhibiting it at the Philadelphia Centennial Exposition of 1876 and elsewhere in Philadelphia, Chicago, Boston, New York, and Springfield, Massachusetts,

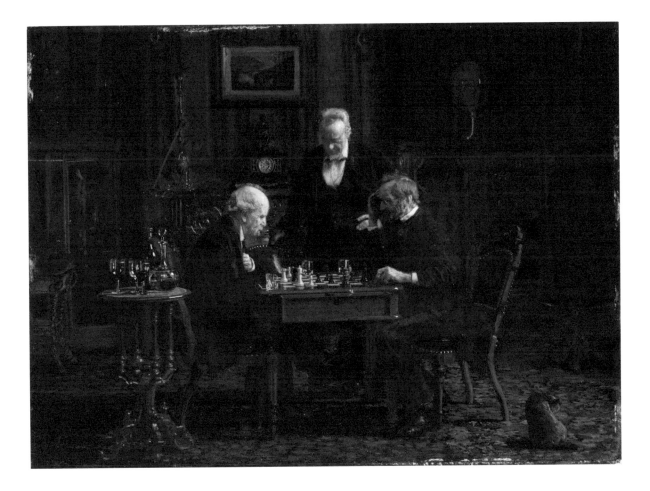

Fig. 14
Thomas Eakins
The Chess Players, 1876
Oil on wood
11¾ × 16¾ in. (29.8 × 42.6 cm)
The Metropolitan Museum of Art,
New York; Gift of the artist, 1881
(81.14)

until 1881, when he gave it to the Metropolitan Museum of Art, a venue where the obvious affiliation between Gérôme and himself would work to his credit with New York's collectors.[44]

There is only indirect evidence of contact between Eakins and Gérôme during the 1880s and 1890s. Students recalled Eakins naming Gérôme "the greatest painter of the nineteenth century."[45] Eakins in 1888, writing a condolence note after Earl Shinn's death, asked: "What ever became of a plaster cast of a sculptured head of our master Gérôme[?] Its intrinsic value is not more than a dollar or two, but I should myself prize it very much if I could obtain it, and I am very sure that Earl would have liked me to have it."[46] Nor was the regard one-sided. When Eakins sent students to Paris in the 1880s and 1890s, they carried his introductions to Gérôme. One wrote back to Philadelphia in 1894, "[Gérôme] thinks a great deal of Eakins. He said that he was a great master and that he was a very intelligent man."[47]

By then, Gérôme could pronounce this on the basis of recent evidence. In 1889, after a fourteen-year hiatus, Eakins again put work on view in Paris.[48] He had three pictures in the Universal Exposition: the watercolor called *The Dancing Lesson* from 1878 (Fig. 15); a head-and-bust portrait from 1885 of his student George Reynolds, titled *The Veteran* (Fig. 16); and a major, three-quarter-length portrait of the physicist George Barker from 1886 (Fig. 17a, b)—which was cut down in the mid-twentieth century.[49] The three together portrayed a masculine, American heroism of scientific achievement and, more somberly, of Civil War sacrifice, which is most obvious in the portrait of Abraham Lincoln and his son Tad appearing on the back wall in

Fig. 15
Thomas Eakins
The Dancing Lesson (Negro Boy Dancing), 1878
Watercolor on off-white wove paper
18¹⁄₁₆ × 22⁹⁄₁₆ in. (46 × 57.4 cm)
The Metropolitan Museum of Art, New York; Fletcher Fund, 1925 (25.97.1)

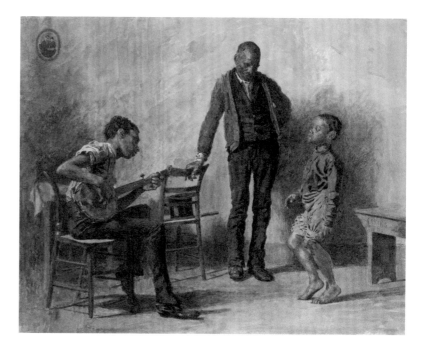

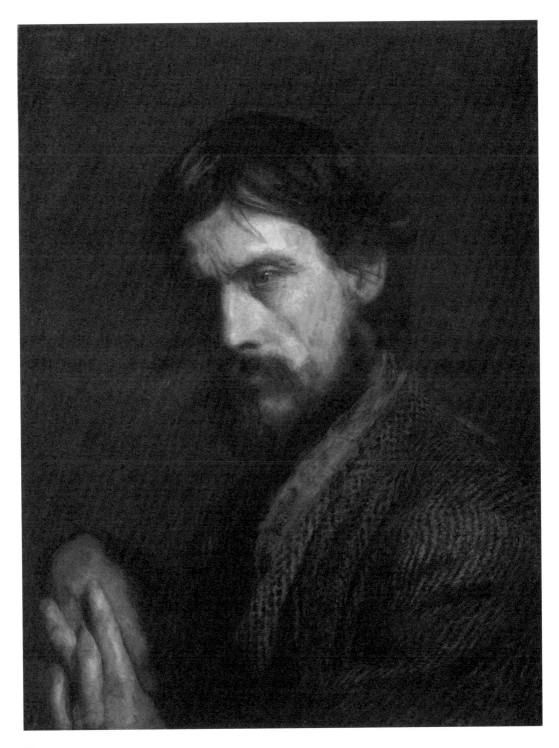

Fig. 16
Thomas Eakins
The Veteran (Portrait of George Reynolds), c. 1885
Oil on canvas
22¼ × 15 in. (56.4 × 43.8 cm)
Yale University Art Gallery, New Haven;
Bequest of Stephen Carlton Clark, B.A.
1903 (1961.18.20)

Fig. 17a
Thomas Eakins, *Professor George F. Barker*, 1886, as photographed for the catalogue *Memorial exhibition of the works of the late Thomas Eakins, beginning December 23, 1917 and continuing through January 13, 1918* (Philadelphia: The Academy, 1918) Courtesy of the Pennsylvania Academy of the Fine Arts, Philadelphia, Archives

Fig. 17b
Thomas Eakins
Professor George F. Barker, 1886
Oil on canvas
33 × 29 in. (83.8 × 73.7 cm)
John R. and Eleanor R. Mitchell Foundation, Cedarhurst Center for the Arts, Mt. Vernon, IL; Gift of Mr. and Mrs. S. Alden Perrine

the watercolor and in the sober demeanor of Reynolds, who wears a subtly depicted medal in *The Veteran*.

The next year, in 1890, for the first time in fifteen years, he exhibited in the Salon, choosing *The Writing Master* (Fig. 18) of 1882, which was among his favorite pictures—"the most treasured for all reasons," as his widow later wrote.[50] As much genre painting as portrait, it shows Eakins's father inscribing a document with elaborate calligraphy. He looks down, intent on his work. Through focus and reflections, Eakins makes us, too, concentrate on the writer's hands: the site of his father's skill and productivity. Much has been made by recent scholars, following on Michael Fried's lead, about the complex relationship of picture making and penmanship in Eakins's works.[51] The signature in this painting about writing is an unremarked-upon but significant detail. It is not among the penned ornaments of the document but in the lower right-hand corner, almost invisible, in block print in the same tones as the table's edge. Parts of it, especially the *s*, are not so much painted as formed by swirling a dry brush through wet paint (Fig. 19). To put his name on the surface would be tantamount to writing it. So Eakins, avoiding all competition with his father, distinguished not only writing from painting but writing from *painted* writing. Showing for only the second time in the Salon, Eakins again sent his father to represent him.

In 1891, Eakins sent works to a still different venue in Paris—an exhibition of American art organized by the commercial dealers Durand-Ruel. The show's catalogue proclaimed it to be a demonstration, "in an obvious, undeniable fashion, [of] the great influence that French art and French masters have exercised on the art of the United States."[52] There were 201 works by eighty-four artists. Three were by Eakins: *Meditation* (now called *Retrospection*; Fig. 20), *The Veteran*, and *The Artist's Wife and His Setter Dog* (Fig. 21). For the first time in France Eakins presented himself as a painter of women.

Close to a decade passed before Eakins next had paintings on view in Paris. The lure, once again, was a world's fair. As with all of the works that Eakins had submitted to French exhibitions in the 1880s and 1890s, the two he sent to the Universal Exposition of 1900 had been widely shown in America. The Pennsylvania Academy of the Fine Arts had even purchased *The Cello Player* (now in a private collection). In the second, the *Salutat* of 1898 (Fig. 22), we see Eakins at the end of his career, circling back to images of masculine camaraderie, entwining physical with mental prowess. The picture shows a young boxer exiting an arena, his right arm raised in victory. We know this because the original frame of the painting bore its title in Latin: *Dextra Victrice Conclamantes Salutat* (with his right hand the victor salutes those acclaiming him). The Latin, no less than the boxer's pose, draws a resonant parallel to Gérôme's *Ave Caesar!*—the work quoted in *The Chess Players* a quarter-century earlier. The contrast between Rome's

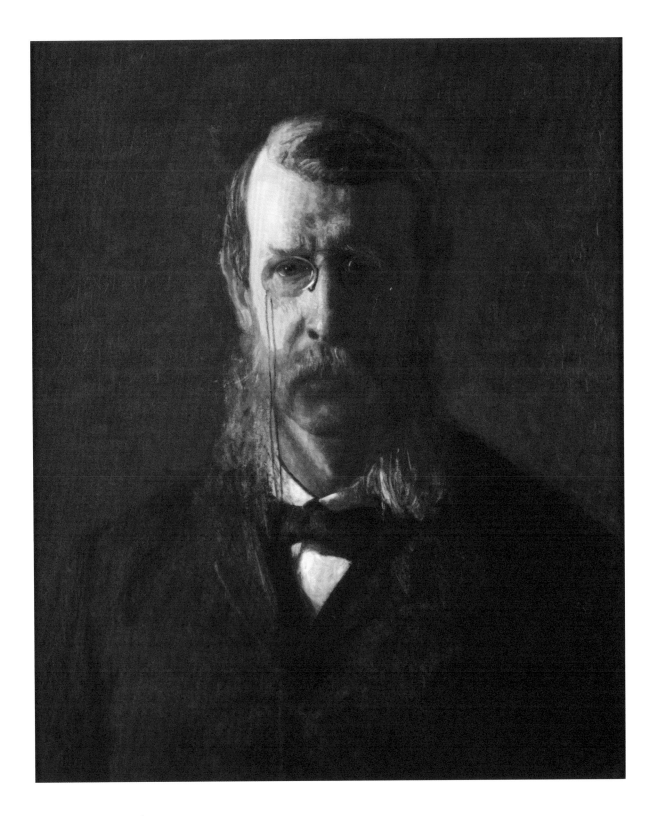

Fig. 18
Thomas Eakins
The Writing Master, 1882
Oil on canvas
30 × 34¼ in. (76.2 × 87 cm)
The Metropolitan Museum of Art,
New York; John Stewart Kennedy Fund,
1917 (17.173)

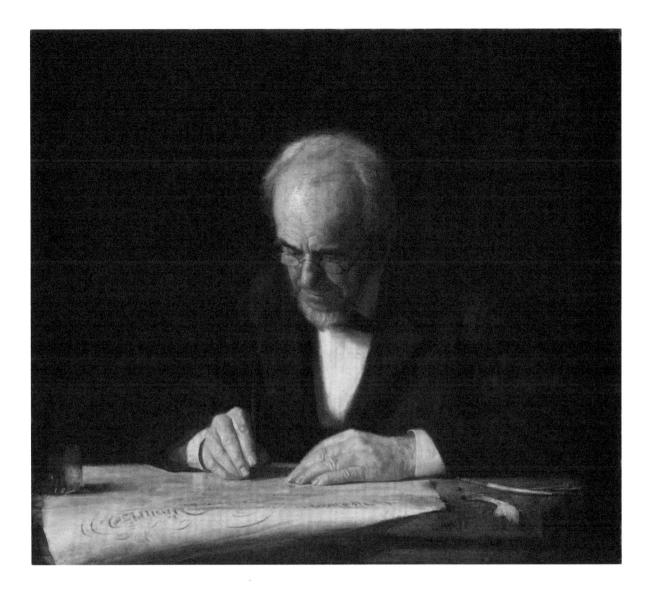

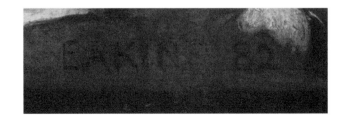

Fig. 19
Detail, Eakins, *The Writing Master*,
1882

Fig. 20
Thomas Eakins
Retrospection, 1880
Oil on wood
14½ × 10⅛ in. (36.9 × 25.7 cm)
Yale University Art Gallery, New Haven;
Bequest of Stephen Carlton Clark, B.A.
1903 (1961.18.19)

Fig. 21
Thomas Eakins
The Artist's Wife and His Setter Dog,
c. 1884–89
Oil on canvas
30 × 23 in. (76.2 × 58.4 cm)
The Metropolitan Museum of Art,
New York; Fletcher Fund, 1923 (23.139)

Fig. 22
Thomas Eakins
Salutat, 1898
Oil on canvas
50 × 40 in. (127 × 101.6 cm)
Addison Gallery of American Art,
Phillips Academy, Andover, MA;
Gift of anonymous donor 1930.18

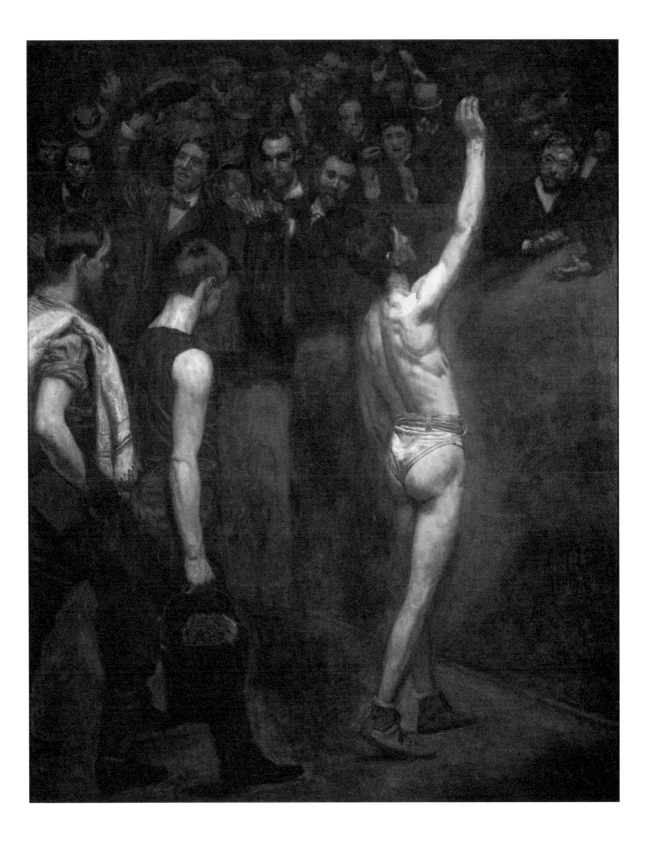

decadent empire and America's enthusiastic meritocracy is pointed. The formal and thematic echoes between the two pictures, however, and Eakins's tribute to Gérôme seem clear. They were so, at least, to the authors of the commemorative volume about the fair's art, who began their entry on *Salutat*: "It is said that Gérôme pronounced Mr. Eakins to be one of the strongest of his pupils."[53] Their reference to the Frenchman was timely, for in 1900 Gérôme, still active, was elevated to the rank of Grand Officer of the Legion of Honor. Unlike nowadays, the association of the two painters was to Eakins's advantage in the art world. With *Salutat* and *The Cello Player*, Eakins won an honorable mention at the 1900 exposition—his first official French honor.

If in *Salutat*—through theme, title, and gesture—Eakins paid homage to his teacher, it is important to note that he also portrayed, sitting quietly at the right edge of the canvas, just above the clapping man, his father, Benjamin. As with paintings seen in the Salons of 1875 and 1890, here too Eakins is paying manifest tribute to both of the men who had formed him. The serendipitous timing of the exposition and Gérôme's elevation to the highest ranks in the Legion of Honor made *Salutat*'s tribute to his master a triumphant one. That for Benjamin was elegiac; Eakins's father had died on December 30, 1899, just before the works were sent to Paris.

Thomas Eakins was the very opposite of the expatriate artist. In 1857, when he was thirteen, his family moved into a large brick house at 1729 Mount Vernon Street in Philadelphia. Barring the years of his schooling in Europe and a brief period when he was first married, this is where Eakins lived all of his life; where, for much of that time, he had his studio; and where, in 1916, he died. His widow, writing in her diary, made a point of the importance of this place for Eakins: "Monday June 26, 1916. My poor Tom away forever from the house this day."[54] Yet through all those decades, as painter and man, he carried the lessons of Paris, honoring the generous men who had befriended him and who had shared with him the traditions of their art. In 1907, the sixty-three-year-old Eakins wrote to a friend from Gérôme's atelier, "I always think of . . . you when I think of France—which I do often."[55] Life and career linked man and place. Eakins spent four years in Paris at the end of the 1860s, yet throughout the following decades he brought the lessons of Paris to his American scenes.

Fifteen years after his body left the Mount Vernon Street house for the last time, Eakins was again in Paris. His proxy this time was *Clara* (Fig. 23).[56] The picture shows the head and shoulders of a handsome woman, with distinctive, regular features. She might, at first, appear still. Indeed, a quiet seems to emanate from the shadowed space behind her. Nonetheless, there is drama here. Clara sits at an angle, her left shoulder away from us, so that she has to turn her head

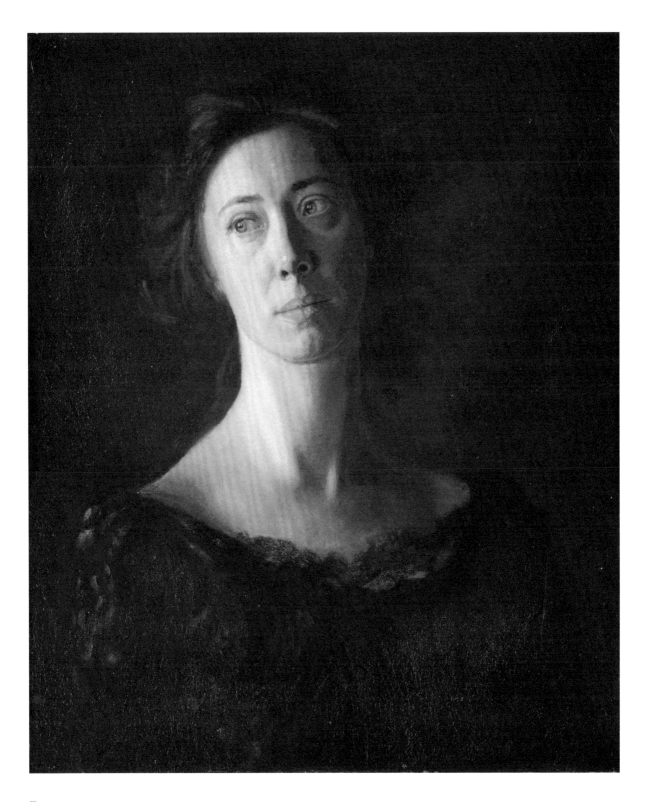

Fig. 23
Thomas Eakins
Clara (Clara J. Mather), 1890
Oil on canvas
24 × 20¹⁄₁₆ in. (61 × 51 cm)
Musée d'Orsay, Paris

to face us straight on. She tilts her head as well, adding further torque. An attempt to replicate her pose will likely give rise to a strain on the farthermost shoulder. Her light gray eyes, moreover, look even further to the side, so that amid the stillness of the pose and the moment portrayed, there is a spiraling, animating movement. This configuration focuses attention on Clara's beautifully exposed neck—the lightest, palest part that we see of her—where sinewy tendon and soft flesh interlock and catch in varying degrees the strong light toward which she looks. Her loosely gathered hair, its waves unfolding around her face, contains the spiraling, as does the gauzy material at the neckline of her dress. These create a quiet, reflective aura that complements and highlights the latent power of her pose.

If we shake ourselves free of Clara's mysterious, hypnotizing mood and remind ourselves that we are looking at a piece of canvas two feet high, with paint applied across it—how would we characterize that laying on of paint? Probably in terms of quietness. There is nothing flashy or showy here—no luscious brushwork à la John Singer Sargent or other painters of Eakins's era. Some long, loose sweeps of the brush suggest falling tresses. But these swoops—perfectly placed to suggest masses of hair—do not draw the eye because their mute color lies so close to the background's hue. The same holds true of Clara's costume—Eakins has chosen several colors and a variety of touches to document his attention there, but not so many as to draw our eye to that part of the canvas. Every stroke of his brush in these regions subordinates itself entirely to its illusionistic function. The result of his superb technique is that the viewer, gazing at Clara's face, sees fictional surface rather than physically present brushstroke.

This picture is understudied to the extent that every substantive reference to it in the published Eakins literature could be typed out, double-spaced, and barely fill a single sheet of paper. There is, however, a wonderful description of this virtuosic painting of flesh in a private letter that Bryson Burroughs—curator of paintings at the Metropolitan Museum of Art from 1909 until 1934—wrote in 1931: "The Clara is finished in that miraculous way Eakins finished, with each tiny form wrought out in that almost Van Eyck fashion, but with greater qualities of large form and solidity, and of most convincing characterization, material and spiritual reality—also perfectly attained. But lo! I talk like a Bulletin article."[57] Eakins and Van Eyck form a pair not often yoked together, but Burroughs's assessment is worth regarding, for he knew well the work of both. It was he who organized Eakins's memorial exhibition at the museum in 1917, and it was he who purchased more than a dozen paintings and watercolors by the artist for that institution.[58] Burroughs also wrote on Van Eyck and bought, in 1933, the diptych that is one of the glories of the museum's European collection (Fig. 24). Thus, he was probably one of the very few people—perhaps the only person—who could authoritatively link

Van Eyck, of the fifteenth century, with Eakins, of the nineteenth. For him, with Van Eyck in mind, Eakins's craft transcended the material intransigence of paint, surpassing the Netherlandish artist in terms of "large form and solidity."

Who is the subject of this "perfectly attained" illusion of material and spiritual reality? Clara Janney was born on November 19, 1870, the eldest of the five children of Catherine and Franklin Janney, who lived in Philadelphia, where Janney was a respected dry-goods merchant.[59] The family was Episcopalian, and Clara herself was apparently of the church from infant baptism to burial (although her daughter later called her a Quaker).[60] She studied painting with Eakins at the Art Students' League, it seems, and afterward privately, but she had to quit when her mother and then her father died in quick succession—in 1896 and 1897, respectively. In the census of 1900 she is listed as living in the family home with her younger siblings, and her occupation is given as "school teacher." In October 1902, just a month shy of her thirty-second birthday, she married L. Montgomery Mather, a poet from a distinguished Pennsylvania family—one that is still prominent

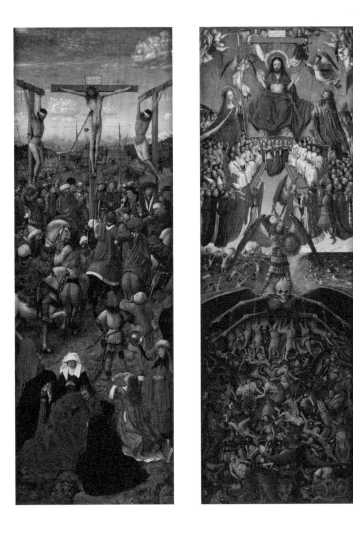

Fig. 24
Jan van Eyck and workshop assistant
The Crucifixion; The Last Judgment,
c. 1430
Oil on canvas, transferred from wood
two panels, each 22¼ × 7⅔ in.
(56.5 × 19.7 cm)
The Metropolitan Museum of Art,
New York; Fletcher Fund, 1933
(33.92a-b)

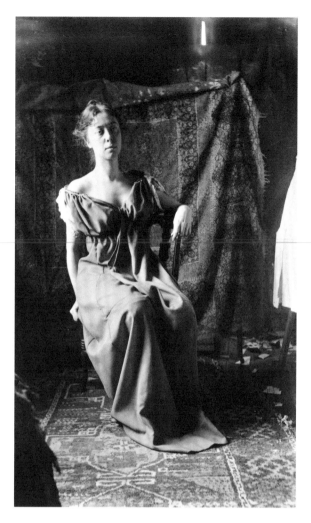

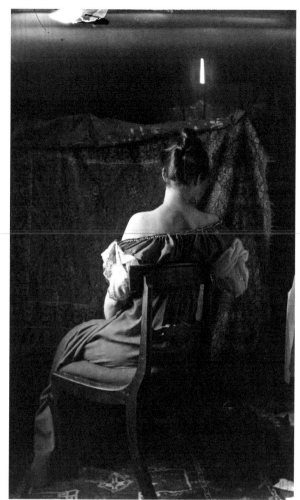

Fig. 25
Circle of Eakins
Clara Mather sitting in lyre-back chair,
c. 1891
Dry-plate negative
8 × 5 in. (20.3 × 12.7 cm)
Pennsylvania Academy of the Fine Arts,
Philadelphia; Charles Bregler's Thomas
Eakins Collection, purchased with the
partial support of the Pew Memorial
Trust 1985.68.2.931

Fig. 26
Circle of Eakins
*Clara Mather sitting in Empire chair,
rear view*, c. 1891
Dry-plate negative
8 × 5 in. (20.3 × 12.7 cm)
Pennsylvania Academy of the Fine Arts,
Philadelphia; Charles Bregler's Thomas
Eakins Collection, purchased with the
partial support of the Pew Memorial
Trust 1985.68.2.933

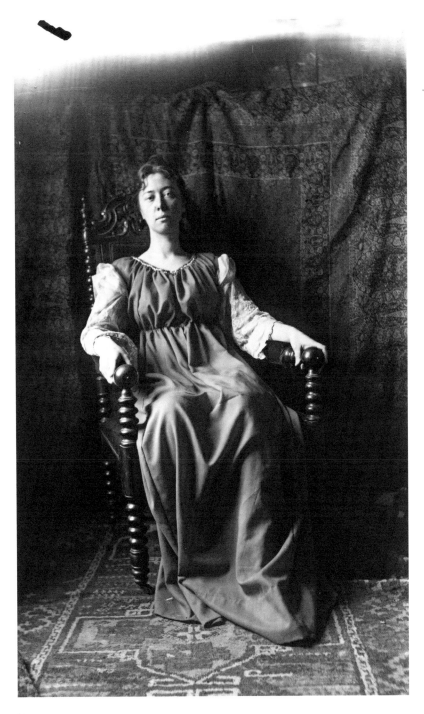

Fig. 27
Circle of Eakins
*Clara Mather sitting in carved
armchair*, c. 1891
Dry-plate negative
8 × 5 in. (20.3 × 12.7 cm)
Pennsylvania Academy of the Fine Arts,
Philadelphia; Charles Bregler's Thomas
Eakins Collection, purchased with the
partial support of the Pew Memorial
Trust 1985.68.2.935

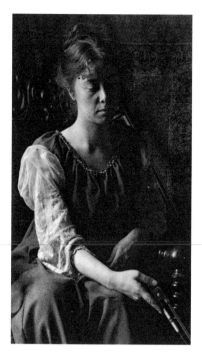

Fig. 28
Circle of Eakins
*Clara Mather sitting in carved armchair,
holding cello bow*, c. 1891
Platinum print
3⁹⁄₁₆ × 2¹⁄₁₆ in. (9 × 5.2 cm)
Pennsylvania Academy of the Fine Arts,
Philadelphia; Charles Bregler's Thomas
Eakins Collection, purchased with the
partial support of the Pew Memorial
Trust 1985.68.2.121

in philanthropic circles. He was more than twenty years her senior.[61] They had their first child, a girl, in 1909, when Clara was thirty-nine and her husband was sixty-two. A son followed in 1912. She was widowed six years later, in 1918. The next two censuses record her residing at different homes in the Philadelphia area; by 1940 she was living with her daughter and son-in-law in Virginia, where she died on March 7, 1941.[62]

Beyond these statistics, the only enlivening glimmer that we can now gain of Clara's life stems from an interview her daughter gave to Eakins's biographer Margaret McHenry in the 1940s. McHenry writes:

> The sitter was a Quaker, Clara Janney Mather. When her daughter Louise had grown up and had become Mrs. Henry Wright Ridg[e]way, she remembered Clara as a gallantly gay person to have had for a mother. The year Louise was born her mother had had an entirely yellow garden, and friends claimed that accounted for Louise's gold red hair. Clara had studied painting with Thomas Eakins as teacher, but she had had to leave art school on the death of her father and mother. After her children were grown and she had time again for painting, Clara couldn't bring herself to touch her brushes again. This distressed Louise, who nevertheless observed that Clara's feeling for line and for color had "come out joyously" in such things as arranging flowers, gardening, sewing, weaving.... During the Eakins Memorial Exhibit at the Academy of the Fine Arts held at the end of 1917, Mrs. Mather gazed long and hard at this portrait of her youth, and a guard came over to her and whispered, "Hello Clara."[63]

This account—albeit retrospective and at second hand—is rich, for it talks of joy and pleasure, bright colors, gallant gaiety.[64] It allows Clara Janney Mather to break from the stillness of the picture and become a complex human. Clara's daughter had to have known the story, of the guard recognizing the near-fifty-year-old as the woman in the portrait painted two decades earlier, because Clara told it to her; we can presume that both the portrait and the guard's response gave her pleasure.

For us, the guard's recognition signals that, above all else, Eakins had captured a physiognomic likeness. Happily, a cache of photographs of Clara Janney now at the Pennsylvania Academy of the Fine Arts proves the point. Three show the elegant Clara in quickly improvised model's smocks—of designs suggestive of olden days and, with a few pins, versatile as to neckline and sleeve length (Figs. 25–27). She sits in three different chairs, and her costume is adapted for each, but the setup is identical: the same Eastern rugs hang behind her and lie at her feet. This series—one of a large group of photographic figure studies that Eakins and those in his circle made as part of their professional practice—also included a close-in view of Clara, sitting again in the Jacobean-style chair with its elaborate crest and turnings, but now gracefully holding a cello bow (Fig. 28). The instrument itself leans

Fig. 29
Circle of Eakins
Clara Mather, bust-length portrait,
c. 1891
Dry-plate negative
8 × 5 in. (20.3 × 12.7 cm)
Pennsylvania Academy of the Fine Arts,
Philadelphia; Charles Bregler's Thomas
Eakins Collection, purchased with the
partial support of the Pew Memorial
Trust 1985.68.2.934

Fig. 30
Circle of Eakins
Clara Mather wearing head scarf and
dress with feathered neckline, c. 1891
Dry-plate negative
8 × 5 in. (20.3 × 12.7 cm)
Pennsylvania Academy of the Fine Arts,
Philadelphia; Charles Bregler's Thomas
Eakins Collection, purchased with the
partial support of the Pew Memorial
Trust 1985.68.2.932

against the side of the chair, almost out of sight, its neck parallel to her upper left arm. It is a rich, sonorous image—the gauze of her sleeve almost already in motion, her hand making the gesture that will, in a moment, fill the space with the deep notes of the cello. The same session included a close-up of Clara's face (Fig. 29). Costume and background seem the same. The picture is overexposed, with too much light on the left and a pronounced dark shadow obscuring the face on the right. Yet for all its technical faults, the picture captures the penetrating power of her eyes, the large pupil set within the light iris. One other photograph of Clara appears to come from a different sitting. Rather than the smock, here Clara wears an elaborately constructed gown, with a tucked, beaded, and feathered bodice, its puffed sleeves formed by carefully gathered pleats (Fig. 30).

Scholars writing on these photographs suggest a date for them of about 1891, and also speculate, for circumstantial reasons including the relatively careful staging, elaborate costumes, and the distinctive size of the negatives, that they were taken not by Eakins but, more likely, by either his sister-in-law Elizabeth Macdowell (with whom Clara was close, according to Mather family tradition) or his wife. They imply,

further, that the Jacobean chair (in Figs. 27 and 28) was part of the Eakins family studio.[65] However, because Elizabeth Macdowell had turned against Eakins in 1886, when he was forced to resign as director of the Pennsylvania Academy Schools amid accusations of sexual impropriety, she was for years forbidden entry to the Eakins house on Mount Vernon Street. She could not, therefore, have made these photos there in 1891. Susan Eakins's retrospective diary records that it was only on September 15, 1894, that, in her words, "Tom writes a kind note to Lid, offering her friendship although she injured him so…[&] she is admitted to our house."[66] If these photographs are indeed by Elizabeth Macdowell, and if they are tied to the Eakins household on Mount Vernon Street, they are likely to date from the mid- or late 1890s.[67]

The dating of the painting is as unclear as the dating of the photographs. When Lloyd Goodrich published his first book on Eakins in 1933, he wrote that the painting was from about 1900, and most American authors have followed him.[68] The Musée d'Orsay, current owner of the picture, dates it about a decade earlier.[69] There is no hard support for either, only observations and some circumstantial evidence. Exhibition history does not help, for Eakins showed *Clara* only once in his lifetime, at the Pennsylvania Academy in 1913.[70]

This question of dating the portrait should not be difficult, for it is, after all, a portrait—a recognizable likeness of a real woman who was born in 1870. Using all the little bits of biography that have thus far been found, it would seem likely that both painting and photos date from sometime between the mid-1890s, when Elizabeth Macdowell once again had access to the Eakins home, and Clara's marriage in 1902, when the sitter was approximately thirty years old. Yet in the portrait Clara seems older, which would accord with Eakins's practice of sometimes consciously aging his sitters.

The effect of that premature aging, taken in conjunction with generally unsmiling expressions, is often characterized as Eakins imposing a sadness onto his sitters. Much recent scholarship on Eakins attributes that sadness, in varying combinations, to the artist's own biography and his thwarted career, to the epidemic of neurasthenia among the middle classes in the decades around 1900, and, in the case of his women sitters, to a misogyny shared by Eakins and his culture.[71] Other writers, notably Marisa Kayyem, whose dissertation is the fullest consideration to date of Eakins's late head-and-bust portraits, have called upon evolutionary theory, along with the era's new sciences of psychology and anthropology, to help understand some of the poignancy—the questioning of self—that these pictures radiate.[72]

But is Clara Janney, in fact, sad? Rushing to judgment on the question may be ill-advised. Psychologists have long debated whether we can accurately read emotional expression, and they have demonstrated that how we perceive the emotions of someone else depends

on many things, including context, nonvisual cues, and, especially, our propensity to project emotions onto others. By and large, when people believe that they are not being watched and are in a passive mode (such as when listening to music or simply absorbed in their own thoughts), the expressiveness of their faces subsides, muscles relax, and gravity has its way with their flesh. The result can look like sadness or weariness to an outside observer, regardless of what the inner emotion of the person being watched may be. (People who commute on subways or buses can testify to the accuracy of this statement.) Clara Janney is here depicted in a quiet, reflective moment. We have neither the skills nor the information to characterize her emotional state further, other than that she certainly projects a private, nonpublic self. Eakins's greatest gift as a portraitist is surely his ability to capture faces more naked of social pretense than anyone generally sees, even when looking in a mirror. That, in turn, speaks of immense trust on Clara's part, a willingness to let down all guards as the tender, soft-spoken artist—who would on occasion slip into a Quakerish "thee" and "thou"—stared at her for hours on end.[73] He shows us an unselfconscious thoughtfulness that is highly unusual in any portraiture and seems to have worked consistently to achieve this look. As early as 1882 one major New York critic coined the term "Eakinsish" to describe an expression in which "mere thinking is portrayed without the aid of gesture or attitude."[74]

The wonderful tale of how *Clara* got to Paris begins in 1929, when Eakins's widow, Susan Macdowell Eakins, and her friend and the co-executor of the artist's estate, Mary Adeline Williams, gave more than seventy of Eakins's works to the Philadelphia Museum of Art (then called the Pennsylvania Museum of Art), among them *Clara*. Such a gift to a public institution would often signal the end to any further entries in a work's provenance.

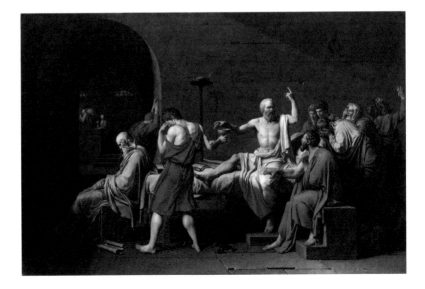

Fig. 31
Jacques-Louis David
The Death of Socrates, 1787
Oil on canvas
51 × 77¼ in. (129.5 × 196.2 cm)
The Metropolitan Museum of Art,
New York; Catharine Lorillard Wolfe
Collection, Wolfe Fund, 1931 (31.45)

In 1931, however, Walter Pach enters our story. In addition to being one of the co-organizers of the 1913 Armory Show, that great beacon of modernism shining in the American art firmament, he was a painter of ambition, an art writer, a collector, and an agent. He was a real enthusiast for Eakins, as were many advanced painters and critics of the 1920s and 1930s. He also spent much time in Paris.[75] In his role as art agent, Pach worked especially closely with Bryson Burroughs, the curator at the Metropolitan who wrote of Eakins's *Clara* as being akin to a Van Eyck. Pach had earlier worked with Burroughs to help the Metropolitan purchase a Cézanne from the Armory Show,[76] but he had Burroughs's attention in early 1931 particularly because it was he who in that year steered Jacques-Louis David's *Death of Socrates* (Fig. 31) to the museum.

In late 1930 or early 1931, while in Paris, Pach showed a small Eakins study that he owned to Jean Guiffrey, the chief paintings curator of the Louvre.[77] When Pach asked him if the Louvre would be interested in owning a work by Eakins, Guiffrey said yes. Thinking to purchase one of the works remaining in Susan Eakins's collection, Pach wrote to her with this news. She responded on January 25: "It is very kind of you to interest the Louvre in the Eakins work. . . . I would prefer to present a picture, rather than sell—so we will not worry about prices. I feel tenderly about Paris, where my husband studied and loved his master Gerome."[78] Susan Eakins duly sent him photographs of some of the works in her collection, nominating "the paintings which I believe would most surely represent the character of my husband's work."[79] She and all of Eakins's students and friends in Philadelphia whom she consulted particularly favored the 1895 portrait of John McLure Hamilton (Fig. 32) as "completely American in subject and character."[80] Two days later, however, she wrote to say that, unbeknownst to her, the Hamilton painting had been sold. But she reiterated her desire "to present a picture."[81] Pach, responding, suggested that Susan ask Bryson Burroughs for his opinion: "With his long-standing and deep admiration for the work of Mr. Eakins," he wrote, "I am sure that his opinion would be worth consulting—especially as he has the type of judgment on desirability [for a museum] which would be especially useful here."[82]

Burroughs, as noted, evinced deep sympathy for and knowledge of Eakins's work.[83] Moreover, he was primed. Pach wrote to him, prompting Burroughs to respond on March 17: "As to the Eakins matter I should be honored to cooperate as you are already aware, when Mrs. Eakins invites me."[84] Over the next several weeks, Susan Eakins in Philadelphia, Walter Pach in Paris, and Bryson Burroughs in New York sent notes to one another. Burroughs was particularly enthusiastic when writing to Pach on March 28: "I am in touch with Mrs. Eakins at last and hope to see Lloyd Goodrich tomorrow who know[s] just which pictures are still free. What a splendid idea—Eakins—

Fig. 32
Thomas Eakins
John McLure Hamilton, 1895
Oil on canvas
80 × 50¼ in. (203.2 × 127.6 cm)
Wadsworth Atheneum Museum of Art, Hartford, CT; The Ella Gallup Sumner and Mary Catlin Sumner Collection Fund 1947.399

in—the—Louvre. My best compliments to you for all your beneficent labors!"[85]

In mid-April things got really interesting. Burroughs wrote to Pach: "I haven't written you before as I've been waiting for the Eakins matter to crystallize. Mrs. Eakins has been most sympathetic." He went on to state his sense of the two likeliest available paintings, but concluded that neither "could be regarded as his *very best*," and that therefore

> I have broached to Mrs. Eakins a little plan I've concocted to which she agrees. It's this—to try to wangle Clara (1) or The Bohemian (2) out of the Pennsylvania Museum, i.e., try to induce them to offer one of the *very best* to the Louvre. What do you think of the idea? Clara was always one that seemed to me a top-notcher.[86]

Burroughs wrote to Fiske Kimball, director of the Pennsylvania Museum, the next day, telling the story of Pach's idea, Guiffrey's enthusiasm, and Susan Eakins's involvement and suggestions, closing with the lines:

> This is all preamble to the expression of an idea I've had which may or may not appeal to you. It is this—Would there be any chance that the Pennsylvania Museum would consider offering to the Louvre as a gift one of the very many fine heads by Eakins which they own? I am writing this letter to you, most officiously perhaps, but not at all officially.[87]

Amazingly, such was the attraction of placing a work by Eakins, the Philadelphia hometown artist, into the Louvre that Kimball and his staff and his trustees all entertained the idea.

The work that they suggested to Burroughs was—*Clara*. Burroughs rejoiced that it was *Clara* that the officials of the Pennsylvania Museum chose "on their own initiative and which happens also to be my own first choice as an appropriate representation of Eakins's work for this purpose."[88] Kimball first proposed a trade with the Louvre, then that Pach might buy a painting for Philadelphia (he was angling for a work by André Derain). In the end, however, on May 25, Kimball convinced himself and his board simply to offer *Clara* as an outright gift to the Louvre.[89] There was a little more to-ing and fro-ing, with Kimball wanting to make sure that the French would indeed accept the gift, that Susan Eakins agreed, and other bureaucratic niceties.[90] Paperwork and transportation all took further time, but by the end of 1931, *Clara* was officially part of the French state collections.[91] The hope was, as Burroughs had earlier written to Pach, that the painting "would be, with Whistler's Mother, a monument to American Art in the greatest museum of European Art."[92] The gift made news, and journalists followed Burroughs's line, with one reporting that hanging *Clara* with Whistler's *Arrangement in Grey and Black, No. 1* in the Louvre was "the highest honor the French Government could

Fig. 33
Clara (Clara J. Mather) in situ at the
Musée d'Orsay, Paris, November 2012

bestow," and that it "brings to a fitting climax a career which found little recognition from Eakins' contemporaries."[93]

What should have been a happy end to a tale of remarkable initiative and generosity was nevertheless beset, early on, with signs to the contrary. In mid-January 1932, Susan Eakins wrote to Kimball that she was pleased that Eakins was now represented in the Louvre; she added, however, in a seeming change of heart, "My preference would have been for a picture more distinctly an expression of America in subject."[94] Then, in late 1937, for whatever reason, something happened to cause newspapers in New York to cast doubts on *Clara*'s whereabouts. A headline on the front page of the *Sun* read: "Louvre's Eakins Portrait Has Strangely Disappeared . . . All Trace of Canvas by American Artist Is Lost."[95] In good yellow journalism fashion, the text claimed that the painting had never been hung, that a supposed transfer of the picture from the Louvre to the Jeu de Paume had been bungled, and that the painting might well be lost or stolen. The *Sun* article included an interview with Walter Pach that recounted, with considerable variation from the historical record, the story of the gift and a call for action. But that was all a tempest in a teapot. The picture was hanging where it was supposed to be—in the Louvre.[96]

Real-world events subsequently intervened in the form of World War II, and in the effort to secure its treasures, the Louvre removed pictures from the museum. *Clara* then truly did vanish from public view, and stayed that way for some time. One American scholar, writing in 1974, noted that from 1939 the picture

> has not been seen since on any wall outside a vault. It is now in storage at a provincial museum in Compiegne, fifty miles north of Paris, where it is nearly inaccessible except to persevering applicants.... It is also likely that people will not see it for another few years; it will be hung, I have been told, on the walls of a museum in Paris for which the plans have not been made, and for which the ground has not been cleared.[97]

The reference, of course, is to the Musée d'Orsay, which did not open until 1986. Rarely afterward, however, if at all, was the picture on the walls of that splendid museum. Until recently, that is. As of this writing, December 2012, *Clara* is proudly at home there (Fig. 33), fulfilling what Bryson Burroughs eighty years ago termed Eakins's "apotheosis, an honor to Philadelphia, to the United States, and to France."[98]

For fifty years, from the time he first set foot in Paris in 1866 until his death in 1916, Eakins put the training and artistic principles he learned in France to use in his career as an artist and teacher. Thanks to the enthusiasm of his widow, the interventions of several art historians, and a selfless and wholly altruistic act on the part of the Philadelphia Museum of Art, one of Eakins's handsomest portraits— *Clara*—now represents him in the city he called, for beginning that career, "the best place."[99]

I would like to thank the Directors of the Sansom Foundation for their invitation to develop a lecture on the topic of Eakins in Paris, which I delivered at the New-York Historical Society on November 29, 2012. That talk, in turn, grew from a much shorter and more limited talk that I gave at the National Gallery in London in connection with the exhibition *Americans in Paris, 1860–1900*, on April 7, 2006, which was my first opportunity to focus on the question of Eakins in Paris; I much appreciate the invitation from Kathleen Adler to play a small part in the project that she and her co-curators, H. Barbara Weinberg and Erica Hirshler, organized. For research assistance in archives stretching from Los Angeles to Philadelphia to Paris, I would like to thank Brett Abbott, Margaret Adler, and Sylvie Patry. For Fronia.

NOTES

1. Quoted in Lloyd Goodrich, *Thomas Eakins: His Life and Work* (New York: Whitney Museum of American Art, 1933), 99. In his expanded biography of Eakins from 1982, Goodrich elaborated that Eakins (hereafter TE) was probably responding to a questionnaire from the *National Cyclopaedia of American Biography*, which repeats the genealogical material (vol. 5 [1894], 421). See Lloyd Goodrich, *Thomas Eakins*, 2 vols. (Cambridge, MA: Harvard University Press for the National Gallery of Art, 1982), 2:5–6, 320.

2. The three biographies are Henry Adams, *Eakins Revealed: The Secret Life of an American Artist* (New York: Oxford University Press, 2005); Sidney D. Kirkpatrick, *The Revenge of Thomas Eakins* (New Haven: Yale University Press, 2006); and William S. McFeely, *Portrait: The Life of Thomas Eakins* (New York: W. W. Norton, 2007). More focused monographic studies in the period include Amy Beth Werbel, *Thomas Eakins: Art, Medicine, and Sexuality in Nineteenth-Century Philadelphia* (New Haven: Yale University Press, 2007); Alan C. Braddock, *Thomas Eakins and the Cultures of Modernity* (Berkeley: University of California Press, 2009); and Akela Reason, *Thomas Eakins and the Uses of History* (Philadelphia: University of Pennsylvania Press, 2010).

3. Scholar and former Philadelphia Museum of Art curator Darrel Sewell noted this sentiment to me as we worked on the catalogue accompanying his exhibition *Thomas Eakins: American Realist* (Philadelphia Museum of Art, 2001).

4. TE to Harrison Morris, April 23, 1894, Pennsylvania Academy of the Fine Arts (hereafter PAFA) Archives, quoted in Goodrich, *Thomas Eakins* (1982), 2:160.

5. For an overview of Eakins's public life, see Elizabeth Milroy, with Douglass Paschall, *Guide to the Thomas Eakins Research Collection with a Lifetime Exhibition Record and Bibliography* (Philadelphia: Philadelphia Museum of Art, 1996). This is my source for comments hereafter concerning Eakins's exhibition practices.

6. Henry F. Huttner to Benjamin Eakins (hereafter BE), January 29, 1867: having received a letter from TE, Huttner recalls to BE how strongly opposed TE had been to going abroad. See Kathleen A. Foster and Cheryl Leibold, *Writing about Eakins: The Manuscripts in Charles Bregler's Thomas Eakins Collection* (Philadelphia: University of Pennsylvania Press for the PAFA, 1989), 339.

7. In the realm of art, as one fellow student and art writer noted just a month earlier, quoting a French acquaintance, the tide of artistic study flowed toward Paris, and "for toleration of taste, for the painter's dream, even America emigrates." E. S. [Earl Shinn], "Art Study Abroad," *The Nation* 3, no. 62 (September 6, 1866): 195.

8. The letters—many of which are in the Charles Bregler Manuscripts Collection of the PAFA Archives; in the Smithsonian Institution's Archives of American Art (hereafter AAA); or in the Hirshhorn Museum and Sculpture Garden—have been usefully introduced and annotated in William Innes Homer, ed., *The Paris Letters*

of Thomas Eakins (Princeton, NJ: Princeton University Press, 2009). The principal studies of Eakins's time in Paris and its impact are Gerald M. Ackerman, "Thomas Eakins and His Parisian Masters Gérôme and Bonnat," *Gazette des Beaux-Arts*, 6th ser., 73 (April 1969): 235–56; Kathleen A. Foster, "Philadelphia and Paris: Thomas Eakins and the Beaux-Arts" (master's thesis, Yale University, 1972); Elizabeth Milroy, "Thomas Eakins' Artistic Training, 1860–1870" (PhD diss., University of Pennsylvania, 1986); and H. Barbara Weinberg, *The Lure of Paris: Nineteenth-Century American Painters and Their French Teachers* (New York: Abbeville, 1991).

9. For Eakins's various addresses in Paris, see Gordon Hendricks, *The Life and Work of Thomas Eakins* (New York: Grossman, 1974), 19–56; and Kathleen Brown, "Chronology," in Darrel Sewell, *Thomas Eakins* (Philadelphia: Philadelphia Museum of Art, 2001), xxv–xxvii.

10. TE to Emily Sartain, November 16, 1866 (Homer, *Paris Letters*, 70–72). This comes between two sentences: "Philadelphia is certainly a city to be proud of, and has advantages for happiness only to be fully appreciated after leaving it.... Many young men after living here a short time do not like America. I am sure they have not known as I have the many reasonable enjoyments to be had there."

11. Indeed, throughout his life he maintained an interest in etymology, as well as in French, German, Italian, and Spanish. His French skills seem to have been particularly accomplished.

12. TE to BE, October 13, 1866 (Homer, *Paris Letters*, 35–46; passage quoted is on 43).

13. TE to BE, November 1, 1866 (Homer, *Paris Letters*, 62–66). This counts neither of his fellow Philadelphians who were inscribed immediately after him: Harry Moore, who was deaf and for whom Eakins served as companion and guardian; and Earl Shinn, who was to become an art writer and early defender of Eakins's work. TE to his sister, Frances, noted that Moore "is as deaf as a post but talks very well. You would think he was a little affected in his speech & he has a childish voice but you would not suspect his deafness. He understands by the motion of the lips & not only English but a little French & a good deal of German. He lost his hearing when ten years old by a scarlet fever" (Good Friday 1868, Homer, *Paris Letters*, 207–9). When together in Seville in January 1870, it seems the two men spoke with sign language (TE to his family, January 6, 1870, Homer, *Paris Letters*, 295). In 1868, when he was studying sculpture under Dumont, Eakins proclaimed his fluency not simply in French but in the argot of the studio—the "slang which we always talk" (TE to BE, March 6, 1868, Homer, *Paris Letters*, 197–200). The fullest study of Gérôme's 150-plus North American pupils, including Lemuel Wilmarth, who alone preceded Eakins in enrolling in Gérôme's atelier, is H. Barbara Weinberg, *The American Pupils of Jean-Léon Gérôme* (Fort Worth, TX: Amon Carter Museum, 1984).

14. See, as particular examples, TE to BE, May 14, 1869, and TE to his family, June 10, 1869, the former with his witness account of riots, secret police, and various tactics of crowd control (Homer, *Paris Letters*, 256–59, 261–63).

15. At least that is what may be concluded from a note to his father that reads: "Nor am I either sorry or ashamed to have accompanied them to the place I suspect to have had some share in your uneasiness. But I would be ashamed if I had been in the least attracted by the vice I saw there" (TE to BE, January 16, 1867, Homer, *Paris Letters*, 82–83). See also his letter of July 24, 1868, concerning other French social customs: "I suppose you would laugh to see us all a hugging & kissing one another good by but that is the French way" (Homer, *Paris Letters*, 215–17).

16. TE to BE, December 23, 1866 (Homer, *Paris Letters*, 75–78).

17. TE to BE, May 7, 1869 (Homer, *Paris Letters*, 254–56). After writing about social

pretension among some society painters, Eakins adds: "A prince or any one at all could not get in to see Gerome or Meissonier or Couture at work. No one but a student can ever get in to Gerome. So every thing I see around me narrows my path and makes me more earnest and hard working."

18. TE to BE, November 11, 1866 (Homer, *Paris Letters*, 70).

19. TE to BE, late November 1867 (Homer, *Paris Letters*, 173–74). In September 1869, after spending time in the atelier of Bonnat, he writes to his father: "I am very glad to have gone to Bonnat & to have his criticisms, but I like Gerome best I think" (TE to BE, September 8, 1869, Homer, *Paris Letters*, 278–79).

20. TE to his sister Frances, April 1, 1869 (Homer, *Paris Letters*, 242–50). He concludes with a comparison of Gérôme and Couture: "They are giants & children each to the other, & they are at the very head of all art." Eakins's letters talk about his struggle to learn and the challenges he faced. These must have been formidable, for as late as 1917 the critic Henry McBride could write: "Apparently he was not a facile student, and a remark of Gérôme's at that time was quoted about the student quarter and is still current. Gérôme said: 'Eakins will never learn to paint, or he will become a very great painter.'" Henry McBride, "Thomas Eakins I," *New York Sun*, November 4, 1917, reprinted in Henry McBride, *The Flow of Art: Essays and Criticisms*, ed. Daniel Catton Rich (1975; New Haven: Yale University Press, 1997), 133.

21. TE to BE, March 6, 1868, TE to BE, fall 1869 (Homer, *Paris Letters*, 198, 283–84).

22. TE to BE, October 29, 1868 (Homer, *Paris Letters*, 229–31). He closes: "Please burn this letter right away for part of it looks so like boasting which ill befits me, but by which I have still hoped to reassure you a little." He writes to much the same effect on June 24, 1869 (Homer, *Paris Letters*, 265–66).

23. TE to BE, fall 1869 (Homer, *Paris Letters*, 283–84). He continues with a fine discussion of the difference between a study and a picture: "It is bad to stay at school after being advanced as far as I am now. The French boys sometimes do & learn to make wonderful fine studies, but I notice those who make such studies seldom make good pictures, for to make these wonderful studies they must make it their special trade, almost must stop learning & pay all their attention to what they are putting on their canvass rather than in their heads.... An attractive study is made from experience & calculations. The picture maker sets down his grand landmarks & lets them dry and never disturbs them, but the study maker must keep many of his landmarks entirely in his head for he must paint at the first lick & only part at a time & that must be entirely finished at once & so that a wonderful study is an accomplishment & not power."

24. Notes, written in French, from the so-called Spanish Notebook (Homer, *Paris Letters,* 302–8).

25. "Quelle est l'habitude des meilleurs peintres? Y a t'il un convenance?" Quoted in Kathleen A. Foster, *Thomas Eakins Rediscovered: Charles Bregler's Thomas Eakins Collection at the Pennsylvania Academy of the Fine Arts* (New Haven: Yale University Press, 1997), 136, 263–64n19.

26. "Je pense sens que je vais bientot faire beaucoup mieux. Dans cet espoir j'invite votre critique si vous voyez dans mes tableaux des tendances mauvais." Ibid., 264n20.

27. Jean-Léon Gérôme to TE, May 10, 1873, quoted in Goodrich, *Thomas Eakins* (1982), 1:114.

28. TE to Jean-Léon Gérôme, May 1874, draft quoted in Foster, *Eakins Rediscovered*, 263n18.

29. There is uncertainty about the identity of this second oil. Many think it was the wonderful *Pushing for Rail* at the Metropolitan Museum of Art. I, however, agree with Kathleen Foster, who has nominated *The Artist and His Father* as the

likelier candidate (Foster, *Eakins Rediscovered*, 134–36, 262–65nn15–21), both as it matches more closely the description Eakins provides in his letter and since it presents the lighting problems that lie at the core of his questions of control. There is, further, a later Salon review with a terse description ("Ces deux toile, contenant chacune deux chasseurs dans un bateau" [These two canvases, each containing two hunters in a boat]) that supports the identification (M. F. de Lagenevais, "Le Salon de 1875," *Revue de deux-mondes* 9 [1875]: 927).

30. Jean-Léon Gérôme to TE, September 18, 1874, quoted in Goodrich, *Thomas Eakins* (1982), 1:116.

31. He wrote, with slight exaggeration: "Gerome calls me his favorite pupil & is proud of having in the New World one doing him so much honor" (TE to Earl Shinn, January 30, 1875, Richard Tapper Cadbury Papers, Friends Historical Library, Swarthmore College, PA). I am grateful to the late William Innes Homer for providing me with copies of Eakins-Shinn correspondence now at Swarthmore.

32. The two known works were *Sailboats Racing on the Delaware* (1874; Philadelphia Museum of Art) and probably *Ships and Sailboats on the Delaware* (1874; Philadelphia Museum of Art).

33. TE to Earl Shinn, April 13, 1875, Cadbury Papers, Swarthmore.

34. A Goupil & Cie ledger book in the Dieterle Family Archive now at the Getty Research Institute, Los Angeles, indicates the two works that sold in London: *Whistling for Plover (Nègre à affût)* on April 16, 1875, to Mr. Kingman, for 400 frs (Eakins's own record book translates this to "$60. gold") on page 79; and *Rail Shooting in the Marshes of the Delaware (Chasse aux États-Unis)* to Mr. Hunnewell on May 4, for 1,000 frs, on page 86. The likeliest clue to the final appearance of the Hunnewell oil is a set of drawings pinned together and labeled "La chasse" from the Bregler Collection, PAFA. See Foster, *Eakins Rediscovered*, 140–42. I am grateful to Brett Abbott for his research assistance in 2006 at the Getty in Los Angeles, well in advance of the digital records of the material now available.

35. Paul Leroi, "Salon de 1875—XV," *L'Art* 2 (1875): 276.

36. De Lagenevais, "Le Salon de 1875."

37. "The contributions of American artists this year are of an unusual high standard of merit.... [Daniel Ridgway Knight, Henry Bacon, Frank Buchser, G. P. A. Healy, Elizabeth Gardner, Mary Cassatt, Miss C. Tompkins, Edward May] ... and Thomas Erkins [*sic*], of Philadelphia, two hunting scenes, which are well and vigorously painted" [All but Buchser, Cassatt, and Eakins are in the regularly posted listing of "Artists Resident in Europe"]; "The Salon of 1875," *The American Register*, May 8, 1875, 6.

38. TE to Earl Shinn, April 13, 1875, Cadbury Papers, Swarthmore. In the same note, looking ahead and writing, I believe, of *The Gross Clinic*, he adds: "What elates me more is that I have just got a new picture blocked in & it is very far better than anything I have ever done.... I have the greatest hopes of this one."

39. For concerted studies of this picture, see Robert Torchia, "*The Chess Players* by Thomas Eakins," *Winterthur Portfolio* 26, no. 4 (Winter 1991): 267–76; and Michael Clapper, "Thomas Eakins and *The Chess Players*," *American Art* 24, no. 3 (Fall 2010): 78–99.

40. TE to BE, January 16, 1867 (Homer, *Paris Letters*, 83).

41. TE to BE, July 12, 1867 (Homer, *Paris Letters*, 138).

42. Commentators from Ackerman, in his 1969 article "Thomas Eakins and His Parisian Masters," onward have pointed this out.

43. Jean-Léon Gérôme to TE, February 22, 1877, quoted in Foster and Leibold, *Writing about Eakins*, 212–13.

44. For details, see Milroy with Paschall, *Eakins Research Collection*, 19–22. Moreover, an illustration of the work represented him in William C. Brownell, "The

Younger Painters of America: First Paper," *Scribner's Monthly* 20, no. 1 (May 1880): 8.

45. Goodrich, *Thomas Eakins* (1982), 1:186. When in the midst of his troubles at the Academy in 1886, Eakins invoked their closeness: "My dear master Gérôme who loved me...helped me always and has to this day interested himself in all I am doing" (TE to Edward Horner Coates, February 15, 1886, quoted in Foster and Leibold, *Writing about Eakins*, 215). See as well "Correspondence with Gérôme" in Foster and Leibold, *Writing about Eakins*, 62–64.

46. TE to Richard T. Cadbury, April 13, 1888, Cadbury Papers, Swarthmore.

47. Frank Linton to Charles Bregler, no day or month noted, 1894, quoted in Foster and Leibold, *Writing about Eakins*, 64.

48. There could be several reasons to explain this long absence. There was the difficulty of having works returned through American customs, although Eakins did send pictures to Munich in 1883 and Toronto in 1884. A much more likely reason is the sheer press of responsibilities—ever-increasing teaching loads up to 1886 and an active exhibition schedule throughout the United States, with even more opportunities for showing works after the opening of the Society of American Artists and many other regional exhibition societies in the 1870s and 1880s. From 1889 to 1891, however, he submitted works to three different kinds of Parisian exhibition—exposition, annual salon, and commercial gallery. Part of the lure of the exposition was, in addition to the prestige, that the artist needed only to arrange for the works to get to New York. In an era when artists often bore the expenses of crating and shipping, this was a strong incentive.

49. Each of these works had been—and would continue to be—seen in important exhibitions across the United States. For details, see Milroy with Paschall, *Eakins Research Collection*, passim.

50. Susan Macdowell Eakins (hereafter SME) to Bryson Burroughs (hereafter BB), December 21, 1917, Museum Archives, Metropolitan Museum of Art, New York, quoted in Natalie Spassky, *American Paintings in the Metropolitan Museum of Art. Vol. II: A Catalogue of Works by Artists Born between 1816 and 1845* (New York: Metropolitan Museum of Art, 1985), 605.

51. Michael Fried, *Realism, Writing, Disfiguration: On Thomas Eakins and Stephen Crane* (Chicago: University of Chicago Press, 1987).

52. "Mais ce qui intéresse le plus le public français, dans cette exposition, c'est de voir, d'une façon évidente, in deniable, la grande influence que l'art français et les maîtres français ont exercée, à travers les mers, sur l'art des États-Unis." Théodore Stanton, foreword, *Exposition de Peintures et Sculptures d'Artistes Américains* (Paris: Galeries Durand-Ruel, 1891), 8.

53. Victor Champier, André Saglio, and William Walton, *The Arts of the XIXth Century: Painting, Sculpture, Architecture, and Decorative Arts of All Races*, 2 vols. (Philadelphia: George Barrie & Son, 1901), 1:49–50.

54. SME, loose diary pages, Bregler Collection, PAFA.

55. Writing to Louis Cure on learning of the death of their mutual friend Ernest Guille: "Je pense toujours à lui et à toi, quand je pense à la France—ce qui m'arrive très souvent" (TE to Louis Cure, March 9, 1907, quoted in Goodrich, *Thomas Eakins* [1982], 2:257–58).

56. During the more than eighty years that the picture has been in the hands of the French state, it has been largely unstudied in the literature—illustrated on occasion, but rarely written of.

57. BB to Walter Pach (hereafter WP), June 24, 1931, AAA.

58. For a discussion of Bryson Burroughs and his development of the Eakins collection at the Metropolitan Museum of Art, see H. Barbara Weinberg, *Thomas Eakins and the Metropolitan Museum of Art*, a dedicated issue of the *Metropolitan*

Museum of Art Bulletin 52, no. 3 (Winter 1994–95), especially 37–42. In addition to mounting the memorial exhibition (*Loan Exhibition of the Works of Thomas Eakins*, 1917) with fifty-four oils and six watercolors, Burroughs acquired many of the most important paintings and watercolors by Eakins now in that museum's stellar collection.

59. The siblings were Josephine, Richard, Antoinette, and Catharine W. (1900 United States Federal Census, Ancestry.com). Sources disagree about the year of Clara's birth. Most, including "Pennsylvania Births and Christenings, 1709–1950" (database, *FamilySearch* [https://familysearch.org/ark:/61903/1:1:V2FX-2MZ: 9 December 2014], Clara Janney, 19 Nov 1870; birth, citing Philadelphia, Pennsylvania; FHL microfilm 1,289,313), cite November 19, 1870, but the official record of Clara's death (Virginia, Death Records, 1912–2104, Ancestry.com) gives the year as 1869.

60. She was baptized on June 25, 1871, at St. Timothy's PE Church in Roxborough, PA, and was buried in Philadelphia at the Episcopal Church of the Saviour, which has since been designated the Episcopal Cathedral of Philadelphia (Pennsylvania and New Jersey, Church and Town Records, Ancestry.com).

61. Louis Montgomery Mather was born September 11, 1847. Horace Mather Lippincott, *The Mather Family of Cheltenham, Pennsylvania; being an account of the descendants of Joseph Mather, compiled from the records of Charles Mather of Jenkintown* (Philadelphia: L. J. Levick, 1910), 95. The U. S. Census of 1910 records his occupation as "own income" (Ancestry.com). His was not, however, a staid and unexciting past. L. Montgomery Mather in 1889 had run a weekly newspaper in Los Angeles, *The Los Angeles Life* (see *An Illustrated History of Los Angeles County, California* [Chicago: Lewis, 1889], 154). Before that he had lived in Hawaii, serving as the court poet to David Kalakaua, the last king of the islands. Various articles in the Honolulu *Daily Herald* report on his activities at court and reproduce some of his odes to King Kalakaua and Princess Liliuokalani (see, for example, "The Birthday Celebration," September 3, 1886). I am grateful to Charles E. Mather III for help in finding materials concerning L. Montgomery Mather.

62. Virginia, Death Records, 1912–2104, Ancestry.com.

63. Margaret McHenry, *Thomas Eakins Who Painted* (Oreland, PA: privately printed, 1946), 122–23.

64. McHenry (ibid.) opens her discussion of the portrait with the lines: "When Mrs. Eakins was asked to choose from among her husband's paintings given to the Philadelphia Museum of Art in 1930 one for presentation to the Paris Louvre, she chose the portrait 'Clara'. It is rather French in its verve." This was not, in fact, how the process developed, as we will see. Nor, *pace* McHenry, does the historical record reveal Clara's ties to the Quakers, although at least her son, whose first wife was the Edward Hicks scholar Eleanore Price Mather, was a Friend ("Milestones: Mather—Robert Worrell Mather," *Friends Journal* 43, no. 10 [October 1997]: 36).

65. Citing information from the Mather family, they write: "There is also a set of large negatives for a series of studies of Clara Mather (see cat. nos. 228–32). She was close to both Elizabeth and Susan Macdowell, and either of them could have been responsible for taking the images. While clearly inspired by some of Eakins's figure studies..., the Mather compositions are set apart from his work by the varied props, the elaborate costuming, and the large size of the negatives." Susan Danly and Cheryl Leibold, "Eakins and the Photograph: An Introduction," in *Eakins and the Photograph: Works by Thomas Eakins and His Circle in the Collection of the Pennsylvania Academy of the Fine Arts*, ed. Danley and Leibold (Washington, DC: Smithsonian Institution Press, 1994), 13. Later in the text they note that all the pictures of Clara, barring the photograph with the cello,

are the same size "as several negatives attributed to Elizabeth Macdowell in the Macdowell family collection, Roanoke, Virginia. The carved armchair visible in cat. no. 228 was acquired with the Bregler collection [and hence as part of the Eakins studio remains] but is not the chair seen in Eakins's painted portraits" (173). There is tentative support for associating Clara and Elizabeth Macdowell in one later note from Eakins to his wife, in which he writes, cryptically: "Its too bad about poor Clara and about Leid too" (TE to SME, May 17, 1905, in the collection of William Innes Homer). Whether this "Clara" refers to Clara Janney Mather is speculative. The rest of the letter, written from Washington, DC, where Eakins was at work on the portrait of Archbishop Wood, gives no further clues as to what the trouble may have been.

66. SME, retrospective diary, Bregler Collection, PAFA.

67. These questions of date illustrate the suppositions and guesses involved in the chronology of Clara's interactions with Eakins and his circle.

68. Goodrich, *Eakins: His Life and Work* (1933), 191.

69. Musée d'Orsay, "Thomas Eakins: Clara," http://www.musee-orsay.fr/en/collections /index-of-works/notice.html?no_cache=1&zsz=5&lnum=&nnumid=9447 (accessed February 25, 2013).

70. Milroy with Paschall, *Eakins Research Collection*, 34, 56n20.

71. See, for example, Sarah Burns, "Ordering the Artist's Body: Thomas Eakins's Acts of Self-Portrayal," *American Art* 19, no. 1 (Spring 2005): 82–107; David M. Lubin, "Modern Psychological Selfhood in the Art of Thomas Eakins," in *Inventing the Psychological: Toward a Cultural History of Emotional Life in America*, ed. Joel Pfister and Nancy Schnog (New Haven: Yale University Press, 1997), 133–66; Kathleen Spies, "Figuring the Neurasthenic: Thomas Eakins, Nervous Illness, and Gender in Victorian America" (1998), amended and reprinted in *Women on the Verge: The Culture of Neurasthenia in Nineteenth-Century America*, ed. Katherine Williams (Stanford, CA: Iris & B. Gerald Cantor Center for Visual Arts, 2004), 36–51; Annette Stott, "Neurasthenia and the New Woman: Thomas Eakins's *Portrait of Amelia Van Buren*," in *In Sickness and in Health: Disease as a Metaphor in Art and Popular Wisdom*, ed. Laurinda S. Dixon, with the assistance of Gabriel Weisberg (Newark: University of Delaware Press, 2004), 125–43; John Wilmerding, "Thomas Eakins' Late Portraits," *Arts* 53, no. 9 (May 1979): 108–12.

72. Marisa Kayyem, "Thomas Eakins's Late-Format Portraits: Identity, Consciousness, and Typology in Turn-of-the-Century Portraiture" (PhD diss., Columbia University, 1998).

73. Goodrich, *Thomas Eakins* (1982), 2:91.

74. Clarence Cook, "The Art Gallery: The Water-Color Society's Exhibition," *The Art Amateur* 6, no. 4 (March 1882): 74. Contrast this to the practice of such other prominent portraitists as John Singer Sargent, for example, who wanted his sitters to have companions while they posed, for conversation so as to keep them looking alert and engaged. Henry James, as just one of many possible examples, wrote of sitting for Sargent: "He *likes* one to have a friend there to talk with and to be talked to by, while he works—for animation of the countenance etc." (James to Jocelyn Persse, May 18, 1913, in *Henry James Letters, Volume IV: 1895–1916*, ed. Leon Edel [Cambridge, MA: Belknap Press of Harvard University Press, 1984], 671–72).

75. Pach lived at 20 rue Jacob, where American poet and playwright Natalie Clifford Barney held her famous salon.

76. Paul Cézanne, *View of the Domaine Saint-Joseph* (late 1880s; The Metropolitan Museum of Art, New York).

77. Guiffrey had, in the early teens, spent at least two years as the paintings curator at the Museum of Fine Arts, Boston, before returning to France. He reportedly

had not known of Eakins's work before this ("Dictionary of Art Historians," http://www.dictionaryofarthistorians.org/guiffreyj1870.htm; accessed February 25, 2013).

78. SME to WP, January 25, 1931, AAA. Susan Eakins remained committed to Eakins's love of Gérôme, writing to "Mr. Barker" around July 9, 1936, of Lloyd Goodrich's biography: "Mr. Goodrich published a most useful volume on Eakins, but how much he may have profited by his research I cannot say, when a man cannot understand the greatness of Gerome I cannot think he understands Eakins" (Bregler Collection, PAFA).

79. SME to WP, February 19, 1931, AAA.

80. SME to WP, February 19, 1931, AAA.

81. SME to WP, February 21, 1931, AAA.

82. WP to SME, March 6, 1931, AAA. Pach added that Guiffrey remained enthusiastic, and indeed, on seeing the 1868 photo of Eakins that SME had sent, said, "Yes, that brings back the whole period, doesn't it? The period, so rich in great men, is one that is gaining in people's esteem."

83. Burroughs's interest in Eakins was a family affair; his son, Alan Burroughs, had written articles on Eakins for the periodical *Arts* in 1923 and 1924, including a list of known works: "Catalogue of the Work of Thomas Eakins," *Arts* 5, no. 6 (June 1924).

84. BB to WP, March 17, 1931, AAA.

85. BB to WP, March 28, 1931, AAA.

86. BB to WP, April 14, 1931, AAA.

87. BB to Fiske Kimball (hereafter FK), April 15, 1931, Philadelphia Museum of Art Archives (hereafter PMA Archives). He also noted that Guiffrey "suggested to Pach that a somewhat smaller picture would be welcome as it is a question of the Louvre itself, not the foreign section of the Luxembourg in the Jeu de Paume, where no one goes anyway unless he has to. Guiffrey also asked Pach if I would make a choice here and did me the honor to say that my choice would be acceptable." My thanks to Maggie Adler for her work on my behalf in the Philadelphia Museum of Art Archives, as well as the kind assistance there of Susan K. Anderson.

88. BB to WP, May 11, 1931, AAA.

89. "Minutes of the Meeting of the Board," May 25, 1931, PMA Archives.

90. On June 27, Susan Eakins wrote to Pach and to the Pennsylvania Museum to signal her enthusiasm for the plan (SME to WP, June 27, 1931, AAA; and SME to the Pennsylvania Museum, June 27, 1931, PMA Archives).

91. Henri Verne, director of the French National Museums, wrote to Pach on January 26, 1932, expressing thanks and, apologizing for the cliché, claimed that this was a further link between the museums of France and the United States (Verne to WP, January 26, 1932, AAA). In the official minutes of the French deliberations, Pach is written of as "Walter Foch," but Pach is clearly meant. See the "Comité consultatif des Musées nationaux," June 11, 1931, 326 (Archives des Musées nationaux, Paris). My thanks to Sylvie Patry for making the relevant records available to me. Other notices of deliberations concerning the Eakins acquisition in the Archives des Musées nationaux: "Comité consultatif des Musées nationaux," December 17, 1931, 384; "Comité artistique des Musées nationaux," January 11, 1932, 22.

92. BB to WP, May 3, 1931, AAA.

93. "In the Louvre," *Art Digest* 6, no. 12 (March 15, 1932): 4.

94. SME to FK, January 21, 1932, PMA Archives.

95. "Louvre's Eakins Portrait Has Strangely Disappeared," *New York Sun*, November 27, 1937.

96. "Louvre Disproves Theft of Eakins' Portrait," unidentified clipping, PMA Archives, dateline "Paris, November 27 I.N.S." (inscribed *New York Sun Tribune*).

97. Hendricks, *Life and Work of Thomas Eakins*, 246–47.

98. BB to WP, May 3, 1931, AAA.

99. TE to BE, fall 1869 (Homer, *Paris Letters*, 283–84).

Trompe l'oeil and Modernity

JUDITH A. BARTER

Lecture given on December 5, 2013

New-York Historical Society

New York City

Trompe l'oeil and Modernity

JUDITH A. BARTER

In the last quarter of the nineteenth century, a revival of trompe l'oeil painting began in Philadelphia and continued to be popular in many of the nation's cities into the twentieth century. These pictures were meant to literally "fool the eye" by making viewers wonder whether what they saw was a painted illusion, or reality. Ironically, while these pictures often depicted old, discarded objects and rarely anything new, they nonetheless were emphatically modern pictures. Though they took the common as subject matter, their treatment of optical issues, the play of reality and illusion, and their investigation into the nature of the picture plane itself were modern and forward-looking. Beyond this, these paintings also were modern because they endowed objects with human agency, associating the things they depicted with memory and symbol. Their meanings were modern as well; in their fascination with time, standardization, professionalism, science, and consumption, they explored the attributes of modernity.

William Michael Harnett (1848–1892), John Frederick Peto (1854–1907), and other trompe l'oeil artists left few explanations about the meanings of their pictures. Indeed, they seemed to have been devoted to the representation of the actual—to bamboozling their viewers with factual, minute detail and fidelity to the nature of familiar objects, using sharp edges, dark tonalities, textures, and life-size scale to eliminate the distinction between object and reality. The painting became reality itself.[1] And yet Harnett, usually seen as a painter who wanted only to perfect optical trickery, once famously said that he wanted his pictures to tell a story.[2] Indeed, trompe l'oeil pictures go beyond modern tensions of the relationship between painting and reality; they also have narrative and symbolic value that can be decoded.

In the summer of 1879 two noteworthy trompe l'oeil pictures appeared in Philadelphia, both still-lifes of letter racks. In June, John Frederick Peto painted *Office Board for Smith Brothers Coal Company* (Fig. 34). This composition quite likely impressed Peto's friend and colleague William Michael Harnett, who painted *The Artist's Letter*

Fig. 34
John Frederick Peto
Office Board for Smith Brothers Coal Company, 1879
Oil on canvas
28¼ × 24 in. (71.8 × 61 cm)
Addison Gallery of American Art,
Phillips Academy, Andover, MA;
Museum purchase 1956.13

Rack that August[3] (Fig. 35). But there was a third artist in that city who must have known the work of both men, and who also painted a rack picture, probably in November of 1879. These pictures, which appeared within five months of one another, reveal a new fascination with trompe l'oeil painting and the expression of modern life.

Peto and Harnett clearly knew each other's compositions. Both were studying at the Pennsylvania Academy of the Fine Arts during the period 1876–79; Harnett had opened his own studio at 400 Locust Street, and Peto was located on nearby Chestnut Street. Perhaps their physical proximity explains why both painted rack pictures during 1879. Doreen Bolger has pointed out that Harnett seems to have made his for a client, probably Clayton W. Peirson, a businessman active in the wool and leather industry in Philadelphia. The Peirson name appears, partly obscured, in the upper right corner of the rack, on the blue envelope addressed to the firm's founder, C.C. Peirson. Other names seen in the picture refer to colleagues in the same business, Israel Reifsnyder ["Snyde," at lower left] and Peter Land. Another piece of mail is directed "to the lady of the house," which, as Bolger has noted, was a common advertising and selling technique for house calls. All these characters and their firms existed in Philadelphia in 1879; this picture documented actual people and businesses.

The theme of Peto's rack picture *Office Board for Smith Brothers Coal Company* has been called fictitious, since no such company existed in Philadelphia. There was, however, a Smith Brothers coal mining company, incorporated in 1866, and located four miles west of Wilkes-Barre, on the Susquehanna River. The company shipped coal by river, canal, and railroad to Philadelphia. Pennsylvania suffered more deeply than many states during the severe economic depression after the Panic of 1873. Miners tried to unionize to protect their jobs, and violent lockouts resulted. Business owners were intent on breaking any union activity and enlisted the support of state government to do so. During the long depression of the 1970s roughly 25 percent of the state's working population was unemployed. In 1877, when the Pennsylvania Railroad cut wages by 10 percent, railroad workers went out on strike, and the miners struck in sympathy. The governor of Pennsylvania called out the militia and terrific violence ensued.[4] The mine owners blamed the mainly Irish and Scots immigrant miners, often called the Molly Maguires. These political actions, rather than a specific client, may have inspired Peto, an Irishman, to create this office board, with its allusion to mining. If, as Harnett said, "my pictures tell a story," then these rack pictures and the objects they depict convey symbolic meaning related to current events and modern American culture.[5] And if trompe l'oeil pictures contain narratives that reflect the modern world, then it is possible to solve the puzzle of *Rack Picture for Dr. Nones* by an unknown artist (Fig. 36) and the third rack picture painted in 1879 under discussion here.

Fig. 35
William Michael Harnett
The Artist's Letter Rack, 1879
Oil on canvas
30 × 25 in. (76.2 × 63.5 cm)
The Metropolitan Museum of Art,
New York; Morris K. Jesup Fund, 1966
(66.13)

Fig. 36
Attributed to William A. Mitchell
Rack Picture for Dr. Nones, 1879
Oil on canvas
17¼ × 14⅛ in. (45.7 × 37.8 cm)
The Art Institute of Chicago; Frederick
G. Wacker Endowment, through prior
gift of Mrs. Albert J. Beveridge in
memory of Abby Louise Spencer Eddy
2000.135

Like Peto's and Harnett's pictures, Dr. Nones's rack composition depicts letters held in place by tapes. It shares elements with Harnett's *The Artist's Letter Rack*—a theater ticket, a newspaper clipping, and inscriptions in chalk and pencil—and as with Peto's *Office Board for Smith Brothers Coal Company*, the tapes holding the objects in place are frayed. Lacking Peto's more painterly brushstroke, the picture has a flattened surface texture similar to Harnett's style of painting. The unknown artist, whose signature "Wm. A. M." appears in the lower left, was surely aware of the works of Harnett and Peto, and, like them, may have known other students at the Pennsylvania Academy of the Fine Arts around 1878–79.

Prominently centered in the middle of the composition of *Rack Picture for Dr. Nones* is a blue envelope addressed to Dr. S. S. Nones, postmarked Friday, October 13, 1879, and sent from Toulouse, France.[6] Dr. Samuel Smith Nones (1837–1915; Fig. 40a), a dentist, came from a distinguished Jewish and military Philadelphia family. His grandfather, Major Benjamin Abraham Nones (1757–1826), had emigrated from southern Bordeaux in 1777. The first Jewish officer appointed in the Continental Army, he fought under General Pulaski during the

Fig. 37
Infrared photograph,
Rack Picture for Dr. Nones, 1879
Courtesy of The Art Institute of
Chicago

Revolutionary War.[7] In 1782 he married Miriam Marks and they had eight children. He served as president of the Congregation Mikveh Israel in 1791 and is buried in Mikveh Israel cemetery in Philadelphia.[8]

Samuel Smith Nones's father, Henry Benjamin Nones (1804–1868; Fig. 38), also had a military career. He entered the Revenue Cutter Service as a second lieutenant and served at the helm of the cutter *Forward* during both the Mexican War and the Civil War, rising to the rank of captain.[9] Nones died in 1868, eleven years before this painting was executed. Henry Beauchamp Nones (1830–1905), Samuel Smith Nones's older brother, followed his father into the Navy in 1855, eventually becoming chief engineer. He served at the Navy Yard, League Island, Philadelphia. The brown letter addressed to him there is slipped under the envelope addressed to his younger brother, the dentist Samuel Smith Nones.

Tucked behind the letters to the Nones bothers is one addressed to Major W. M. Notson (1836–1882) in Columbus, Ohio. Major William Morrow Notson may have known Captain Nones, as both were Philadelphians. Major Notson was an assistant surgeon in the Army during the Civil War.[10] He served with the 142nd Pennsylvania Volunteers, where he was in charge of the field hospital outside Frederick, Maryland, during the battle of Antietam in 1862.[11] Severely wounded at Gettysburg, he was highly decorated. Notson was then assigned to a hospital in Washington, DC, and was one of several doctors at President Lincoln's bedside the night he was shot.[12] A career Army surgeon, Notson was photographed in New York by Mathew Brady (Fig. 39) and served in Texas, Michigan, and Wyoming. He was on leave in Philadelphia from October 5, 1878, through February 16, 1879. In July 1879 he was posted to Columbus, Ohio, where he remained until his death (from "nervous prostration") on June 23, 1882.[13] Because of the Columbus address and November postmark on the letter, we know that the Nones picture was painted around November of 1879, several months after Peto and Harnett painted their first rack pictures.

Notson graduated from Jefferson Medical College in Philadelphia, as did John H. McQuillen (1826–1879), whose misspelled name (McQuillan) appears on the second brown letter in the upper right of the composition. Both Nones and McQuillen had dental practices on Arch Street (see map, Fig. 40).

Professor John Hugh McQuillen was born in Philadelphia, the son of distinguished military officer Captain Hugh McQuillen, who had served in the War of 1812. John McQuillen graduated from Jefferson Medical College in 1852. He also studied dentistry, receiving an honorary DDS at the first commencement of the Philadelphia College of Dental Surgery in 1853. In 1857 he was elected to the chair of the Department of Operative Dentistry and Dental Physiology at the Pennsylvania College of Dental Surgery. He edited the professional journal *Dental Cosmos*, in which Dr. Nones published many articles.

Fig. 40a
Dr. Samuel Smith Nones (left)
From "Obituary: Samuel Smith Nones,
D.D.S.," in *The Dental Summary*, 35
(1915), 688

Fig. 40b
Frank H. Taylor
S.S. White Building
Albumen print
8¹¹⁄₁₆ × 6⅛ in. (22.1 × 15.5 cm)
Free Library of Philadelphia Print
and Picture Collection; Gift of
Frank H. Taylor, 1922

Later he chaired the Department of General Anatomy and Physiology. As president of the American Dental Association during the Civil War, he wrote numerous important articles about dental hygiene and its role in preventing fatal infections, and he lobbied tirelessly but unsuccessfully to get toothbrushes and good dental care for Union troops. During the Civil War and after, soldiers received no dental care. In 1863, principally through his efforts, a charter was obtained to found the Philadelphia Dental College, where he would serve as dean and professor of Physiology until his sudden death on March 3, 1879, in his early fifties. His obituary described him as unselfish, industrious, talented, and an important advocate for educational progress and reform in his profession.[14] His son Daniel was also a dentist and had a practice at the same address as his father's, 1713 Arch Street. McQuillen's letter is postmarked November 1878, four months before his death. Dr. Samuel Smith Nones graduated from the Pennsylvania College of Dental Surgery in 1859, where he undoubtedly studied with McQuillen. He too became a distinguished dentist, writing for *Dental Cosmos*, and opened his practice in Philadelphia in 1864. Both Nones and McQuillen were charter members of the Pennsylvania State Dental Society, which advocated for dental surgeons to be assigned to the Army. They, along with Philadelphian Dr. Samuel White of the S.S. White Dental Manufacturing Company, located just blocks from Nones's office, took the case to President Lincoln, who referred their concerns to Secretary of War Edwin Stanton, where the issue died.[15]

The final envelope of the five is partially obscured but is surely addressed to W.P. Mit[chell]. William P. Mitchell graduated from the Philadelphia Dental College in 1879 and opened his practice at 114 South Twelfth Street.[16] He no doubt either knew or studied with both Nones and McQuillen. The address on his letter is partially covered, perhaps denoting his youth and his status as a new dentist just starting out—his story not yet fully written. Dr. Mitchell lived and practiced in his father's home, directly across the street from the S.S. White building (Fig. 40b). His father, William A. Mitchell, was a harness maker, and also took in boarders. The only person with the initials "Wm. A.M." related to this group of friends and colleagues was William A. Mitchell, the admiring father of a new dentist. This may be our artist. Infrared photography shows that the composition was probably laid out with a ruler or T square, simplifying the artistic requirements (Fig. 37). The picture also seems to be a one-off by a talented amateur, for no other trompe l'oeil paintings by Wm. A.M. have surfaced.

Now that the cast of characters is in place, it is possible to chart the proximity of these relationships. Two, H.B. Nones and William Notson, were military professionals who served in the Civil War. Four (Notson, Samuel Nones, W.P. Mitchell, and McQuillen) were medical professionals: surgeons and dentists, their professions noted in the

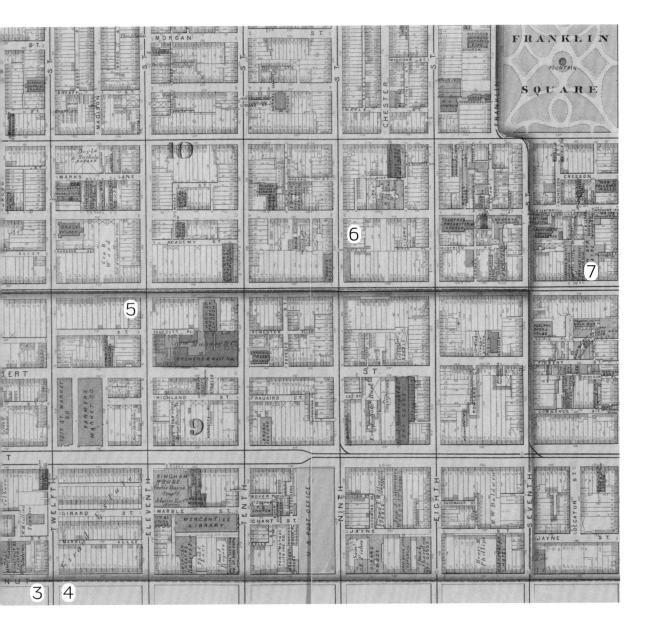

Fig. 40
Map composite from *City Atlas
of Philadelphia, 2nd to 20th and
29th and 31st Wards*, 1875
Color lithographs
Free Library of Philadelphia
Map Collection

1. Dental offices of Dr. John H. McQuillen
2. Pennsylvania Academy of the Fine Arts
3. Dental offices of Dr. William P. Mitchell
4. S.S. White building
5. Dental offices of Dr. Samuel Smith Nomes
6. Home of Louisa Lane Drew
7. Arch Street Theatre

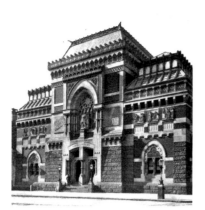

Fig. 40c
*Pennsylvania Academy of
the Fine Arts*, c. 1895
Photograph from *Philadelphia:
Photographs Album* (Philadelphia:
J. Murray Jordan, 1897), 20

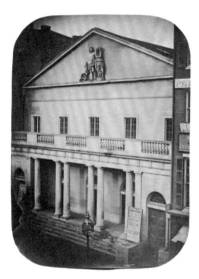

Fig. 40d
Photographer unknown
Arch Street Theatre
Albumin print
7⁵⁄₁₆ × 5⁵⁄₁₆ in. (18.6 × 13.5 cm)
Free Library of Philadelphia Print
and Picture Collection

chalk writing on the board, "DOC." The military figures are perhaps symbolized by the two pairs of what appear to be fencers; these could also be thespians of some sort, for a theater ticket is painted at the lower left.

Plotting the various addresses on a period map of Philadelphia (Fig. 40) shows that Mitchell's, Nones's, and McQuillen's offices were within walking distance of one another. Both Nones's and McQuillen's practices were located on Arch Street, and Mitchell's was five blocks south of Nones's office, on Twelfth Street. Close to Nones's practice was the Pennsylvania Academy of the Fine Arts, haunted by both Peto and Harnett (Fig. 40c). Down the street from Nones's office, at Ninth and Cherry Streets, about three blocks away, lived Mrs. John Drew (1820–1897). She was the proprietor of Mrs. John Drew's Arch Street Theatre at Arch and Sixth (Fig. 40d), some five blocks from Nones's practice, and the theater ticket references her establishment.

Mrs. John Drew, the famous English actress Louisa Lane (Fig. 41), married Irish comedian John Drew (1827–1862), who was the manager of the Arch Street Theatre. Mr. Drew proved to be incompetent, and his wife took over the theater in 1861 and renamed it eponymously. John Drew died suddenly in May 1862 at age thirty-four. Until her retirement in 1892, Louisa Lane Drew, with four children to support, operated the theater as one of America's most successful stock companies. Her son John was also an actor working at the theater. Her daughter Georgiana married Anglo-American actor Maurice Barrymore, and they would become the parents of Lionel Barrymore, Ethel Barrymore, and John Barrymore, and the great-grandparents of Drew Barrymore.

In the upper right corner of the composition is a painted newspaper notice of a recent feat of extraordinary dentistry: "They carried her to the doctors / All scarlet [illeg] opium / And [illeg] / How are you John [illeg] / Nones pull out a great big / Tooth that no one else could, / Budge, he fetched it out / In a masterly style, that filled / The beholders with admiration / And they left convinced that / He was a master of the art."

Our picture, then, recalls a momentous event at which some, if not all, of these people might have been present. Did our gentlemen, along with the actress's son John, carry the opiated Mrs. Drew to Dr. Nones, who extracted the painful tooth? Are the pair shown on the back side of the faux carte de visite Mrs. John Drew and her son leaving Dr. Nones's office? If so, it is a witty send-up of the carte de visite, or photographic calling card, which usually pictured people frontally. So here an event is commemorated, one possibly shared by this group of professionals and acquaintances. Through these objects and letters, the protagonists communicate with one another. The picture becomes a modern conversation piece, and a group portrait, marking a specific incident.

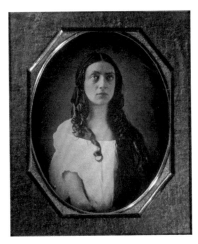

Fig. 41
Photographer unknown
Louisa Lane Drew, c. 1840–48
Daguerreotype, quarter plate
Harvard Theatre Collection,
Houghton Library, Harvard University,
Cambridge, MA

Beyond depicting that event or moment in time, the painting illustrates the cultural values shared by the group. The dentists, surgeons, engineers, career officers, and actors and actresses referenced in Nones's rack picture are professionals at the peak of their careers—all are pioneers and masters of their arts. They prospered during the industrial growth during and after the Civil War and benefited from the increased specialization and professionalism that resulted. After the war, with the growth of railroads, banking, mining, manufacturing, and other industries, there was a new faith in progress, in science, and in the economic future of the reunited nation. These beliefs, the common bond of bourgeois professionalism that bound our protagonists together, trumped any ethnic differences that might have divided the Jews, Protestants, Irish Catholics, and Englishwoman represented here.

Nones's letter rack also illustrates the relationship between the individual and society in the modern world. While each letter places the individual quite literally in the center of the composition, the letters overlap, some items are torn, and individuality becomes subsumed by the group through their interconnectedness. Historian Jackson Lears has written that during the Gilded Age, with the growth of modern, urban culture, a sense of individual autonomy was lost. Populations became more diverse and mobile, and the sense of the individual's self-worth as it related to work or professionalism grew more important.[17] "The fragmentation of the self" that Lears describes was rooted in the interdependent commodity marketplace, filled with the consumption of things, where people, through increased specialization and division of labor, became commodities too, to be manipulated and used like objects.[18]

These fragments of selfhood exist in the very things illustrated in Dr. Nones's rack picture. Human beings are represented through mundane, quotidian things—and things were the currency of the Gilded Age. Dr. Nones's letters, tickets, and newspaper clipping are the detritus of life—objects that only have meaning in their association to human beings. The importance of *things* is underscored in Henry James's *The Portrait of a Lady*, published in serial form in 1880–81. Madame Merle explains to her provincial friend Isabel Archer: "There's no such thing as an isolated man or woman; we're each of us made up of some cluster of appurtenances. What shall we call our "self"? Where does it begin? Where does it end? It overflows into everything that belongs to us—and then it flows back again. I know a large part of myself is in the clothes I choose to wear. I've a great respect for *things*!"[19]

Rack pictures, technically part of the still-life genre, are in effect history paintings—the objects represented have no intrinsic value, but they symbolize a history of human interaction, and that gives ordinary material goods meaning and life.[20] Dr. Nones's collection of letters is

Fig. 42
Roy Lichtenstein
*Trompe l'oeil with Léger Head
and Paintbrush*, 1973
Magna on canvas
46 × 36 in (116.8 × 91.4 cm)
Private collection

the glue that embodies the relationships among this group of people, commemorating a desire not to lose the past.

The modern nature of trompe l'oeil painting was explored in the twentieth century by both Roy Lichtenstein and Jasper Johns. Lichtenstein's trompe l'oeil painting (Fig. 42) is clearly not as illusionistic as Dr. Nones's rack picture. But Lichtenstein's approach to trompe l'oeil was not stylistic, or mimetic, but rather an attraction to the mundane scraps that form memory. Lichtenstein's signature elements—precise technique, lack of brushstroke, and incorporation of banal, everyday objects—show his great debt to Harnett, Peto, and others. Jasper Johns wrote that he gravitated toward objects that were "things which are seen and not looked at, not examined, and . . . have clearly defined areas which could be measured and transferred to canvas."[21] This certainly applies to Dr. Nones's picture, where, as we have seen in an infrared photograph, the elements seem to have been carefully laid out in life size with a T square.

Consumption, a driving force of modernity, is often linked to the rise of department stores and advertising in the 1870s. It is not coincidental that many owners of trompe l'oeil pictures were department store executives, lawyers, and saloon and restaurant owners—all middle-class businessmen. While much has been made of American modernism's debt to Cubism, pictures like Stuart Davis's *Bull Durham* (Fig. 44) incorporate the imagery, flatness, and lack of texture of both trompe l'oeil painting and American advertising in the 1880s (Fig. 43). Thoroughly American in subject, Davis's picture of tobacco papers, complete with commercial graphics, and a convincingly textured burlap tobacco pouch and a drawstring, is a two-dimensional visual puzzle based on actual objects.[22] Davis, like Peto, Harnett, and others, mimicked objects that were essentially two-dimensional, the better to deceive.

Fig. 43
*Lima Beans, H.K. & F.B. Thurber &
Co., New York*, c. 1875–84
Chromolithographed trade card
2⅝ × 4¾ in. (6.7 × 12.1 cm)
Printed by Forbes Co., Boston

Fig. 44
Stuart Davis
Bull Durham, 1921
Oil on canvas
30¼ × 15¼ in. (76.9 × 38.7 cm)
The Baltimore Museum of Art;
Edward Joseph Gallagher III
Memorial Collection 1952.208

Fig. 45
George Cope
*Civil War Regalia of Major
Levi Gheen McCauley*, 1887
Oil on canvas
50 × 46½ in. (127 × 92.7 cm)
The Art Institute of Chicago; Quinn
E. Delaney and Chauncey and Marion
McCormick funds, Wesley M. Dixon
Endowment 2000.134

Some objects displayed in trompe l'oeil paintings are just contemporary enough to tap the realm of recent memory. For example, a painting by George Cope, *Civil War Regalia of Major Levi Gheen McCauley* (Fig. 45), portrays only the soldier's medals and accoutrements, and is arguably the first American trompe l'oeil picture to feature war weaponry. McCauley was also a Pennsylvanian, born in Chester County, and trained as a mechanical engineer. He may well have known Dr. Nones's brother, Henry Beauchamp Nones, who became the chief engineer of the Navy. McCauley was in Alabama developing iron interests when the Civil War broke out in 1861 and he was forced to come home. He volunteered immediately in Pennsylvania's Seventh Regiment, rising from private to brevet major by the end of the war. His bravery and commendations cost him dearly, as he left his right arm on the field at the Seven Days Battles near Richmond. McCauley held the flank of the Union Army, even after severe losses to his regiment, and eventually reversed the tide of battle, leading his troops in hand-to-hand combat. He was taken prisoner and sent to the notorious Libby Prison, where he lay without medical attention or adequate food for more than seventy days. He was exchanged and assigned to Washington until his discharge in 1866.[23]

Thus things, such as the weaponry and gear pictured here, could symbolize memories that were yet too raw to recreate. Timothy O'Sullivan's Civil War photographs of Union and Confederate dead looking like slaughtered animals (Fig. 46) were scenes too real, too horrific to paint. The American public had not seen bloated corpses or piles of severed limbs until now, through the relatively new medium of photography. Body parts separated from bodies made men seem like

Fig. 46
Timothy O'Sullivan
*Field Where General Reynolds Fell,
Gettysburg*, July 1863
Plate 37 from the album *Gardner's
Photographic Sketch Book of the War*,
I, 1866
Albumen print
7 × 9 in. (17.8 × 22.9 cm)
The Art Institute of Chicago; Gift of
Mrs. Everett Kovler, 1967.330.37

nothing more than butchered animals—and as objects of revulsion—mere things. Drew Gilpin Faust in her book *This Republic of Suffering* has shown that to paint such horrors would have undermined the Victorian attitude toward death as a heroic event, a crossing over into new, eternal life. In fact, another reason that the bloodshed was so unprecedented was that war was now mechanized. The availability of new, more powerful guns, the use of snipers and spies, and the sheer masses of men engaged in combat made the Civil War a sophisticated killing machine. As many as 620,000 soldiers died, a percentage of the country's population equivalent to six million people today. This is a figure higher than all American casualties in all of the nation's wars and six times the number of American casualties in World War II.[24] Such carnage was impossible to imagine.[25]

McCauley, now a highly successful businessman, commissioned George Cope's painting of his medals, canteen, swords, cap, and other battle accoutrements in 1887.[26] A quarter of a century after the terrible events of McCauley's soldier days, the objects that represented war were still in his possession and had meaning because they held the memories of those tragic events. The distinction between the real objects and their painted representations was blurred. Cope's painting became another object—an object about objects. As a trompe l'oeil painting of monumental size, it had a lasting power and gravitas not afforded by photography. McCauley could have commissioned a traditional portrait, but instead asked for a painting of things—much as Dr. Nones's painting is a group portrait of people and an event represented by things.

Replicating objects gave life to memory and attempted to assure the ongoing lives of the objects and owner alike—even beyond the grave. While actual objects could disappear, the record of the sacrifice they symbolized might endure. For McCauley, the hopefulness and youthful passion for the Union cause was well worth remembering. By 1887, many Civil War veterans were dying, and many who witnessed the failure of Reconstruction wondered what their sacrifices, and those of their dead comrades, had been for. Even twenty-five years later, McCauley may have retained the guilt of the survivor, so eloquently described by Emily Dickinson in 1863:

> It feels a shame to be Alive—
> When Men so brave—are dead—
> One envies the Distinguished Dust—
> Permitted—such a Head—
>
> The price is great—Sublimely paid—
> Do we deserve—a Thing—
> That lives—like Dollars—must be piled
> Before we may obtain?

Fig. 47
Jasper Johns
Three Flags, 1958
Encaustic on canvas
30⅝ × 45½ × 4⅝ in.
(77.8 × 115.6 × 11.7 cm)
Whitney Museum of American Art,
New York; purchase, with funds
from the Gilman Foundation, Inc.,
The Lauder Foundation, A. Alfred
Taubman, Laura Lee Whittier
Woods, Howard Lipman, and Ed
Downe in honor of the Museum's
50th Anniversary 80.32

Are we that wait—sufficient worth—
That such Enormous Pearl
As life—dissolved be—for Us—
In Battle's—horrid Bowl?

Dickinson too measures the awful price of war in *things*—a pile of dollars, the literal cost of the war in lives and material, in graft and profiteering.[27] Life is also equated to a thing as "the pearl of great price"[28] and is dissolved with disdain in a horrid bowl—another object. These dead, unsustained in their sacrifice, may well have died for naught, leaving behind only these things for remembrance. Both Dickinson's poem, written during the war, and Cope's portrait of McCauley, seen through his medals, reflect the destabilizing effect the Civil War would have on American life for decades, and the anxious search for meaning that was the legacy of the survivors. Cope invests these visually ordinary objects with meaning leading to personal reflection.

In this last we are reminded of the flag paintings of Jasper Johns. The flag, an ordinary object, a piece of colored, woven cloth, is also one that is invested with great emotional and symbolic meaning. Yet Johns paints the flag, not as we usually see it, but as a composition of encaustic and printed paper collage on paper laid down on canvas. He replicates the image, but with a sensuous surface that suggests that this is and is not the flag. We are compelled to separate symbol from its referent as he deconstructs an ordinary object that represents larger ideas about nationality, patriotism, and identity. Like Cope's painting of medals, Johns's picture asks us to think about the meaning of a flag—when is a flag a flag, and when is it just a depiction of a flag, a design or a thing. In John's multiple flag pictures the viewer's eye seeks the depth of a three-dimensional illusion but is stopped and forced back to the picture plane (Fig. 47).

Fig. 48
John Haberle
Grandma's Hearthstone, 1890
Oil on canvas
99 × 66 in. (251.5 × 167.6 cm)
Detroit Institute of Arts; Gift of
C. W. Churchill in memory of his
father 50.31

Fig. 49
Marsden Hartley
Portrait of a German Officer, 1914
Oil on canvas
68¼ × 41⅜ in. (173.4 × 105.1 cm)
The Metropolitan Museum of Art,
New York; Alfred Stieglitz Collection,
1949 (49.70.42)

Fig. 50
Charles Demuth
Poster Portrait of O'Keeffe, 1923–24
Poster paint on pressed-paper board
23¼ × 18⅞ in. (59 × 48 cm), framed
Yale Collection of American Literature,
Beinecke Rare Book and Manuscript
Library, Yale University, New Haven

Fig. 51
Charles Demuth
The Figure 5 in Gold, 1928
Oil on cardboard
35½ × 30 in. (90.2 × 76.2 cm)
The Metropolitan Museum of Art,
New York; Alfred Stieglitz Collection,
1949 (49.59.1)

John Haberle, the painter of *Grandma's Hearthstone* (Fig. 48), used objects in the same way. These old objects are invested with nostalgia for the early nineteenth century, then almost a hundred years in the past. They were provided to the artist by a patron who wished to commemorate his family history.[29] Like Johns, Haberle explores the three- versus two-dimensional qualities of the picture plane. The walls of the hearth form an avenue into the picture, but Haberle brings us back to the two-dimensional reality of the painting's surface by placing objects extending outside the painted frame. The bed warmer, cane, mantel, and horns all emphasize that this is a flat paint surface, wittily negating the painted frame and the illusionism and depth of the composition.

Haberle's portrait of Grandma's things, George Cope's composition of Levi Gheen McCauley's medals, and Dr. Nones's letter rack painting all construct identity and assemble a portrait through objects. This would not be done again in American art until Marsden Hartley painted his 1914 *Portrait of a German Officer* (Fig. 49) and, like Cope in his portrait of McCauley's war medals, used military symbols and signs to represent his subject. Charles Demuth's 1923–29 poster portrait series also constructs the personality of his "sitters" through their attributes. Demuth painted his artist-friends through the objects that symbolized them: Georgia O'Keeffe is represented as a plant (Fig. 50), and poet William Carlos Williams is embodied in his verse "I saw the figure 5 / in gold" (Fig. 51), inspired by a fire truck streaking down a Manhattan street. Williams, who famously wrote that "there is no meaning but in things," admired the series of "portraits" that Demuth executed, in which things stood in for people. Demuth's portraits showed how intertwined lives were with the objects and ideas that exemplified them, as well as the overlapping relationships within their artistic disciplines. Like many trompe l'oeil artists, Demuth used Roman letters and numerals to refer to people. His work anticipates Pop art, where Andy Warhol's soup cans, or his multiplied dollar bills, create monumentality for the mundane through scale and repetition (Fig. 52).

In addition to consumption and the objectification of people, modernity is characterized by measurement, time, and standardization. The standardization of time was, during the last quarter of the nineteenth century, a new topic of importance. Today, we take for granted that emails, photos, and other documents are dated and timed. Even Dr. Nones's letters are date-stamped and cancelled—locating them precisely in time. But these were still marked with local, rather than standardized, time. A decade after Dr. Nones's rack picture was painted, John Haberle composed a trompe l'oeil entitled *Time and Eternity* (Fig. 53). On the left side of the picture is a pocket watch with a broken crystal. Juxtaposed against the objective precision of the mechanical timepiece are objects that relate to subjective timelessness,

or eternity. In the late 1870s, prompted by increasingly difficult problems with railroad schedules, timekeeping became a subject for debate. In 1879, for example, the state of Connecticut had five different regional time zones, based on New York, New Haven, Hartford, Boston, and New London. Up until this point, time had been fluid and specific to each community, determined by the natural rhythms of the sun. With increasing railroad travel after 1840, the local nature of time became problematic and made timetables more difficult. During the 1870s the American Metrological Society, devoted to standardizing measurements of all sorts, recommended the invention of time zones. In 1883, Canada and the United States standardized time into regions, creating the Eastern and Central Standard Time Zones. Keeping time became a modern invention.

The watch pictured here may be an Elgin timepiece, invented in 1869, which was required equipment for railroad employees. The broken glass likely signifies that time has been broken or changed. Time, once a personal and autonomous possession, became part of the professionalization, standardization, and corporatization of America, now conforming to rules imposed by the business world and the organized national markets. Against this rational, bureaucratic regulation, represented by the watch, is set a rosary, a crucifix, and playing cards. Standard time was opposed by religious fundamentalists who believed that such artificial time management was blasphemy, interfering with God's creation and the natural order of the universe.[30]

Haberle presents the viewer with opposing forces: the religious items represent eternity and a system of belief and organization wholly different from the modern and temporal precision of the watch. The precision of the watch is also in opposition to the subjective, vague, and multiple meanings of the tarot. The cards, the King of Spades and the Nine of Hearts, cover the flotsam of life: a ticket stub, a pawnbroker's receipt, a cigarette picture, and a photograph.[31] The King of Spades epitomizes wisdom, cunning, and spiritual energy. The Nine of Hearts, the wish card, represents the desire to attain happiness, gratification, and contentment, and is considered the most auspicious card in the deck. Haberle married about this time, and this may reflect the satisfaction of his new state. Here, then, Haberle depicts a series of systems of belief and regulation, from the scientific and secular on the left, to the spiritual and superstitious on the right—all united by the experience of time.

On the left side of the picture, the rational side, a painted newspaper clipping refers to the Rhode Island city of Providence (a pun referring to God) and the arrest of Bob Ingersoll, a famous atheist who lectured widely on his controversial views. Opposed to any and all religions, Ingersoll favored women's rights and stood up against animal vivisection, the death penalty, and racism. Opponents attempted (unsuccessfully) to prosecute him for blasphemy. The subject of the

Fig. 54
Charles Shaw
Montage, c. 1935–50
Paper playing cards, clay pipes,
ivory discs, and wood snuff box
mounted on velvet
15 × 13 × 2⅛ in. (38.1 × 33.0 × 5.4 cm)
Smithsonian American Art Museum,
Washington, DC; Gift of Patricia and
Phillip Frost 1986.92.87

newspaper clipping attests to another important facet of the emerging modern world—the demise of organized religion. By the 1890s liberal Protestantism was in decline, church attendance had fallen off dramatically, and faith in science, progress, and wealth had replaced more traditional religious values. In general, America's ruling business class had remained Protestant throughout the nineteenth century, but the working class, made up heavily of Irish and German Catholics, may also figure in Haberle's composition. The watch, representing railroad time (and white, Anglo-Saxon railroad management), is set against the crucifix and rosary and the Protestant perception of the "superstitious" Catholicism practiced by immigrants. With the waning and diversity of religious and supernatural belief systems, the dislocation of the individual in society increased.[32]

Compare Haberle's work to a montage made by Charles Green Shaw, one of the practitioners of abstract American modernism (Fig. 54). Shaw, a founding member of the Abstract American Artists in 1936, put actual objects in a shadow box. While this is not a trompe l'oeil, his composition similarly emphasizes the common, overlooked object, used and worn: even the frame is Victorian. Referring back to the types of paintings discussed above, the artist imbues the genre not only with a fresh sense of design, but also with new meaning. The wood snuffbox with a hunter and dog on its cover recalls the keeping of snuff or tobacco. The pipes represent the artist's days at Yale, where graduating seniors traditionally were given pipes to smoke then break. Pipes, seen in so many nineteenth-century still-lifes, were the favorite form of smoking until after World War I, when they were replaced by cigars and eventually by cigarettes. The playing cards point to fate or superstition; the Ace of Clubs signifies new beginnings and adventures in life, while the Queen of Diamonds represents a worldly woman possessing energy, electricity, and intelligence, who attracts money and material rewards. This card may also be a veiled allusion to Shaw's homosexuality. The Victorian shadow box is itself a bow to the past, of course, but the balanced composition of circles, rectangles, and two- and three-dimensional objects speaks to twentieth-century abstraction. In this modernist work, Shaw refers back to trompe l'oeil painting and its choice of biographically connected objects to inject meaning into his art.

American trompe l'oeil painting of the Gilded Age can be thought of as the beginnings of American modernism. Debunking the high moral purposes of "art," these painters questioned what was the appropriate subject matter of painting, looking for ideas and identities in the quotidian and the transient. Trompe l'oeil painting focused the viewer's attention on the two-dimensional painting surface, and the play between the painted surface and the represented object. These decoded pictures also symbolize the issues of modernity. They address the rapidly changing and tricky realities that faced individuals in a

new world of consumption, specialization, and standardization, where the loss of faith was accompanied by an embrace of science, progress, conformity, and money. By addressing the values of the Gilded Age, trompe l'oeil painting foreshadowed modernist art, and the future of modern American culture.

NOTES

1. David E. Shi, *Facing Facts: Realism in American Thought and Culture, 1850–1920* (New York: Oxford University Press, 1995), 129.

2. "Painted Like Real Things: The Man Whose Pictures Are a Wonder and a Puzzle," interview in *New York News*, 1889 or 1890, quoted in Alfred Frankenstein, *After the Hunt* (Berkeley: University of California Press, 1953), 28–29.

3. Doreen Bolger, "Early Rack Paintings of John F. Peto: 'Beneath the Nose of the Whole World,'" in *The Object as Subject: Studies in the Interpretation of Still Life*, ed. Anne W. Lowenthal (Princeton, NJ: Princeton University Press, 1996), 4–32.

4. See Herbert G. Gutman, *Work, Culture and Society in Industrializing America* (New York: Vintage, 1977), 321–43.

5. Lest one question these symbolic meanings, we need only look at the painting by S. S. David (De Scott Evans) of a small shamrock and two potatoes hanging by their necks with a note reading "The Irish Question" (The Art Institute of Chicago) to understand that trompe l'oeil certainly could be used to express political opinions. Probably painted in 1889, the year Irish politician Charles Stewart Parnell toured America looking for support for Irish Home Rule, the picture makes David's view of the issue quite clear. He, like so many other Americans, was apparently xenophobic toward the large groups of immigrants who entered the working classes in the 1870s and 1880s.

6. October 13, 1879, was actually a Monday. We cannot ascertain whether the *Friday* and *13* were meant to be superstitious in meaning or whether the artist made a mistake.

7. Later he served as the official Interpreter of French and Spanish to the United States Government, working for the U. S. Department of State at 22 Chestnut Street.

8. Norma Nones Irwin Family Genealogy, P-334; American Jewish Historical Society, Center for Jewish History, Philadelphia; Henry Samuel Morais, *The Jews of Philadelphia: Their History from the Earliest Settlements to the Present Time* (Philadelphia: Levytype, 1894), 26–27, 471.

9. United States Coast Guard, "Illustrations & Photographs of United States Revenue Marine & Revenue Cutter Service Uniforms 1790 through 1889," http://www.uscg.mil/history/uscghist/USRCS_Uniform_photos_1889.asp.

10. *House Documents of the House of Representatives*, otherwise published as Executive Documents, 13th Congress, 2nd session, 49th Congress, 1st session (1882–1883), 483 (Washington, DC: Government Printing Office, 1883). Major Notson's obituary, June 23, 1882, ibid.

11. "Remembering the 142nd Pennsylvania Volunteer Infantry," September 30, 2012, http://142ndpainfantry.blogspot.com.

12. Edward Steers, *The Lincoln Assassination Encyclopedia* (New York: Harper Perennial, 2010), 182.

13. Record for William M. Notson in *U.S. Registers of Deaths in the Regular Army, 1860–1889,* vol. 12. Records of the Adjutant General's Office, Record group 94. National Archives and Records, Administration, Washington, DC (online database) Provo, Utah, Ancestry.com; F.B. Heitman, *Historical Register and Dictionary of the United States Army* (Washington, DC: Government Printing Office, 1903), 667.

14. "Obituary: Professor John Hugh McQuillen, M.D., D.D.S," *The Dental Cosmos: A Monthly Record of Dental Science* 21, no. 4 (April 1879): 226–29.

15. John M. Hyson, Joseph W.A. Whitehorne, and John T. Greenwood, *A History of Dentistry in the U.S. Army to World War II* (Washington, DC: Government Printing Office, 2008), 40.

16. *The Dental Cosmos: A Monthly Record of Dental Science* 21, no. 4 (April 1879): 222–23; *Philadelphia City Directory*, 1879, 1156.

17. T.J. Jackson Lears, *No Place of Grace: Antimodernism and the Transformation of American Culture, 1880–1920* (Chicago: University of Chicago Press, 1994), 36–39.

18. Ibid., 36–37.

19. Henry James, *The Portrait of a Lady*, in *Henry James: Novels 1881–1886* (New York: Library of America, 1985), 397.

20. Bill Brown, *A Sense of Things: The Object Matter of American Literature* (Chicago: University of Chicago Press, 2003), 100.

21. Walter Hopps, "An Interview with Jasper Johns," *Artforum* 3, no. 6 (March 1965): 32–36.

22. Karen Wilkin, *Stuart Davis* (New York: Abbeville, 1987), 87–88; and Barbara Zabel, "Stuart Davis's Appropriation of Advertising: The Tobacco Series, 1921–24," *American Art* 5, no. 4 (Fall 1991): 60.

23. *Encyclopedia of Genealogy and Biography of the State of Pennsylvania* (New York: Lewis, 1904), 882–83.

24. Drew Gilpin Faust, *This Republic of Suffering: Death and the American Civil War* (New York: Vintage, 2008), xi.

25. By the end of the 1880s, a new generation was in danger of forgetting the carnage and cost of the American Civil War. The memorialization of Civil War heroes began as the conflict was passing from memory. From 1884 to 1887, *Century* magazine published a series of stories called "Battles and Leaders of the Civil War," which stressed heroic acts (on both sides) and encapsulated the valor and courage of that earlier time.

26. Cope painted another trompe l'oeil in 1887 of *Hunter's Paraphernalia*, which was certainly indebted to William Harnett's *After the Hunt* (1885; Fine Arts Museums of San Francisco).

27. Helen Vendler, *Dickinson: Selected Poems and Commentaries* (Cambridge, MA: Harvard University Press, 2010), 241.

28. Matthew 13:45–46.

29. The painting was commissioned by paper manufacturer James T. Abbe of Holyoke, MA; see E. P. Richardson, "Grandma's Hearthstone by John Haberle," *Bulletin of the Detroit Institute of Arts* 31, no. 1 (1951–52): 9–11.

30. Carlene E. Stephens, *Inventing Standard Time* (Washington, DC: National Museum of American History, Smithsonian Institution, 1983), n.p.

31. Gertrude Grace Sill, *John Haberle, Master of Illusion* (Springfield, MA: Museum of Fine Arts Springfield, 1985), 51.

32. T. J. Jackson Lears, "From Salvation to Self-Realization," in *The Culture of Consumption: Critical Essays in American History, 1880–1980*, ed. Richard Wightman Fox and Lears (New York: Pantheon, 1983), 9.

All About Eve?
William Glackens's Audacious
Girl with Apple

TERESA A. CARBONE

Lecture given on December 4, 2014

New-York Historical Society

New York City

All About Eve?
William Glackens's Audacious
Girl with Apple

TERESA A. CARBONE

William Glackens's *Girl with Apple* (Fig. 55) is one of the highlights of the Brooklyn Museum's outstanding American painting collection, and an exceptional example of turn-of-the-century American realism. As a large studio nude painted for exhibition, it was a rarity in the context of Glackens's work to that point, and in the context of work by even his most progressive American peers. While many art historians have addressed *Girl with Apple*, none has focused on the significance of Glackens's model and the details of her disposition, or fully conveyed the exceptional role the painting played in the year of its debut. In creating *Girl with Apple*, Glackens intentionally produced a breakout work, not only for his own career, but for progressive American art and culture as well. This painting and a handful of other daring female figure subjects dating specifically from 1909 to 1910 were statements emerging from, and allied with, the rise of women's rights activism, a movement now known as first-wave feminism.

In the final chapters of his important 1905 volume, *The History of American Painting*, the critic Samuel Isham described the very limited options open to American figure painters: "With religious, mytholog-ical, historical, and nude painting unavailable or to be practiced only under unfavorable conditions, it would seem as if there were little field left for imaginative art and that the painters would be forced to realistic copying of the life about them." Blaming the situation on the Puritan origins of the American population, Isham continued, "They have no goddesses or saints, they have forgotten their legends, they do not read the poets, but something of what goddess, saint or heroine represented to other races they find in the idealization of their wom-ankind.... There is no room for the note of unrestrained passion, still less for sensuality. It is ... the tenderness of motherhood, the beauty and purity of young girls which they demand, but especially the last." Isham identified the "Gibson Girl" as the best-known version of "the last," describing her as "a creature rather overwhelming in her perfec-tions, with no occupation in life save to be adored by young athletes in

Fig. 55
William Glackens
Girl with Apple, 1909–10
Oil on canvas
39⁷⁄₁₆ × 56³⁄₁₆ in. (100.2 × 142.7 cm)
Brooklyn Museum, New York;
Dick S. Ramsay Fund 56.70

tennis clothes or by disreputable foreign noblemen."[1] Artists such as Frank Weston Benson took up this type as well (Fig. 56), conveying the health and vibrancy of outdoorsy girls nurtured by comfortable lives and healthful habits.

This is not to say that turn-of-the-century American painters never undertook nudes. Nude figures were acceptable in the context of highly idealized or allegorical subjects, quite a few of which were produced in connection with decorative commissions for private and public spaces during the American Renaissance era. There were relatively few other options, but the Cincinnati painter Frank Duveneck encountered one in 1900. Duveneck had trained in Munich in the 1870s and spent much of his career in Europe painting costumed figure subjects. When he returned to the States permanently in 1900 and took a faculty position at the Cincinnati Art Academy, he produced nudes as demonstration pieces but had few opportunities to exhibit them. The exception was

Fig. 57
Frank Duveneck
Siesta or *Foucar's Nude*, 1900
Pastel on paper
34 × 64½ in. (86.4 × 163.8 cm)
Cincinnati Art Museum; Gift of
Theodore M. Foucar

when he executed a nearly life-size pastel titled *Siesta* (Fig. 57) as a commission for the Cincinnati saloon owner Theodore Foucar, who installed it in his Walnut Street bar. *Siesta* pleased customers and provoked the ire of the so-called "good women of the town" until 1919, when Foucar was closed down as Pennsylvania enacted Prohibition but won the last laugh by donating the piece to the Cincinnati Art Museum.[2]

One might easily assume that the American realists, inspired and sustained by their mentor Robert Henri—a tireless champion of art that faced modern life head-on—would have been rather fearless in their attention to the body, but they were not. They were rigidly limited by the mores that governed social behavior, and by the cultural strictures that enforced notions of propriety in American art well into the first decade of the twentieth century. Consider the work of John Sloan, who created lively visual records of American life in lower Manhattan. There he and his wife, Dolly, lived a socially and politically liberal existence among the working poor and freethinking bohemians who populated the Tenderloin district and Greenwich Village. Sloan did not shy from painting the city's seamier nightspots or the working women who led increasingly public lives in and around them. In *The Haymarket, Sixth Avenue* of 1907 (Fig. 58), he painted the notorious dance hall and venue for prostitution on Sixth Avenue and Twenty-ninth Street, and the women patrons he described as lively and pleasure-seeking.[3] Nudes, however, appear to have been in a different category for Sloan, and one that he resisted. His painting *The Cot*, also from 1907 (Fig. 59), features the unidealized figure of

a woman in a simple nightdress standing with one leg lifted onto an unmade bed. But a diary entry of June 18, 1907, in which he identified the model as the Greenwich Village favorite Eugenie Stein, reveals that the composition was a reworking of an earlier one in which the figure was unclothed: "Took up the *nude* [author's emphasis] on the bed started months ago and painted out the figure, putting drapery on the stooping figure. Rather like the thing now."[4] Sloan's "problem" with nudes at this time is indicative of the risk Glackens was taking with *Girl with Apple*. In a subsequent diary entry on October 24, 1908, Sloan questioned the motives of artists who undertook nude female subjects presuming they were "a lofty flight into the higher realms of glorious Art." He described the type of work as "a picture that could only inspire lust in a perverted mind so little is there of humanity in it."[5] The first finished nude we know by Sloan dates from 1912 (*Prone Nude* [*Katherine Wenzel*]; Weatherspoon Art Museum, Greensboro, NC), after he had moved into a new studio on Sixth Avenue and West

Fourth Street and was no longer constrained by painting in a corner of his and Dolly's cramped apartment on East Twenty-second Street.

Like Sloan, Glackens had also begun pushing boundaries in his work before 1909, as in his bold *Dancer in Blue*, from about 1905 (Fig. 60), featuring a highly individualized dance hall performer—reportedly a "Miss K of the Chorus"—lifting her skirts for the viewer far higher than was acceptable in polite company. Glackens was taking his cues from the French realist Édouard Manet, a favorite of his mentor, Henri, and an artist whose work he had experienced firsthand during a yearlong stay in Paris from 1895 to 1896, and again during his honeymoon in 1906. One can easily compare *Dancer in Blue* to Manet's *Nana* (Fig. 61), which represents an unabashed young Parisian courtesan attended by a client. Glackens not only adopted a Manet-inspired palette and boldly broad and fluid application of paint, he also channeled Manet's inclination for edgy subjects—here, the well-shy-of-proper world of the modern theater, and the uninhibited women who

commanded the attention of their audiences. Particularly after the landmark, renegade exhibition at the Macbeth Galleries mounted in 1908 by Henri and his young followers (including Sloan and Glackens) who dubbed themselves The Eight, the impact of Manet's subjects and style on New York's emerging realists was uncontestable. The leading critic Walter Pach, a proponent for modern styles in New York, devoted an entire article to the subject of "Manet and Modern American Art" in the *Craftsman* magazine in February of 1910. Pach believed Manet's influence derived from the French artist's commitment to the themes of modern life: "Manet ... turned away from the false classicism of his time, and instead of ... pseudo-Venuses, he took as his subject a living woman, and we have his 'Olympia.'"[6]

A little more than a month after Pach's article appeared, Glackens debuted *Girl with Apple* at a second renegade show, the *Exhibition of Independent Artists*. Henri had been eager to repeat the success of the 1908 Macbeth Galleries exhibition, which had directly challenged the conservatism of the annual juried exhibitions organized by the National Academy of Design. Plans for the Independents exhibition took a number of turns before the project moved forward under the direction of Henri, Sloan, and the younger Walt Kuhn, who had devised an arrangement whereby artists invited by a core group of funders—including Glackens—would pay a graduated entry fee and could exhibit any works of their choosing. The venue for the monthlong exhibition was a vacant and gutted town house on West Thirty-fifth Street, whose three floors were installed for an April 1 opening with 260 paintings, 344 drawings, and 22 sculptures by 103 artists. The public's appetite had been so thoroughly whetted by the scandalous 1908 exhibition that a crowd numbering 2,500 showed up for opening day and the police were called in to keep things under control.[7] James B. Townsend of *American Art News* announced that, with this first real independent exhibition, a Rubicon had been crossed in New York and throughout the country. He described the presentation as "a manifestation of the new art movement in America, which has been bubbling and seething under the surface for ten years past, breaking through the crust now and then in a sporadic canvas." He continued, "The agitation came to a head this year, largely aided by the explosions of Matisse and his followers in France, and it is a pleasure to record the first eruption and lava flow."[8] Works such as Glackens's *Race Track* (Fig. 166) were among those that demonstrated the "Matisse effect."[9] The majority of critics warned of the discordant effect among so large a group of works; the critic and painter Arthur Hoeber wrote, "You shall see things good and bad, some of them very good, many of them, alas, very very bad departures." But he described the exhibition as "unmistakably the day of the Insurgent, the revolutionist, the Independent, in art as in other directions."[10] James Huneker concurred, "All the lads and lasses, the insurgents, revolutionists, anarchs, socialists, all

Fig. 62
Édouard Manet
Olympia, 1863
Oil on canvas
51³⁄₁₆ × 74¹³⁄₁₆ in. (130 × 190 cm)
Musée d'Orsay, Paris; Offered to the
French State by public subscription
initiated by Claude Monet, 1890

the opponents to any form of government, to any method of discipline are to be seen at this vaudeville in color."[11] Only a writer for the *New York Times* saw a unifying thread; contesting the "Matisse effect," he projected that the Independents exhibition would ultimately be seen as a clear manifestation of "what by that time will be known as the 'Manet tradition.'"[12]

All of the critics who wrote about the Independents exhibition agreed on one thing—that Glackens's *Girl with Apple* was the undisputed highlight. One of only approximately twenty nudes among the hundreds of paintings in the exhibition, the canvas had been prominently positioned at the base of a staircase, very likely by Glackens himself, who was a lead voice on the seven-person hanging committee. At over three by four feet, the work was imposing in scale by the standards of the day. Huneker wrote, "Mr. Glackens's big nude is surprisingly brilliant."[13] Above all, there can be no doubt that Glackens was doing his share to advance the "Manet tradition" in his quotation of the French painter's scandalous 1863 painting *Olympia* (Fig. 62), which had been purchased for the French government and placed on view at the Musée du Luxembourg by 1890. Manet had shocked audiences at the Paris Salon of 1865 with this representation of a favorite model,

Victorine Meurent, posing as an uninhibited young prostitute between appointments. He had not only recast an idealized Renaissance nude by Titian, he had dared to describe the all too recognizably modern details of the character and her setting in a style that was equally bold, with its unforgiving high contrasts rendered in broad strokes, forgoing any of the modulating middle tones that might have mediated the subject's directness. In composing *Girl with Apple*, Glackens clearly referred to Olympia's semi-reclining posture, bent elbow, and direct gaze, but with subtle variations to the figure: the cropping of the lower legs—which are bent at the knee rather than extending the length of the couch; the strategic draping of a small corner of cloth across the model's privates—an alternative to the assertive hand with which Olympia proprietarily protects her dubious modesty; and the addition of the apple in the nearer hand, a detail recalling the longer tradition of depictions of the biblical temptress Eve. Each of these alterations contributes to a subtle flirtatiousness that Manet eschewed in his characterization of the bluntly sexual Olympia.

Glackens developed the figure in a number of preparatory sketches in charcoal and pastel whose progress reveals a series of choices. In two charcoal drawings from a sketchbook (Figs. 63, 64), he established the basic disposition of the figure on the couch, with the right elbow resting on the arm of the sofa and an apple in hand. He clearly was uncertain about the placement of the lower legs, first treating the model's left leg in a fully extended position before deciding to have both knees bent and both lower legs cropped. In the more heavily rendered drawing, he also appears to have experimented with raising the model's left arm. The pile of clothing and the hat are present in both sketches, but in the darker, and presumably second, sketch he introduced the crucial drape of fabric on the model. Glackens additionally rehearsed the composition in two corresponding sketches in pastel, in which he extended his quotation of Manet's nude by establishing the model's gaze as outward and unselfconscious. The setting has come more fully into play in both of these sketches, but significant variations in the arrangement of the clothing remain. In what is presumably the earlier of the two (Fig. 65), the figure is completely undraped and the heap of clothing is complemented by a green umbrella; whereas in the more resolved Brooklyn Museum pastel, Glackens described drapery both under the figure and on it (Fig. 66). The elements of clothing are also more defined, and the hat has grown significantly in proportion, but the amazing blue shoes have yet to appear. Glackens made further subtle changes and added key details in the final painting. He sharpened his reference to Manet's *Olympia* in gathering up the model's hair, and more pointedly in his addition of the dark ribbon around her neck. In a shift not predicted by the series of sketches, he also lowered the model's right hand, distancing the apple from the breast with which it previously had been paired. The change results in

Fig. 63
William Glackens
New York (Study for Woman with Apple), c. 1909–10
Charcoal on paper
5½ × 8 in. (14 × 20 cm)
NSU Art Museum Fort Lauderdale, FL;
Gift of the Sansom Foundation 92.59

Fig. 64
William Glackens
New York (Study for Woman with Apple), c. 1909–10
Charcoal on paper
5½ × 8 in. (14 × 20 cm)
NSU Art Museum Fort Lauderdale, FL;
Gift of the Sansom Foundation 92.59

a greater emphasis on the model's gaze, and thus on her own psychological presence; the offered apple is no longer equated solely with the body. And finally, Glackens gave legible detail to the pile of clothing and made the decisive addition of the distinctive blue shoes, the more prominent of which points emphatically toward the extended leg that Glackens coyly cropped just at the ankle.

The reception of *Girl with Apple* was framed from the outset by an article prepared by Robert Henri for publication in the *Craftsman* immediately before the opening of the Independents exhibition. Promoting the show as a gathering of truly independent artists unified by their strong connection to the present and to the belief that art was an integral part of its full experience, Henri wrote of *Girl with Apple* and its artist:

> William Glackens is in this exhibition, as usual, unique in mind, unique in his appreciation of human character, with an element of humor, an element of criticism, always without fear. He shows a wonderful painting of a nude that has many of the qualities that you notice in the neo-impressionist movement. But Glackens seems to me to have attained a greater beauty and a more fundamental truth. There is something rare, something new in the thing that he has to say. At first it may shock you a little, perhaps a great deal; you question, but you keep looking; you grow friendly toward his art; you come back and you get to feel toward the things that you have criticized as you do toward the defects in the face of a person whom you have grown to like very much. They become essential to you in the whole, and the whole with Glackens is always so much alive, so much the manifestation of a temperament intensely sincere and intensely brave.[14]

As so carefully articulated by Henri, this was above all a daring work—new, truthful, and even shocking. A careful consideration of each of the elements in the painting proves why.

We have become accustomed to considering Glackens's artistic and domestic lives as thoroughly linked through contiguous studio and domestic spaces. This assumption derives in part from the familiar parlor settings and furnishings shared by his lovingly-painted family scenes, such as *Family Group* (Fig. 139), and works in the vein of *Girl with Apple*. The artist's home and studio were in fact distinctly separate spaces, particularly after 1908, when the Glackens family moved from a brick row house (3 Washington Square) to a more gracious space at 23 Fifth Avenue at Ninth Street (Fig. 158), and Glackens established a studio on the south side of Washington Square, on the parlor floor of number 50. As remembered by his son, Ira, "This was a typical old New York house, with high ceilings, and had seen much better days. . . . He painted in the front room, where the north light was good, . . . and there was some old furniture, tables, chairs, the sofa that appears in 'Nude with Apple,' some piles of draperies, a woman's large old-fashioned hat covered with flowers."[15]

Fig. 65
William Glackens
Study for Girl with Apple, c. 1909–10
Pastel on paper
10 × 14 in. (25.4 × 35.6 cm)
Collection of Mina and Stephen Weiner

Fig. 66
William Glackens
Girl with Apple, c. 1909–10
Pastel on wove paper mounted to
pulpboard
8¼ × 11¾ in. (21 × 29.8 cm)
Brooklyn Museum, New York;
Gift of Arthur G. Altschul 1994.210

Fig. 67
William Merritt Chase
A Study in Curves, 1890
Oil on canvas
22 × 40 in. (55.9 × 101.6 cm)
Private collection

Fig. 68
Gustave Caillebotte
Nude on a Couch, c. 1880
Oil on canvas
51 × 77 in. (129.5 × 195.6 cm)
Minneapolis Institute of Arts;
The John R. Van Derlip Fund 67.67

Fig. 69
William Glackens
New York (Study for Woman with Apple), c. 1909–10
Charcoal on paper
8 × 5½ in. (20 × 14 cm)
NSU Art Museum Fort Lauderdale, FL;
Gift of the Sansom Foundation 92.59

The studio couch was a staple in the art of progressive realist painters of the late nineteenth century. In works that paired couch and model, there was opportunity for boldness, as an essential relationship at the heart of creative production was explored with liberated candor. In a watercolor from the early 1880s, James McNeill Whistler painted the model Milly Finch on his studio divan (Fig. 70), disposed so as to embody the essence of flirtation—the semi-reclining position exposing her lower legs, while one hand is coyly raised to her lips and the other holds a fully opened red fan. Glackens appears to have made his first foray into the model-and-couch theme in 1894 with *Girl in White* (Fig. 119) while still a newspaper artist and art student in Philadelphia, and before his formative 1895 stay in Paris. This large canvas holds the germ of the comparably scaled *Girl with Apple*, in the semi-reclining figure with legs bent and extending downward, the white drape laid out beneath the model, the direct gaze, and an ancillary still life. The figure is largely demure, however, as befit a work probably intended for an American exhibition in the 1890s.

Often enough in the late nineteenth century, models on couches posed and were depicted without their clothes, and the resulting works were a lively feature of French exhibitions, though a far rarer commodity in American ones. William Merritt Chase prepared *A Study in Curves* (Fig. 67), very likely his only frontal nude, as an exhibition piece that debuted at the 1893 annual of the comparatively liberal Society of American Artists in New York. This work conformed to the studio setting type, wherein the studio is acknowledged as such and not disguised through props and costumes to represent historicized places or imaginative narratives. In his *Nude on a Couch*, of about 1880 (Fig. 68), the French Impressionist Gustave Caillebotte portrayed the present day more emphatically through the discarded clothing and prominently placed shoes, as well as by the way the torso still bears the marks of a recently worn corset. These elements situate the model more firmly in time than those employed by Chase, including the traditional studio drape and a Middle Eastern–inspired tasseled pillow.

The studio couch appears to have been the primary locus for Glackens's study of nude and semi-nude models. On a page in the same sketchbook that contains the two charcoal drawings for *Girl with Apple*, the artist described a model's casual moment between formal poses (Fig. 69); and in two oils of semi-nude models, both from 1909 (Figs. 71, 72), Glackens demonstrated a more liberal approach to the model-on-couch theme, and to his employment and use of models in his Washington Square studio fifteen years after painting *Girl in White*. The change in his practice had all to do with the growing availability of autonomous young women who were open to the work. Here the models have removed their blouses and undergarments down to their waists. They remain partially dressed, however, reminding us that the most salient feature of *Girl with Apple* is that the model is fully nude

Fig. 70
James McNeill Whistler
Milly Finch, 1883–84
Watercolor on paper
11¾ × 8⅞ in. (29.8 × 22.5 cm)
Freer Gallery of Art, Washington, DC;
Gift of Charles Lang Freer,
F1907.170a-d

Fig. 71
William Glackens
A Red-Haired Model, 1909
Oil on canvas
24¼ × 20¼ in. (61.6 × 51.4 cm)
Private collection

Fig. 72
William Glackens
Semi Nude with Hat, c. 1909
Oil on canvas
30 × 25 in. (76.2 × 63.5 cm)
Private collection

and that her nudity is made all the more prominent by virtue of the pile of clothing that Glackens boldly situated next to her.

Glackens was fully aware of narrative possibilities of clothing that has been shed. In *Edouard Swore and Raved Like a Madman* of 1903 (Fig. 74), his illustration for a series of novels by the French writer Paul de Kock (and one of the many illustrations which provided him a livelihood when he first came to New York), he described a scandalous scene in which a husband discovers his wife with a lover. Glackens's composition shares certain features with the infamously scandalous *Rolla* by the French artist Henri Gervex (Fig. 73), which was expelled from the Salon of 1878. The leading Impressionist Edgar Degas had suggested to Gervex the inclusion of the voluptuous Rolla's cast-off dress and corset, and he remarked when the painting was removed from the Salon, "You see . . . they understood that she's a woman who takes her clothes off."[16]

Glackens was deliberate and masterful in his description of the clothing heaped next to his beautiful young model in *Girl with Apple*. Although his Impressionist-inspired application of paint restricts the legibility of fine detail, he managed to articulate the layered garments, from the patterned fabric of the white-and-yellow dress draped over the back of the couch, to the underslip spread across its seat, to the chemise under the tip of the shoe; and perhaps most daringly, to the white stocking—still gathered at the top in a way that references its removal from the leg to which the stylish shoe so effectively directs our attention. We are made to understand that this is a woman whose work as a model requires her to remove her clothes. A return to the painting's 1909 context suggests that the exceedingly prominent hat is meant to fortify this perception. Glackens developed the hat's pivotal role in the composition over the course of his work in the preparatory drawings. In comparison to the hat's scale in the pastel, its expanded proportions

Fig. 73
Henri Gervex
Rolla, 1878
Oil on canvas
68⅞ × 86⅝ in. (175 × 220 cm)
Musée d'Orsay, Paris; Bequest of
M. Bérardi, 1926

Fig. 74
William Glackens
Edouard Swore and Raved like a
Madman (Censored Version), 1903
Photogravure
NSU Art Museum Fort Lauderdale, FL;
Bequest of Ira D. Glackens 91.40.311

Fig. 75
Fashionable Models from Macy's Exhibits, 1909
Catalogue page, R.H. Macy and Co., New York
New York Public Library
Mid-Manhattan Picture Collection

Fig. 76
Zomer mode (Summer Fashion), 1909
Five black-and white photographs
app. 9 × 6¼ in. (20 × 16 cm) overall
National Archives of the Netherlands/
Collection Spaarnestad, The Hague

Fig. 77
Still from *Those Awful Hats*,
directed by D.W. Griffith, 1909
American Mutoscope and Biograph

in the finished composition clearly were his intended goal. Glackens was, after all, describing a very particular sort of contemporary hat, a fact that has been obscured to some degree by his son Ira's generic description of the "woman's large old-fashioned hat" that was among his father's most familiar studio props. In 1909, however, this very style was the cutting edge in women's fashion, from New York to Paris. A Macy's ad from 1909 (Fig. 75) shows the various permutations of the oversize silhouette, from brimmed versions to the inverted basketlike type at the center. The proportions verged so near the extreme that a Dutch parody of the fad (Fig. 76) employed everything from a laundry basket to a cake pan. The fashion captivated even the Hollywood director D. W. Griffith, who that year produced a hilarious short film, *Those Awful Hats* (Fig. 77), in which a woman whose vast millinery obstructs the view of her fellow moviegoers is plucked from her seat by a large overhead mechanical claw. The silhouette from behind was perhaps the most notable aspect of the oversize hat style, especially when paired with the equally current, compact silhouettes of dresses and suits with cinched waists and less voluminous, shorter skirts required by active young women who negotiated modern conveniences such as streetcars. Glackens was keenly attentive to the relative proportions and in numerous sketchbook drawings (Fig. 78) delighted in exaggerating their juxtaposition for an amusing effect.

Fig. 78
William Glackens
New York (Walking Woman
in Large Hat from Behind), 1910
Charcoal on paper
8 × 5½ in. (20 × 14 cm)
NSU Art Museum Fort Lauderdale, FL;
Gift of the Sansom Foundation 92.59

Fig. 79
Xavier Sager
La dernière mode, 1909
Color lithograph
Bibliothèque des Arts décoratifs, Paris

Glackens also surely was aware that in 1909 this sort of hat had quickly come to be perceived, in New York and elsewhere, as an attribute of a less-inhibited sort of modern girl. A French postcard from 1909 (Fig. 79) featured the hat as the protagonist in a double entendre on the notion of "la dernière mode"—the latest style—in public comportment as well as in fashion. And back in New York, one of numerous such cartoons featured a big-hatted girl as the increasingly familiar character in a faddish 1909 popular song, *I Love, I Love, I Love My Wife—But Oh! You Kid!* (Fig. 80). Written by Harry Von Tilzer and Jimmy Lucas, and regarded by popular-music historians as the first overtly bawdy American lyric, the song spread like wildfire via popular performers and sheet music sales after its introduction that May, in spite of its condemnation by censorious newspaper editors and clergy who found it indicative of the growing moral depredation of American culture.[17] This type of big-hatted girl was also featured, or lampooned, in a series of popular lithographs published by the Dunston-Weiler Company (Fig. 81) that reveal just how deep-seated anxieties were around the seismic shift in women's roles and behaviors in American society as feminist activism (so named for the first time in the United States in 1910) began to accelerate on all fronts. Cartoons such as these were pointed reminders that women were increasingly seeking control over their bodies and their sexuality, over the nature of and compensation for their work, and were raising their voices in the public and political arenas.

One might assume, then, that the young model selected by Glackens for *Girl with Apple*, whose key attribute is a very large and very modern hat, would have been marked as one of the bold and self-possessed individuals, here confident in her role as an artist's model, which is revealed as such with no mitigating narrative pretext. The directness of this characterization was shared by the painting of the other leading lady of the 1910 Independents exhibition: the more assertive presence embodied by Robert Henri's full-length figure subject of 1909, *Salome Dancer* (Fig. 82). Henri's Salomé was the other most-talked-about work in the galleries (of his two versions of the portrait, the one included in the Independents exhibition is in the collection of the Mead Art Museum, Amherst College). Already a marked work owing to its rejection two months earlier by the jury for the National Academy's spring annual, it drew the attention of critics for its edginess as much as for the painter's skill. James Huneker wrote in the *Sun*, "Mr. Henri ... shows a Salome dancer, startling in its coarseness, as befits the theme, therefore a human document. ... Henri achieves with a virtuosity that overwhelms."[18] Others were more uneasy in noting the discord between Henri's painterly brio and the unpleasantness of so overtly sexual a subject. The *Post*'s reviewer called the picture "a vivid perpetuation of a moment hardly worth eternizing on this scale," and the *Times* concurred, noting that while it was "a tour de force of

Fig. 80
I Love My Wife But Oh You Kid, 1909
Color lithograph

Fig. 81
Dunston-Weiler Lithograph Company
Queen of the Poll, from *Suffragette
Series No. 9*, 1909
Color lithograph
Catherine H. Palczewski Postcard
Archive, University of Northern Iowa,
Cedar Falls

vivacious treatment . . . the ugliness of the subject as material for art seems rather to be emphasized rather than diminished by the extreme cleverness of the handling."[19]

Henri's choices in producing *Salome Dancer* offer further context for those that Glackens undertook in creating *Girl with Apple*. Rebecca Zurier and Robert Snyder were the first to link Henri's subject to the flood of vaudeville Salomés that swamped American popular stages between 1907 and 1909, performing everything from hootchy-cootchy to comedic parody of the biblical theme.[20] Henri's precise model was, however, more immediate, and can be best understood among the range of Salomé performances that evolved over the course of about fifteen years. The phenomenon began with Oscar Wilde's play, published in English in 1894 with decadently stylized illustrations by Aubrey Beardsley. Wilde's narrative transformed the biblical Salomé into a far more autonomous force, driven by boundless lust and thirst for vengeance. His Salomé performs a wildly erotic *Dance of the Seven Veils* to overcome her stepfather, Herod, and thus win the death of John the Baptist, who has spurned her advances; she completes the scene with a chillingly amorous interaction with the apostle's severed head. In 1905, three years after Wilde's play debuted in Berlin, Richard Strauss launched his operatic version in which the battling passions of Herod and Salomé are heightened over the course of a full nine minutes of music devoted to the *Dance of the Seven Veils*. Strauss's extravaganza debuted at New York's Metropolitan Opera House in January of 1907 with a tandem performance of the Salomé role by the

Fig. 82
Robert Henri
Salome Dancer, 1909
Oil on canvas
77 × 37 in. (195.6 × 94 cm)
Mead Art Museum at Amherst
College, Amherst, MA; Museum
purchase AC 1973.68

250-pound soprano Olive Fremstad (Fig. 83) and the far more lithe Metropolitan ballet dancer Bianca Froelich, who executed the choreography. New York was not Berlin, however, and the production was closed down after a single performance owing to objections—primarily from the daughter of J. P. Morgan—to the soprano's overtly erotic interaction with the papier-mâché head. Froelich's rendition was no better received, with critics likening her to the gyrating "Little Egypt" belly dancers made famous on the midway of the 1893 Chicago Columbian Exposition, and characterizing her movement as "the height of lasciviousness." Suddenly unemployed, Froelich took her act to the Lincoln Square Variety Theater, where she continued to perform it as a so-called cooch dancer. [21]

Meanwhile, in 1907 in Berlin, the California-raised, expatriate modern dancer Maud Allan (Fig. 84), inspired by American-born modernists at work in Europe including Isadora Duncan and Loie Fuller, debuted her production of *The Vision of Salomé*, capitalizing on the popularity of the Strauss opera and its sensational *Dance of the Seven Veils* (complete with the erotic encounter with the severed head). Allan's original choreography was very much in the vein of Duncan-esque expressive movement, and she performed in a costume of her own design, with gem-encrusted breastplates and a transparent skirt connected by strings of pearls and jewels. England's charming Edward VII convinced her to offer a two-week engagement at London's Palace Theatre, which in fact lasted from February of 1908 to October of 1909 and sadly degraded her performance by virtue of its setting among the sort of slapstick and animal acts typical of variety reviews. In response, the clever Americans Oscar and William Hammerstein detected the box-office potential of "Salomania" and sent the cunning performer Gertrude Hoffman to London to lift Allan's act wholesale, complete with costume.[22] Hoffman opened "her" *A Vision of Salomé* (Fig. 85) at Hammerstein's Victoria Theater on July 4, 1908 (trumping the competition's plans to import Maud Allan herself in the role). The few alterations that Hoffman and the Hammersteins made to Allan's act included replacing Strauss's music with a more upbeat score, tailoring Allan's choreography to get to the meatier movements right away, and adding a healthy dose of tongue-in-cheek teasing of the audience and their too-eager rapture. Hoffman demonstrated her moxie in describing her knocked-off costume as "one pair of six-inch trunks, two jeweled saucepans, a black net skirt and ropes of pearls."[23] A clearly astonished writer for the *New York Telegraph* recounted the climax of the performance: "Suddenly she turns and sees the head of John the Baptist. She takes it with a combination of eagerness and aversion.... places the head before her and in wild abandon as if to conquer her loathing begins a tempestuous dance. She is garbed with draperies and gewgaws of a bloody age, but ... the effect is that she were bare."[24] Hoffman's *A Vision of Salomé* was sold-out for twenty-two

Fig. 83
Photographer unknown
Olive Fremstad as Salomé, 1907
Black-and-white photograph
The Metropolitan Opera Archives,
New York

MISS PAULINE CHASE

MISS ZENA DARE

MISS MAUD ALLEN

MISS MARIE STUDHOLME

MISS GABRIELLE RAY

REUTLINGER

weeks, and then embarked on a twenty-five-week national tour, stirring up the authorities in the hinterlands before returning for another New York engagement. Inspired in turn by Hoffman, a flood of Salomés reached full force that summer of 1908, owing at least in part to the success of a school for Salomés run by one La Belle Dazie, also known as Daisy Peterkin, from Detroit, who in tandem with an overweight singer had parodied the Metropolitan Opera's team of Fremstad and Froelich for the inaugural Ziegfeld Follies of 1907.[25]

Scholars have long thought that, for his portrayal of Salomé, Henri had hired a dancer and requested that she wear a signature Salomé costume while posing. Henri's model, whose surname he had recorded as "Voclezca," was not just any dancer, however, but rather one Ayesha Hara Voclezca, who debuted her own Salomé act in November 1908, at Brooklyn's Olympia theater. Mademoiselle V. was of the Hoffman school—in both choreography and costume—and quickly won the attention of a *Variety* reviewer in spite of her minor place on the bill: "Ayesha Hara claimed to be making her first American appearance

with Abe Leavitt's burlesque troop undoubtedly stands at the head of all 'Salomers' in burlesque. She gives the dance more completely than any other of the other [*sic*] olio features so far seen, and adds some dramatic force to it, but not enough to worry over. 'Ayesha'... is up against the 'Salome' stagnation around the Metropolis, but that need not alarm her. A bit more 'wiggling' and she can feature herself as a boss 'coocher'." [26] Henri certainly chose Voclezca's Salomé as his model precisely to summon her boldness in a way that would raise the ire of the National Academy jury. As his fellow realist John Sloan remarked after the fact, Henri's "Salome dancer with the naked leg... Of course that was too much for them."[27] But the Salomé acts in general were transgressive not only in their exuberant display of flesh and uninhibited, suggestive movement, but in the implications of the Salomé character and its ability to captivate the American girls who were compelled to enact it. Even as they performed in the established arena of the stage as male marketplace, these many Salomés eagerly adopted the role of a powerful and indeed dangerous female, as well as an autonomously creative and sexual one. The American stage Salomés

represented the intersection of vaudeville performance and rising feminism: even as they portrayed a male fantasy, they offered a female fantasy of liberation and an overturning of cultural power structures. These performances moved the feminist cause ahead, as did Henri's canvas.[28] The Salomé phenomenon inspired the reinterpretation of other canonical biblical characters, as demonstrated by the opening act of the Ziegfeld Follies of 1908, the *Garden of Eden*, with the British actress Lucy Weston playing Eve, and her American colleague Nora Bayes playing "Satanette" (and performing a gratuitous Salomé dance). The production included the song *Be Good*, which ended with the line, "Be good as you can when you're out with a man … [and] if you can't be good, be careful." The Ziegfeld opener spurred at least one offshoot, reported by the *New York Star* in October: "A resourceful dancer has invented a new 'Garden of Eden' dance. Looks like going the Salomé craze one worse."[29]

What to make, then, of Glackens's "Eve" and the girl who "played" her? The models enlisted by Henri and Glackens were not the art school models of even five years earlier, whose services were contingent upon comparatively low social standing and were not usually allied to greater ambitions. By 1909, however, the women who modeled for these progressive artists tended to be individuals with emphatically public lives, whose uninhibited behavior often underpinned higher ambitions for newly prized careers on the popular stage or movie screen. A treasure among Glackens's sketchbooks is one labeled "MODELS" (Fig. 86), which includes the names, addresses, and phone numbers of more than one hundred available girls. It is not surprising that a significant number of them fit this newer mold. There was Audrey Munson (Fig. 87), who had been discovered on a New York street in 1906, at the

Fig. 87
Arnold Genthe
Nude woman, possibly Audrey Munson,
c. 1906–42
Autochrome
Arnold Genthe Collection, Library
of Congress Prints and Photographs
Division, Washington, DC

Fig. 88
William. Glackens
Café Lafayette (Portrait of Kay Laurell),
1914
Oil on canvas
31¾ × 26 in. (80.6 × 66 cm)
Collection of Barney A. Ebsworth

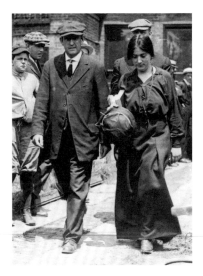

Fig. 89
*Becky Edelson [Edelsohn] Under Arrest—
Tarrytown*, published by Bain News
Service (detail), 1914
Digital file created from glass negative
5 × 7 in. (12.7 × 17.8 cm)
Library of Congress Prints and
Photographs Division, Washington, DC

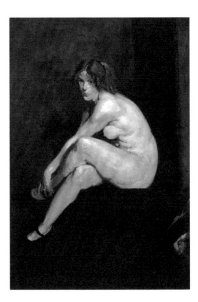

Fig. 90
George Bellows
Nude Girl, Miss Leslie Hall, 1909
Oil on canvas
60 × 42 in. (152.4 × 106.7 cm)
Terra Foundation for American Art,
Chicago; Daniel J. Terra Art Acquisition
Endowment Fund 1999.5

age of fifteen, and was instantly one of the most highly sought artist's models in the city (particularly among sculptors). She moved on to Hollywood in 1915 to star in silent pictures, including *Inspiration*, in which she became the first woman to appear fully nude on film.[30] Kay Laurell was a Pennsylvania farm girl whose portrait Glackens painted against the setting of the Hotel Lafayette café (Fig. 88) in 1914, the year of her sensational debut in the Ziegfeld Follies with a near-nude performance based on the wildly popular painting *September Morn* by the Frenchman Paul Chabas.[31] The bold and independent women in Glackens's register included Becky Edelsohn (Fig. 89), a Ukrainian-born anarchist taken under the wing of Emma Goldman and arrested almost annually from 1906 until she gained fame for her 1914 prison hunger strike.[32] Some of the young women were artists themselves, such as Genevieve Warner, a member of the Art Workers' Club for Women, whose entry is annotated with "Big, blonde gaiety girl type, good." But in large measure they were aspiring starlets of stage and screen, including Gertrude Clarke, who appeared in the 1911 feature *The Baby of the Boarding House*; Caroline Oden, who performed in a 1910 Bijou Theatre production of *Welcome to Our City*; the Broadway actress Zita Rieth, who starred in *A Man's Friends* in 1913; and the film actress Betty Dodsworth, whose entry Glackens annotated with the words "red hair."[33] Glackens also listed Leslie Hall, who in 1909—without a doubt the watershed year for daring nudes by the American realists—posed unclothed for an exceptional portrait by George Bellows (Fig. 90). Given the profiles of so many of the bold young models enlisted by Glackens and his peers, it is unlikely that Miss Hall was, as one writer has recently suggested, "a working girl whose labor is decidedly . . . demeaning, who pushes carts loaded with goods for sale through the streets of lower Manhattan."[34]

Eight days after the 1910 Independents exhibition closed its doors, the first of New York's historic suffrage parades (Fig. 91), three thousand marchers strong, commandeered Fifth Avenue from Fifty-seventh Street to Union Square. William and Edith Glackens were surely on hand. By 1911, when the parade swelled by thousands more and included more working and unmarried women, and two hundred men, Edith Glackens presided as the honorary secretary of the National Union of Women's Suffrage Societies. The performance of the 1911 parade was highly orchestrated, with three floats presenting the evolution of women's lives over the previous one hundred years. While the first float represented pre-industrial work, the second carried actresses, artists, musicians, and writers. Glackens himself was among the hundreds more men who marched in 1913.[35]

William Glackens was a progressive man as well as a progressive artist. His wife, a rich Connecticut girl who had sought the independent artist's life in New York City, was bold, creative, and politically active. In Glackens's admiring portrait of her (Fig. 137) from 1904,

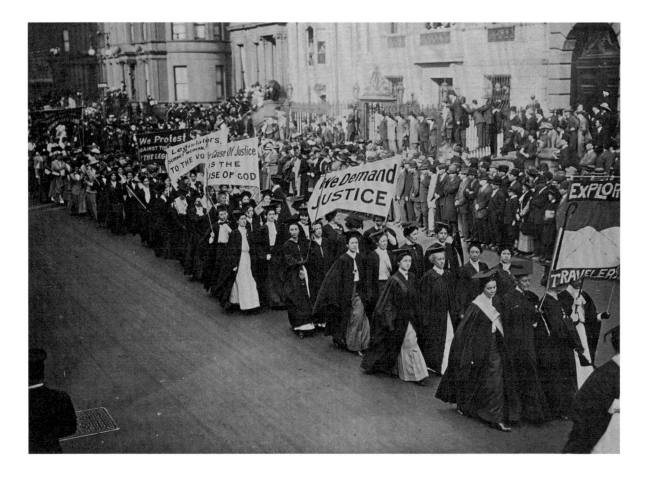

Fig. 91
Jessie Tarbox Beals
Women in academic dress marching in a suffrage parade in New York City,
c. 1910
Gelatin silver print
4⅞ × 6¾ in. (12.4 × 17.1 cm)
Schlesinger Library, Radcliffe Institute, Harvard University, Cambridge, MA

the year of their marriage, he placed her beside a prominent still life from which she has selected an apple, and captured an expression that suggests it would be offered only on her terms. Reiterating the notion of Eve in his painting of the fully nude figure in *Girl with Apple*, Glackens also restated his admiration for the daringly independent, modern women he preferred as his models. With this nude and other boldly sensual figure subjects from 1909—a truly pivotal moment for the type in American art—a handful of progressive male realists celebrated the liberation of women to control and reinvent themselves in the context of first-wave feminism.

NOTES

1. Samuel Isham, *The History of American Painting* (New York: MacMillan, 1905), 468, 471.

2. For biographical information on Duveneck, see Robert Neuhaus, *Unsuspected Genius: The Art and Life of Frank Duveneck* (San Francisco: Bedford, 1987); *Siesta*, or *Foucar's Nude*, is discussed on 122 and 124.

3. See Suzanne L. Kinser, "Prostitutes in the Art of John Sloan," *Prospects* 9 (1984): 240–41.

4. As quoted in an entry of the work in Rowland Elzea, *John Sloan's Oil Paintings: A Catalogue Raisonné* (Newark: University of Delaware Press and Associated University Presses, 1991), 73–74.

5. As quoted in Patricia Hills, "John Sloan's Images of Working-Class Women," *Prospects* 5 (1980): 178.

6. Walter Pach, "Manet and Modern American Art," *Craftsman* 17, no. 5 (February 1910): 483.

7. A detailed account of the organization of the exhibition and its contents, and a facsimile of the catalogue, are included in *The Fiftieth Anniversary of the Exhibition of Independent Artists in 1910* (Wilmington: Delaware Art Center, 1960).

8. James B. Townsend, "The Independent Artists," *American Art News* 8, no. 26 (April 9, 1910): 2.

9. "Independents Hold an Art Exhibit," *New York World*, April 3, 1910, sec. 2, 7.

10. Arthur Hoeber, "Art and Artists," *New York Globe and Commercial Advertiser*, April 5, 1910, 10.

11. James G. Huneker, "Around the Galleries," *New York Sun*, April 7, 1910, 6.

12. "Many and Varied Talents Displayed at the Exhibition Given by the Independent Artists," *New York Times*, April 17, 1910, 15.

13. Huneker, "Around the Galleries."

14. Robert Henri, "The New York Exhibition of Independent Artists," *Craftsman* 18, no. 2 (May 1910): 162.

15. Ira Glackens, *William Glackens and the Ashcan Group: The Emergence of Realism in American Art* (New York: Writers and Readers Publishing and Tenth Avenue Editions, 1957), 116.

16. As quoted in Valerie Steele, "Édouard Manet: Nana," in *Impressionism, Fashion, and Modernity*, ed. Gloria Groom (Chicago: The Art Institute of Chicago, 2012), 133.

17. The history and impact of the song are explored in depth by Judy Rosen, in "Oh! You Kid!," *Slate*, June 2, 2014, http://www.slate.com/articles/arts/culturebox/2014/06/sex_and_pop_the_forgotten_1909_hit_that_introduced_adultery_to_american.html.

18. Huneker, "Around the Galleries."

19. "The Independent Artists," *New York Evening Post*, April 2, 1910, 7; and "Many and Varied Talents Displayed at the Exhibition," 15.

20. Rebecca Zurier and Robert W. Snyder, "Introduction," in Zurier, Snyder, and Virginia M. Mecklenburg, *Metropolitan Lives: The Ashcan Artists and Their New York* (Washington, DC: National Museum of American Art, 1995), 19–21.

21. For a detailed account of the origins and dissemination of the popularized Salomé at the turn of the century, see Susan A. Glenn, "The Americanization of Salome," in *Female Spectacle: The Theatrical Roots of Modern Feminism* (Cambridge, MA: Harvard University Press, 2000), 96–125.

22. For remarkable documentation of the Salomé performances of Allan and Hoffman, see Glenn, *Female Spectacle*, 102–6; and Larry Hamberlin, *Tin Pan Opera: Novelty Songs in the Ragtime Era* (New York: Oxford University Press, 2011), 111–13.

23. As quoted in Glenn, *Female Spectacle*, 105.

24. Ibid., 103.

25. Ibid., 101.

26. "Representative Artists," *Variety* 59, no. 9 (November 7, 1908): 32; and Sime Silverman, "Ayesha Hara. 'Salomé,'" *Variety* 59, no. 9 (November 14, 1908): 13.

27. Sloan diary entry, quoted in Zurier, Snyder, and Mecklenburg, *Metropolitan Lives*, 19.

28. For a consideration of the feminist nuances of the Salomé craze in turn-of-the-century America, see Mary Simonson, *Body Knowledge: Performance, Intermediality, and American Entertainment at the Turn of the Twentieth Century* (New York: Oxford University Press, 2013), 45–47.

29. The Garden of Eden program is considered in Ann Ommen van der Merwe, *The Ziegfeld Follies: A History in Song* (Lanham, MD: Scarecrow, 2009), 12–20. *New York Star*, October 31, 1908, 15.

30. For biographical information on Munson, see Saki Knafo, "The Girl Beneath the Gilding," *New York Times*, December 9, 2007, http://www.nytimes.com/2007/12/09/nyregion/thecity/09muns.html; and *Wikipedia*, "Audrey Munson," https://en.wikipedia.org/wiki/Audrey_Munson.

31. *Wikipedia*, "Kay Laurell," https://en.wikipedia.org/wiki/Kay_Laurell.

32. *Wikipedia*, "Becky Edelsohn," https://en.wikipedia.org/wiki/Becky_Edelsohn.

33. The work of young starlets is traceable in a minimal fashion on Internet Movie Database (IMDb), www.imdb.com.

34. See Marianne Doezema, "Tenement Life: Cliff Dwellers, 1906–1913," in Charles Brock et al., *George Bellows* (Washington, DC: National Gallery of Art, 2012), 50.

35. The early New York Suffrage parades are discussed in detail in Pamela Cobrin, *From Winning the Vote to Directing on Broadway: The Emergence of Women on the New York Stage, 1880–1927* (Newark: University of Delaware Press, 2009), 43–50. The Glackens family's commitment to the Suffrage movement is documented in Ira Glackens, *William Glackens and the Ashcan Group*, 184–85.

The Exhibition Game:
Rockwell Kent and The Twelve

CHARLES BROCK

Lecture given on December 3, 2015

New-York Historical Society

New York City

AN INDEPENDENT EXHIBITION
OF THE PAINTINGS AND DRAW
INGS OF TWELVE MEN AT THE
GALLERY OF THE SOCIETY OF
BEAUX ARTS ARCHITECTS
NUMBER SIXTEEN EAST THIRTY
THIRD STREET NEW YORK CITY

OPEN DAILY FROM MARCH TWENTY
SIXTH TO APRIL TWENTY FIRST
INCLUSIVE FROM NINE IN THE MORN
ING UNTIL TEN AT NIGHT EXCEPTING
APRIL FIRST NINTH AND TENTH

The Exhibition Game:
Rockwell Kent and The Twelve

CHARLES BROCK

One of the most significant achievements of the American modernists was their reinvention of the New York art world. A key to changing that world was what John Sloan liked to call "The Exhibition Game."[1] Cutting across all isms and camps, the game was played in New York in earnest during the first two decades of the twentieth century by the American avant-garde, who used alternative exhibition formats to challenge the National Academy of Design's restrictive membership policies and break the Academy's monopoly on the display and sale of contemporary American art in the city. A crucial turning point occurred in 1908, the year of Robert Henri's watershed exhibition of The Eight at the Macbeth Galleries; the *Exhibition of Paintings and Drawings by Contemporary American Artists* at the Harmonie Club, featuring fifteen of Henri's students; and the first drawing and painting shows at Alfred Stieglitz's Little Galleries of the Photo-Secession, known as 291.[2] These displays upset the Academy's status quo and set in motion a range of different approaches to presenting contemporary art, from intimate and experimental at 291 to sprawling and encyclopedic at the 1913 Armory Show.

The exhibition game proved to be highly competitive and never conclusive, with each successive round producing different lineups and fresh schemes. Even when promoting the more narrow interests of the artists who had organized them, the exhibitions of the period deployed a variety of strategies that collectively established a fairer, more inclusive art world and a broader market for contemporary work. In disrupting the prevailing rules of the game, the early American modernists succeeded in opening up new playing fields for modern American visual culture, where a kaleidoscopic array of eclectic styles representing multiple modernisms would clash and contend with one another for the rest of the century in both private galleries and public museums. The players of the volatile American exhibition game, if never fully achieving their radically democratic goals, nonetheless progressed toward them in significant ways.

Fig. 92
Rockwell Kent
An Independent Exhibition of the Paintings and Drawings of Twelve Men at the Gallery of the Society of Beaux Arts Architects (catalogue cover)
New York, 1911
Special Collections, University of Delaware Library, Newark

A word that resounded throughout the early modernist period was "Independent." There were the Independents exhibitions, the Independent School of Art, and the Society of Independent Artists. Artists self-consciously thought of themselves as "independents." The exhibition game was always dealing with the difficult, if not impossible, task of reconciling the aims of highly individualistic artists to the goals of art organizations, of trying to ascertain what independent meant if everyone was on their own, of devising ways for modern artists—conservatives and radicals, insiders and outsiders—to somehow be independent together, simultaneously.

These quandaries reflected the abiding conundrum of American democracy and justice, *E pluribus unum*. Essential issues of governance were constantly being addressed in detailed documents such as the constitution of the American Painters and Sculptors, drafted by the organizers of the Armory Show. But, if clearly liberating and productive, the democratic free-for-all that took place between Henri and his coterie of talented students—among them Rockwell Kent—and the colleagues of Stieglitz, Marcel Duchamp, and many others, also produced a combative and chaotic creative and economic environment. It is not surprising then that attempts to reconcile the seemingly irresolvable terms of the many and the one, as Allan Antliff has shown, also inevitably drew upon the anarchist philosophies of extreme individual liberty that were in vogue at the time.[3]

Driven by an atomistic, democratic, at times anarchic spirit, the wilder side of American modernism was indiscriminate and defied definition. In challenging traditional connoisseurship and the elite standards of taste represented by the Academy, the early American modernists confounded questions of quality. Unwilling to accept authority in any guise, they were always cognizant of how recognition or monetary success could paradoxically signal failure. Sloan wrote, for instance, that "we always regarded contemporary success as artistic failure."[4] Stieglitz commented, "When I feel success coming, I walk around the corner."[5] Upon his arrival in New York in 1915, Duchamp searched for ways to further upset the American game. He endeavored to break free from the standards of the conventional art world and looked for any strategy that would help him avoid falling into the trap of being a traditional artist or categorized in any way by critics or art historians. Henri, with his rallying cry of "art for life's sake," like the multi-faceted Stieglitz and Duchamp, was as interested in art's potential to transform and even transcend personal identity as he was in its finished, formal qualities. As a consequence, what artists did beyond the studio was often as significant as what they achieved in the studio. The accomplishments of artists as gallerists, teachers, and galvanizing personalities during this early period cannot be underestimated. Ideas mattered. Politics mattered. *Life* mattered.

Particularly when considered from the perspective of the rest of

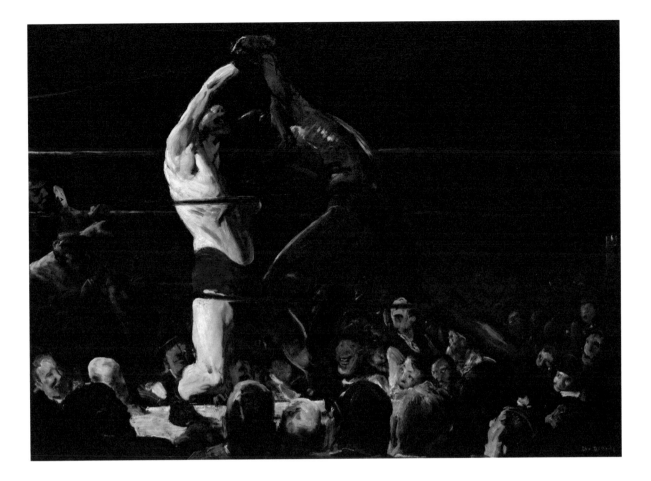

Fig. 93
George Bellows
Both Members of This Club, 1909
Oil on canvas
45¼ × 63³⁄₁₆ in. (115 × 160.5 cm)
National Gallery of Art, Washington, DC;
Chester Dale Collection 1944.13.1

the country, the American modernists working in New York might be usefully understood as provisional members of a somewhat disreputable, transient confederation that, like the members of the semi-legal, private/public athletic clubs George Bellows depicted in his boxing pictures (Fig. 93), operated in the shadows and on the fringes of American society, at the edges of the law. Conflating private struggle and public spectacle, the New York avant-garde inhabited a netherworld of perpetual outsiders where victory and defeat were never clear-cut and were always up for grabs. This new arena where the rules were continually being rewritten was at times profoundly disorienting, and in some instances destructive—a place of tragedy as much as triumph. In the helter-skelter of the American modernist scheme, with sales often harder to come by than publicity, artists might achieve some modicum of recognition, but most eventually found themselves displaced, knocked out of the ring, and lost in the crowd. Such an intensely conflicted atmosphere expressed the fever-pitch dualities and dilemmas of modern American life and of modernity itself.

In the spring of 1911, Rockwell Kent made his own singular contribution to the exhibition game when he organized *An Independent*

Exhibition of the Paintings and Drawings of Twelve Men at the Gallery of the Society of Beaux Arts Architects (Fig. 92). Kent used the exhibition as a platform not only to antagonize the National Academy of Design but to quite audaciously make a name for himself. This entailed usurping the directorship of the Independents movement from his mentor at the New York School of Art, Robert Henri. Kent's provocations were a calculated response to the more conciliatory tone of Henri's exhibition philosophy. They were also very much in keeping with the hurly-burly of an era that would see artists' reputations rise and fall with almost every passing exhibition season.

The discussion that follows will document and analyze the exhibition that would come to be known simply as "The Twelve," or more colloquially as "Kent's Tent." It will examine in turn the particulars of how Kent's show came about, the artists who participated in it, what was shown, and how the exhibition was received by the critics. The conclusion considers the ways in which a careful reconstruction and rethinking of the events surrounding Kent's Tent furthers our understanding of some of the period's most dynamic actors and more broadly illuminates the early history and nature of American modernism.

Fig. 94
Gertrude Käsebier
Robert Henri, 1907
Platinum print
8¼ × 6¼ in. (21 × 15.9 cm)
Delaware Art Museum, Wilmington;
Gift of Helen Farr Sloan 1978–589.11

CONTENDERS

When the second exhibition of Independent artists opened on March 26, 1911, it featured a rather unusual lineup. Among the twelve exhibitors were five of Robert Henri's former students, who were part of a group known as "The Fifteen": Rockwell Kent, Guy Pène du Bois, Julius Golz, Homer Boss, and Glenn O. Coleman; three members from Henri's group "The Eight": George Luks, Arthur B. Davies, and Maurice Prendergast; and, perhaps most surprising, three figures then closely associated with Alfred Stieglitz's 291 gallery: John Marin, Marsden Hartley, and Alfred Maurer.[6] Conspicuously missing were Henri himself, the "presiding genius" of the first Independents show, and Kent's original collaborator on the second show, John Sloan, as well as Henri and Sloan's other cohorts from The Eight: Everett Shinn, William Glackens, and Ernest Lawson, all of whom had been on the initial list of invitees. How can we account for these curious inclusions and omissions?

The four men who were most involved during the early stages of The Twelve were Henri, Sloan, Davies, and Kent. Henri (Fig. 94) had been born Robert Henry Cozad in Cincinnati in 1865 but thought it prudent to change his name in 1883 after his father killed a man in a land dispute and the family had to flee to Colorado.[7] Elected to the National Academy of Design in 1906, but never quite comfortable in a club that would have him as a member, he would spend the remainder of his life questioning the Academy's authority. John Sloan (Fig. 95) was born in Pennsylvania in 1871 and was one of a group of

Fig. 95
Gertrude Käsebier
John Sloan, 1907
Platinum print
8¼ × 6⅜ in. (21 × 16.2 cm)
Delaware Art Museum, Wilmington;
Gift of Helen Farr Sloan 1978–589.17

Philadelphia newspaper artist-reporters whom Henri encouraged to become painters. A politically committed individual who worked for the socialist magazine *The Masses*, Sloan nonetheless believed that art should be kept free of politics and left to its own devices, and in time he became receptive to the experiments of Picasso and other European modernists.[8] Arthur B. Davies (Fig. 96), born in Utica, New York, in 1862, pursued an esoteric painting style indebted to Symbolism, the classicizing work of Puvis de Chavannes, Cubism, yoga, and the musical principles of eurhythmics, all the while leading a secret double life as a bigamist.[9] In the aftermath of Kent's display, Davies would go on to gain lasting fame as one of the visionary organizers of the 1913 Armory Show and later as an adviser to Lillie P. Bliss, a founder of the Museum of Modern Art. Finally, Rockwell Kent (Fig. 97), born in Tarrytown, New York, in 1882 and the youngest of the four, was a man of unbounded energies who, in between his later expeditions to Alaska, Greenland, South America, and other far-flung places, practiced architecture, painting, printmaking, illustration, writing, farming, and politics.[10] Kent would be a lifelong advocate for left-wing causes and yet—as the most radical of individualists, no matter where he found himself, whether in America or later the Soviet Union—managed to remain a monument of isolation, a supreme egoist setting himself apart from the political and cultural worlds he so bravely loved to provoke.

The first *Exhibition of Independent Artists*, organized by Henri in 1910, had been a no jury/no prizes show of 260 paintings, 344 works on paper, and 22 sculptures by 103 invited artists, held on three floors of a rented building on Thirty-fifth Street, west of Fifth Avenue.[11] The exhibition garnered tremendous publicity after it was mobbed by over

two thousand visitors at its opening on April Fool's Day in 1910. Henri articulated his intentions in the May 1910 edition of the *Craftsman*: "The exhibition of Independent Artists is not a movement headed by any one man or small group of men . . . one of the most damaging things that could happen to the progress of art in America would be to personalize this movement in any way. Neither is it . . . an exhibition of people who have had their pictures accepted or refused by the Academy. It is not a gathering together of kickers of any description. . . . Freedom to think and to show what you are thinking about, that is what the exhibition stands for."[12] Henri then clarified his notion of independent: "This is called an independent exhibition because it is a manifestation of independence in art. . . . It does not mean that it is an independent organization, but that it is made up of the independent points of view. . . . I personally have no interest whatever in forming it into a society, and if . . . I were to become a member of it, I would probably be the first man to secede."[13] Kent's *The Road Roller* (Fig. 98), then titled *Road Breaking*, was the first image featured in Henri's article and Kent the first artist Henri singled out for praise: "Take, for instance, Rockwell Kent. He is interested in everything. . . . The very things that he portrays on his canvas are the things that he sees written in the great organization of life."[14]

In his 1955 autobiography *It's Me O Lord*, Kent related how in early 1911 he and his family were residing below John and Dolly Sloan at 165 West Twenty-third Street while Kent eked out a living as an architectural draftsman. Kent regarded the first Independents exhibition "as something to be repeated whenever a hopeful opportunity should present itself."[15] So when his employer made the Society of Beaux-Arts Architects exhibition space at 16 East Thirty-third Street available to him, Kent "grabbed his hand in thanks. And . . . hot-footed it to Henri's. . . . If I had only had a tail to wag as Henri opened his door to me: how I would have waggled it!"[16]

Despite his claims of puppy-dog innocence, Kent's real intent was to bite the hand that fed him. For in formulating his Independents show he chose to diverge from Henri's precedent in a very pointed way: whereas Henri wanted to keep an open-door policy with the National Academy of Design and discourage the "kickers," as he put it, Kent, in no uncertain terms, wanted to be confrontational; Kent wanted to kick. He saw the issue as "not merely one of bitterly conflicting ideals, but one of substance in that it involved the Academy's . . . monopoly of virtually the only public exhibition space in the city; and . . . an actual coercive power over artists. Conform, it might have said, or stay unknown. My own impulse had been . . . that youth and all the dissidents should boycott it."[17]

The disagreement between the two men escalated. Kent recalled: "Henri didn't see. . . . In no time, as I tried to argue, he was mad, damn mad. It seemed to me just common justice that with New York's

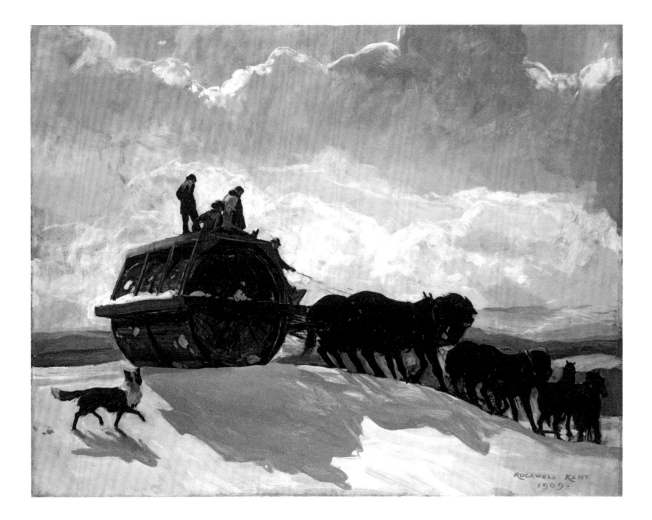

Fig. 98
Rockwell Kent
The Road Roller, 1909
Oil on canvas
34⅛ × 44¼ in. (86.7 × 112.4 cm)
The Phillips Collection, Washington, DC;
Acquired 1918

exhibition space so limited, the more privileged artists should be restrained from showing everywhere."[18] Kent questioned Henri's commitment to changing the status quo, noting that as a member of the Academy he was in effect "the object, not the subject, of the verb reform."[19] Kent wouldn't allow Henri to play on both sides of the fence.

Henri in turn threatened to turn the tables on Kent by organizing his own boycott of Kent's show.[20] Kent remained undeterred, telling Henri: "The show...will be held exactly as I've said it should be. And if no one else will join me I'll paint enough pictures to fill the whole gallery with my own work."[21] Kent then retreated with Henri shouting after him, "When you have done as much for art as I have... you'll have a right to talk."[22] Writing more than forty years after these events, Kent was willing to admit, in a case of too little too late, that "there was much justice in Henri's parting shot."[23] Regardless, clearly Henri's hope of not "personalizing" the Independents movement "in any way" was not in the cards.

Kent next turned for help to "the poet of a modernized classicism," Arthur B. Davies, who we are told was also eager that Henri be "put in his place."[24] Davies pledged to recruit two fellow artists from The Eight, George Luks and Maurice Prendergast, and contributed more than two hundred dollars to Kent's cause, the same sum he had given to Henri the year before for his Independents show. Kent also lobbied Sloan, who allegedly was, like Davies, keen that Henri be "taught a lesson."[25] Kent remembered, or perhaps concocted, a dramatic vote to mutiny against Henri taken at Sloan's studio, which left Henri and Bellows in "inglorious isolation."[26] Later, supposedly under pressure from Henri, and much to Kent's chagrin, Sloan withdrew, leaving Kent to ruminate: "He that is not with me...is against me."[27]

John Sloan's diary and correspondence provide us with a contemporaneous, less dramatic, and undoubtedly more accurate version of events.[28] In point of fact Kent first discussed the show with his neighbor Sloan before confiding in Davies, who was away in Italy until February.[29] In Sloan's January 12, 1911, entry we learn that he initially had little enthusiasm for Kent's plan: "R. Kent...is quite anxious that we should have another exhibition. I told him that I was in a state of Grouch about the whole exhibition game and did not feel disposed."[30] Sloan's entry of February 7 provides a more nuanced explanation of the ensuing disagreement between Kent and Henri: "It appears that Kent...used the expressions 'force these men'...to 'come out and not show their pictures at the Academy.'...Kent said that he and the rest of us...had not got anywhere in our 'fight.' I felt after a long argument with Henri that he was most nearly right in his attitude. Henri is right in saying that we have never put the 'screws on' anyone in our exhibitions. I came away quite undecided with a bias in favor of H.'s position."[31]

On February 21, Kent sent out a formal letter of invitation to his Independents show. In it he took a less aggressive stance toward the

Academy by not insisting on a boycott and promising not to intentionally foment any kind of public controversy: "It is *assumed* that the exhibitors will not show at the Academy during the current year of 1911. The relation of this exhibition to the Academy *will not* be advertised."[32] Henri was not assuaged, writing to Sloan: "D [Davies] is going to exhibit says he has confidence in Kent, etc, thinks in my regard that Kents action has only been foolish youth action.—How different this would look to D were the action towards him instead of me."[33]

Finally on March 6, Davies concluded the preliminaries to the show in a letter to Kent: "I think now that the March Squall has passed, we had better get down to work on our canvases…Henri, Sloan, Bellows and possibly Glackens are out but we can go ahead…and I am sure the exhibition will be interesting and keep alive a spirit that should never 'die.'" Davies then added a suggestion that would prove critical to the show's success: "If you can get others of the Stieglitz crowd—through Stieglitz. Max Weber, Hartley and some others if by invitation only—I would do so."[34]

These interactions reveal at the most personal level how the exhibition game was played. In this particular iteration, we find the four primary actors constantly jostling and pushing one another into different and not entirely consistent positions. Henri claimed to be for an all-inclusive exhibition that catered to new young artists as well as established academicians, one that would run without a permanent organizational structure and be free from the biases of a single charismatic personality. Yet, despite his claims to the contrary, Henri harbored a bias in favor of figurative and representational art, and was himself a charismatic figure who immediately became threatened when Kent, one of his most talented young protégés, took the initiative to organize an Independents show on his own terms. Kent, on the other hand, in taking a more hardline stand against the Academy, and hence against Henri, succeeded in grabbing the spotlight from his mentor in order to elevate his own visibility and status. In attacking Henri and the Academy, Kent may also have been seeking to stalemate his leading contemporary rival George Bellows, who had been elected an associate member of the National Academy in 1909 and would exhibit there regularly until his death in 1925. Near the end of his narrative Kent acknowledged: "It is clear to me now…that what I showed enhanced my reputation. I may be said to have 'arrived.'"[35]

Meanwhile Davies deftly took advantage of the rift between Henri and Kent to step in and expand the reach of the second Independents show to encompass the new styles he thought deserved attention, in particular those practiced by some of his friends in the Stieglitz circle. Sloan later observed: "A silent, poetic type like Davies turned out to be a dictator at heart."[36] Finally it is Sloan who ultimately emerges as the most sympathetic and broad-minded figure of the four—a more tolerant moderator of different opinions.

CATALOGUE

HOMER BOSS
Paintings

1. Clouds After Rain
2. Late Afternoon
3. Prosper Invernizzi, Esq.
4. A Woman of the East
5. A Young Woman
6. Portrait of a Man
7. An Old Man

GLENN O. COLEMAN
Paintings

1. Candy Stand
2. The Green House
3. Hop Charley
4. Drugs

Drawings

5. Ninth Avenue Suffragette
6. On a Balcony
7. A Rehearsal
8. Seeing China Town
9. To Our Lady of Mt. Carmel
10. Sunday Evening
11. Masqueraders
12. Diamond Tony

ARTHUR B. DAVIES
Paintings

1. Descended Pleiad
2. Reverie
3. Esmerelda
4. Sleep Lies Perfect in Them
5. Tendrils
6. The Door of Paradise
7. A Song and a Dream
8. Free of the Cloud
9. Clothed in Dominion
10. Night to Night
11. Into the Night
12. Summer Solstice
13. Refluent Season
14. Upon Branches
15. Serenade
16. In Summer

Drawings
16–23

GUY PENE DU BOIS
Paintings

1. Girl Sewing

2–7. Sketches

JULIUS GOLZ
Paintings

1. The White Horse
2. The Village—Forenoon
3. The Village—Afternoon
4. Kelp Rocks
5. Post Office Hill—Monhegan
6. Carnival
7. A City Square

MARSDEN HARTLEY
Paintings

1. Aged Earth
2. Autumn, the Lake
3. Autumn
4. Gardenia
5. Deserted Farm
6. Landscape, November
7. Deserted Farm
8. Deserted Farm
9. Autumn

Drawings

10. The Lake
11. The Bridge
12. Running Water
13. Running Water
14. Brook
15. Miles Notch

ROCKWELL KENT
Paintings

1. A Spring Morning
2. Seiners
3. Down to the Sea
4. The Winter Sea
5. The Blaze of the Sun upon the Land
6. Snow Fields
7. Early Spring
8. Men and Mountains
9. In a Tent's Shade
10. Autumn Fires
11. The Flake Yard, Evening
12. Golden Evening
13. A Berkshire Landscape
14. An Evening Sky
15. In the Shade of Great Trees

Drawings
16–29

GEORGE B. LUKS
Paintings

1. Aunt Mary
2. Cats
3. Nocturn, Gansevoort Dock
4. Dumping Snow
5. Winter, Spuyten Duyvil
6. Peonies
7. The Guitar
8. Suter Johnny
9. Portrait of W. A. Fraser, Esq.
10. The Chef
11. Little Milliner
12. Glowing Bowl
13. Girls Dancing
14. Little Grey Girl
15. Mrs. George Luks

JOHN MARIN
Water Colors

1. Palisades of the Hudson
2. New York from Weehawken Heights
3. New York from Weehawken Heights
4. New York from Weehawken Heights
5. New York from Weehawken Heights
6. New York from Weehawken Heights
7. From the Hudson Heights, New Jersey
8. Front Street, New York
9. Peekskill, Hudson
10. The West Shore
11. West Shore Grain Elevators
12. The Hudson near West Point
13. The Blue Mountain, Tyrol
14. In the Tyrol
15. Mountain and Clouds, Tyrol
16. The Mountain, Tyrol
17. Girl Sewing
18–21. Water Colors

ALFRED MAURER
Paintings

1. Still Life
2. Still Life
3. Still Life
4. Still Life
5. Still Life
6. Still Life

JOHN McPHERSON
Paintings

1. Rain Clouds
2. Landscape
3. Landscape
4. Landscape
5. Lighted Valley
6. River and City
7. Wind Billows
8. The Creek
9. Rolling Sky
10. Afternoon Hills
11. Postponed Game
12. The Palisades

MAURICE PRENDERGAST
Paintings

1. Under the Trees
2. By the Sea
3. Evening Promenade
4. The Opal Sea

Water Colors

5. The Willows
6. Sail Boats
7. Water and Rocks
8. Midsummer Day
9. On the Sands
10. Crescent Beach
11. Taking the Air
12. The Seaside
13. An Old Fort
14. Along the Ramparts
15. Breeze is Blowing
16. Bathing

Henri and Kent's dispute was the type of irresolvable clash, of teacher versus student, old versus young, Academy insider versus modernist outsider, inclusivity versus exclusivity, that permeated and fueled the early New York avant-garde culture. Unstable, sometimes duplicitous relationships among individuals and institutions, with opponents often mirroring each other's position and then flipping roles, were part and parcel of the new art world that the American modernists were forging. This was an environment where an artist's status was always precarious and where nothing remained settled. As perspectives shifted, independents could turn into conformists, radicals into conservatives, knowns into unknowns, winners into losers, in the blink of an eye.

The predicament shared by all four men was how to aspire to a new, ideal group exhibition format while maintaining their own stances and serving their own career interests. With everyone seeking their own independent, principled positions on their own terms, the four could never be entirely reconciled, nor, if truth be told, did they ever really wish to be. In the case of The Twelve, by explicitly challenging Henri's policy toward the Academy, Kent had shrewdly forced everyone to at least reveal their current positions, to show their cards in the latest hand that the exhibition game had dealt them. When the smoke had cleared, Henri and Sloan were out and Kent and Davies remained. Ironically neither Henri, Sloan, nor Davies would ever exhibit in the National Academy annuals again, while Kent, in true contrarian fashion, eventually returned to the Academy fold in 1935.[37]

THE TWELVE

Reflecting the dilemmas that animated American modernism, Kent's Tent featured an extraordinarily eclectic mix of artists, all of whom, in struggling to achieve their own individual artistic identities, had to come to terms with a myriad of modernist influences both at home and abroad (Fig. 99).[38] Among the twelve exhibitors were Marin and Prendergast, artists who had invented recognizable and ultimately more marketable and sustainable signature styles; Maurer and Hartley, two painters who pursued multiple styles; four very different types of realists, namely Luks, Coleman, Boss, and Pène du Bois; a pair of multitalented figures who had established reputations across a number of fields, Davies and Kent; and finally two lesser-known painters who for the most part have been lost to history, Julius Golz and John McPherson. Critics caught the wide-ranging, catch-as-catch-can spirit that resonated throughout Kent's installation. The *Herald* reported: "Each exhibitor has a length of twenty-five feet of wall or screen space on which to show the manifestations of his theory of what constitutes painting."[39] The *Lotus Magazine* noted: "There are some pictures [that] are mere freaks. . . . But there are others that will repay a visit—

Fig. 99
Catalogue pages
An Independent Exhibition of the Paintings and Drawings of Twelve Men at the Gallery of the Society of Beaux Arts Architects, New York, 1911
Special Collections, University of Delaware Library, Newark

Fig. 100
John Marin
Clouds and Mountains at Kufstein, 1910
Watercolor on paper
15½ × 18½ in. (394. × 47 cm)
Museum of Fine Arts, Boston;
The Hayden Collection—Charles Henry
Hayden Fund 61.1139

Fig. 101
John Marin
West Shore Docks, Weehawken,
New Jersey, 1910
Watercolor on ivory wove paper
(top, right and left edges trimmed),
laid down on white card
10⅞ × 8⁹⁄₁₆ in. (27.6 × 21.8 cm)
The Art Institute of Chicago;
Alfred Stieglitz Collection 1956.374

will induce you to carry one of the high stools that are placed here and there about the room, to points from which these pictures can best be viewed. They are worth the trouble."[40]

Signature Styles:

John Marin (1870–1953) and Maurice Prendergast (1858–1924)

Many of John Marin's watercolors had just been exhibited in his February 1911 one-artist show at 291 entitled *The Tyrol and Vicinity of New York*.[41] The 291 exhibition in tandem with Kent's Tent marked a critical turning point in the artist's career. Encouraged by Stieglitz, Marin was quickly moving from depictions of Swiss landscapes (Fig. 100), to oblique scenes of New York viewed from Weehawken, New Jersey (Fig. 101), to works devoted to the city itself. The late 1910 New York views were the forerunners to Marin's iconic 1912 renderings of the Woolworth Building skyscraper, his quintessential

modernist subject. Marin was exceptional among the contributors to Kent's Tent in that all his works were watercolors, a medium he was in the process of elevating, as Stieglitz was photography, to a status previously reserved for oil painting.

At fifty-two the oldest member of The Twelve, Maurice Prendergast, who resided in France from 1891 to 1894, had assimilated an array of influences, from Art Nouveau, Whistler, Vuillard, Bonnard, and Seurat to Matisse.[42] The cumulative effect of the long series of works he devoted to crowds promenading serenely in a park or by a sea devoid of drama was of a type of pure painting verging on abstraction where color, surface, pattern, and mark became nearly autonomous elements (Fig. 102).[43] The titles of the works he exhibited in Kent's Tent conveyed the abstract, contemplative nature of his art: *Taking the Air*, *On the Sands*, *By the Sea*, *Evening Promenade*.

Marin and Prendergast had both recently spent time in Paris: Prendergast for five months in 1907, and Marin from the fall of 1905 to the fall of 1910, when he returned to America shortly before the opening of Kent's Tent. By the time of their participation in The Twelve, each man's work had a distinctive facture that transcended their European influences and made their images instantly recognizable. Their styles were literally signature styles, defined in the case of Prendergast by dabs of staccato brushwork, and in Marin's by rapid, calligraphic applications of watercolor to paper.

The Realists:

George Luks (1867–1933), Homer Boss (1882–1956),

Glenn O. Coleman (1887–1932), and Guy Pène du Bois (1884–1958)

George Luks's entries included a number of his sympathetic depictions of outcasts on the streets of New York (Fig. 103).[44] Luks, who drew the popular comic strip *Hogan's Alley* featuring "The Yellow Kid," was an erratic, larger-than-life character who, despite his realist style, was prone to embellishing his own biography. He had not participated in Henri's Independents show in 1910 and felt no qualms about cutting ties with the National Academy. The critic for the *Evening Post* used Luks to illustrate the shifting relationship between conservative and radical styles among the Independents: "What strides 'independence' has made in the last few years is shown when one compares the paintings of George B. Luks, who only a short time ago was considered a terrible revolutionist, with those of Marsden Hartley and Alfred Maurer. One feels inclined to ask 'Que diable allait-il faire dans cette galerie?' ['What the devil is going on in this gallery?'] so conservative does his work appear compared with theirs."[45]

At the March 26 opening of The Twelve, Luks loudly regaled visitors with stories and managed to insult the show's financial sponsors before his wife intervened and directed Kent to escort him home.[46]

Fig. 102
Maurice Prendergast
Opal Sea, 1907–10
Oil on canvas
22 × 34⅛ in. (55.9 × 86.7 cm)
Terra Foundation for American Art,
Chicago; Daniel J. Terra Collection
1999.118

Fig. 103
George Luks
The Spielers, 1905
Oil on canvas
36¹⁄₁₆ × 26¼ in. (91.6 × 66.7 cm)
Addison Gallery of American Art,
Phillips Academy, Andover, MA;
Gift of anonymous donor 1931.9

Luks's life would end under tragic circumstances. On October 29, 1933, at the age of sixty-seven, he was found beaten to death on a New York street after a barroom brawl.

Homer Boss's relationship with Henri at the time of The Twelve was becoming as fraught as Kent's.[47] In June 1910, shortly after the first Independents show and before leaving for Europe, Henri had signed an agreement that deeded the Henri School of Art in the Lincoln Arcade building to his protégé.[48] In spring 1912, after Henri insisted that the school adopt the new color theory of Hardesty Maratta and Boss refused, Henri resigned from his teaching post, leaving Boss free to change the institution's name to, in keeping with the spirit of the times, the Independent School of Art.[49]

As one of The Twelve, Boss exhibited a number of striking full-length formal portraits (Fig. 104) that, like Henri's work, featured a

Fig. 104
Homer Boss
Young Woman in Black, c. 1910
Oil on canvas
74 × 35¾ in. (188 × 90.8 cm)
Chazen Museum of Art, University of
Wisconsin–Madison; Gift of Drs. Jon
and Susan Udell in memory of Suzanne
and Homer Boss 1978.18

dark tonal palette and painterly technique inspired by Whistler and Manet.[50] Both artists later shifted to a vibrantly colorful palette.[51] Boss's philosophy also was identical to Henri's: "Have no affiliations, conform to no dogma or creed of art."[52] Boss and Henri present yet another curious case of two figures who, while mirroring each other's styles and beliefs, nevertheless felt compelled to assert their independence from each other. The era's ethos fostered discord and rivalry as much as comradery and agreement. Following Kent's Tent, Boss went on to mentor the young American modernists Yasuo Kuniyoshi and Stuart Davis and became a founding member of the Society of Independent Artists in 1916 and the Modern Artists of America in 1921.[53]

Shortly before The Twelve, Glenn O. Coleman was quoted in an article entitled "An Artist of the New York Underworld": "These disguises of men and women, these curious shapes and forms, these shadows and masses of buildings are images always on my mind ... because they have this terrible energy of New York life."[54] Unlike the other varieties of urban realism practiced by Henri's students that were on view, Coleman's work, with its raw, folk art style, was not indebted to seventeenth-century Dutch or late nineteenth-century realist painting. Rather than being a flâneur observing the life of the city as it passed before him, Coleman lived and worked among the impoverished denizens of New York that he portrayed in his scenes of the Bowery, Chinatown, and Greenwich Village (Fig. 105). He used his early drawings, twelve of which were featured in the second Independents show, as the basis for a series of prints in 1928 titled *Lithographs of New York*.[55] Despite being actively collected and exhibited by Juliana Force and Gertrude Vanderbilt Whitney, Coleman always struggled to make a living and died in the early years of the Depression. Little known today, he is nonetheless a prime example of the type of minor/major, insider/outsider artist that characterized the early American modernist period.[56]

Guy Pène du Bois, an admirer of Coleman's work, had also fallen under the spell of realism that Henri cast at the New York School of Art.[57] In contrast to the grittier urban street scenes of Luks and Coleman, Pène du Bois explored the psychological states of mind of isolated figures cloistered in domestic interiors in ways that foreshadowed his mature style (Fig. 106).[58] These early interior scenes explored the predicament of being alone together that typified the American independent artists' movement and more generally, beginning in the late nineteenth century, expressed the alienation of modern life. Raised in an urbane, intellectual household in Brooklyn with family roots in the Creole culture of New Orleans, Pène du Bois was equally adept as artist and critic. His paintings and writings, including his memoir, *Artists Say the Silliest Things*, satirized the foibles of contemporary art and the upper reaches of society.[59]

Fig. 105
Glenn O. Coleman
Chinatown Balcony, 1910
Oil on canvas
25⅛ × 30⅛ in. (63.8 × 76.5 cm)
Whitney Museum of American Art,
New York; Gift of Henry Kaufman
99·73

Multiple Styles:
Marsden Hartley (1877–1943) and Alfred Maurer (1868–1932)

That a number of Marsden Hartley's works exhibited in Kent's Tent had been shown previously at 291 explains one reviewer's criticism: "When we saw Marsden Hartley's pictures a year ago at the Photo-Secession Galleries we believed he was striving for something that he might eventually reach. We fail to see in his paintings at the Independent exhibition that he has moved one step forward."[60]

Hartley's originality and range of expression, from the dark and somber to the colorful and vibrant, had recently attracted the attention of Stieglitz (Figs. 107, 108).[61] At his first one-artist show, at 291 in the spring of 1909, Hartley showed several Maine landscapes done in his early neo-impressionist style. These were inspired in part by the divisionist technique of the Swiss painter Giovanni Segantini, and had certain affinities with Prendergast's patterned brushwork. Yet even at this early stage of his career, Hartley was transcending these influences and was infusing his work with an expressionist current even before he had met Wassily Kandinsky and Franz Marc or experienced German Expressionism firsthand. In early 1911 at the time of The Twelve, Hartley was in something of a holding pattern as he made plans to leave for Europe the following year. Once there, after a stay in Paris, he would move on to Berlin, and embark upon the first in a long line of remarkable stylistic transformations that would mark the rest of his eclectic career.

Shortly before leaving for France in 1912, Hartley gave Rockwell Kent *Mountain Lake—Autumn.*[62] Once Hartley arrived in Paris he kept Kent informed about Picasso and Gertrude Stein and the avant-garde's latest modernist experiments in a series of detailed letters rivaled only by those he sent to Stieglitz.[63] In 1926, Kent donated Hartley's painting to the director of the first museum of modern art in America, Duncan Phillips.[64]

Alfred Maurer was still residing in Paris at the time of Kent's exhibition and only returned to America when World War I erupted in Europe in the fall of 1914.[65] The reviewers were well aware of the surprising evolution of Maurer's work (Figs. 109, 110): "[A few years ago] he was regarded by some as a possible inheritor of the black mantle of Whistler... today his work is the most astonishing still-life painting I have ever seen. These vases filled with flowers of Oriental brilliance and crudity of color, in which raw reds and vivid greens and blues are juxtaposed with each other against a background of luminous yellow, made everything else in the exhibition appear tame and pale."[66]

In contrast to the often derogatory assessments of Maurer's previous shows at 291, the reviews of his work in the 1911 Independents exhibition were insightful, a clear indication that the tide of critical opinion against Maurer and the more experimental forms of American

Fig. 106
Guy Pène du Bois
The Seamstress, 1913
Oil on canvas
24 × 18⅛ in. (61 × 46 cm)
Lehigh University Art Galleries
Teaching Museum, Bethlehem, PA

Fig. 107
Marsden Hartley
Mountain Lake—Autumn, c. 1910
Oil on academy board
12 × 12 in. (30.5 × 30.5 cm)
The Phillips Collection, Washington, DC;
Gift of Rockwell Kent, 1926

Fig. 108
Marsden Hartley
Deserted Farm, 1909
Oil on composition board
24 × 20 in. (61 × 50.8 cm)
Frederick R. Weisman Art Museum
at the University of Minnesota,
Minneapolis; Gift of Ione and
Hudson D. Walker 1961.2

Fig. 109
Alfred Maurer
Flowers in a Glass Vase, c. 1910
Oil on canvas
18 × 15 in. (45.7 × 38.1 cm)
Collection of Tommy and Gill LiPuma

Fig. 110
Alfred Maurer
The Iron Table, c. 1911
Oil on canvas
21 × 18 in. (53.3 × 45.7 cm)
Collection of Tommy and Gill LiPuma

modernism had begun to turn. No artist garnered more constructive attention, and it seemed that Maurer was in a position to emerge as the leading light of the American modernist movement.[67] Yet his career, like Hartley's and so many others in Europe, was disrupted by war. Maurer was forced to flee Paris just as Hartley would have to leave Berlin. Although Maurer, as Stacey Epstein has shown, would continue to produce innovative work in New York, neither he nor Hartley would ever be able to establish a stable, fully integrated artistic identity, a failure that ironically only compounds and confirms their status as modernists. The tragic dimension of American modernism was never more profoundly felt than when Maurer committed suicide in New York in 1932 during the early years of the Great Depression.

Multiple Roles:

Arthur B. Davies (1862–1928) and Rockwell Kent (1882–1971)

The two primary organizers of the Twelve, Rockwell Kent and Arthur B. Davies, not surprisingly had the two largest displays: fifteen paintings and fourteen drawings for Kent and sixteen oils and seven drawings for Davies. These multitalented men, while they had very different temperaments, were both well equipped to weather the vicissitudes of the modernist era.

Davies, with the high level of sustained support for his work provided by Lillie "Lizzie" Bliss beginning in 1909, was one of the most financially secure artists of his generation. As his own fortunes grew, he was able to provide fiscal backing for major displays like the first and second Independents exhibitions and the Armory Show, and quietly assisted individual artists in various ways, including purchas-

Fig. 111
Arthur B. Davies
Sleep Lies Perfect in Them, 1908
Oil on canvas
18⅛ × 40¹⁄₁₆ in. (46 × 101.8 cm)
Worcester Art Museum, MA;
Gift of Cornelius N. Bliss 1941.7

Fig. 112
Arthur B. Davies
Esmeralda, c. 1915
Oil on canvas
17⅛ × 22 in. (43.5 × 55.9 cm)
Huntington Museum of Art, WV;
Gift of Ruth Woods Dayton 1967.1.64

ing Maurer's work from 291.[68] Capable of playing multiple roles as impresario, patron, and artist, Davies possessed an uncanny ability to remain anonymous while wielding considerable influence. In fact, as indicated by Kent's first catalogue design—advertising The Eleven, not The Twelve—he at one point contemplated not being an exhibitor in favor of staying behind the scenes.[69] Davies's special standing in the art world was reflected in the critics' deference to his work (Fig. 111): "Arthur B. Davies . . . exercises his personal choices and moves toward his individual ideal with a freedom and originality that place him beyond analysis. . . . In the picture called 'And Sleep Lies Perfect in Them' he has perhaps come nearest to embodying an abstraction after the classic manner."[70]

In contrast to Davies's Arcadian dreamscapes (Fig. 112), Rockwell Kent presented an ambitious selection of bracing scenes of sea and snow set in northern climes in his more visceral, realist style (Fig. 113).[71] Unlike Davies's paintings, fueled as much by imagination as direct observation, Kent's were often painted outdoors and were

Fig. 113
Rockwell Kent
Snow Fields (Winter in the Berkshires),
1909
Oil on canvas
38 × 44 in. (96.5 × 111.7 cm)
Smithsonian American Art Museum,
Washington, DC; Bequest of Henry
Ward Ranger through the National
Academy of Design 1981.75

informed by deep knowledge of and active engagement with the sub-jects he depicted and the life-and-death challenges that were part and parcel of their working lives.

Despite their differences, the two men's personalities and styles proved to be complementary. While the forty-eight-year-old Davies preferred to work anonymously, the twenty-eight-year-old Kent, as we have seen, enjoyed public notoriety and fame. Their two displays also demonstrated a shared affinity for symbolist and philosophical allusions; a number of Kent's paintings, such as *Men and Mountains* (Fig. 114), with its classical Arcadian references, were indebted to Davies's art.

Just as his break with Henri had elevated his profile in the New York art world, the positive professional and artistic associations that Kent cultivated with the widely respected, well-established Davies

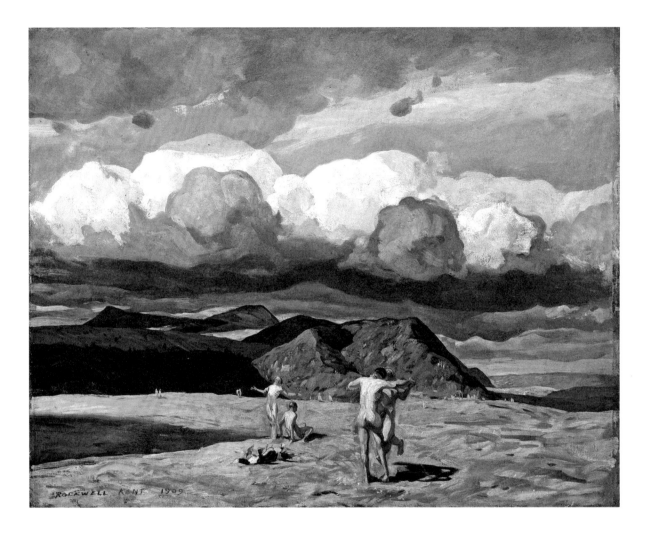

Fig. 114
Rockwell Kent
Men and Mountains, 1909
Oil on canvas
33 × 43¼ in. (83.8 × 109.9 cm)
Columbus Museum of Art, OH;
Gift of Ferdinand Howald 1931.190

served to further bolster his reputation. The influential critic James Huneker's review asserted: "The strong man among the younger generation (that knocks) is Rockwell Kent."[72] Soon after the close of The Twelve, Kent received substantial financial support from the Macbeth Galleries, where Davies and other members of The Eight had exhibited for years. Once launched, Kent, with such a formidable array of skills at his disposal and despite many challenges and controversies, would remain undeterred over the course of his long and remarkably productive career.

Missing in Action:

Julius Golz (1878–1965) and John McPherson (1885–1971)

Among the roll call of The Twelve are two figures who have been largely forgotten: Julius Golz and John McPherson. Both were Henri students and worked with Rockwell Kent on Monhegan Island in Maine. Kent and Golz established the Monhegan Summer School of Art for one season in 1910. The following summer, immediately after the close of The Twelve, McPherson and Homer Boss painted with Kent while renting one of the small houses that Kent had recently constructed on the island. Contemporary reviews describe in some detail a painting called *The White Horse* by Golz and compare McPherson to Prendergast, but their specific contributions to the show remain to be discovered.[73]

It is difficult to recapture the mercurial nature of the exhibition game. The history is as much about disconnections as it is about connections. Artists, oscillating back and forth between their individual predilections and group allegiances, coalesced, fell apart, and then regrouped in many different configurations with the one continually giving way to the many and the many regularly giving way to the one. The structure of exhibitions changed as organizers constantly recalibrated their formulas. Trying to "keep alive a spirit that should never die," as Davies put it, American modernist installations took myriad forms. In the case of The Twelve, Kent's aggressive self-promotion, the withdrawal of the core members of The Eight, and happenstance conspired to produce an innovative format: a hybrid of a small select group show like Henri's Eight and a massive omnibus exhibition like Henri's Independents show in 1910.

The Twelve denoted a completely new composite of three different previous alignments: The Eight, the group of Henri students known as The Fifteen, and an alliance of nine artists dubbed the *Younger American Painters* at 291 by Stieglitz in 1910. Just as Kent, by diverging from his mentor's exhibition philosophy, had distanced himself from Henri, so the other artists participating in The Twelve were determined to

no longer be defined narrowly by their relationship to Henri, to their peers, or to Stieglitz. Most contemporary artists consented to temporary affiliations but refused to be permanently associated with any one camp. All the various coalitions that arose at the time are, as their generic numeric titles indicate, better understood as loose, general alliances of individuals pursuing their own disparate paths and always subject to change. The Twelve was composed of fierce individualists who, as the earlier groupings crumbled, improvised a new kind of modernist gathering. Both Henri, a gifted and inspiring teacher, and Stieglitz, a passionate experimenter and gallerist, explicitly encouraged individuality, originality, and freedom of expression, so it should not be surprising to find that upon closer inspection The Twelve was not an entirely coherent collective. It was simply the latest regime.

Beyond their commentary on specific works or the contributions of individual artists to Kent's Tent, reviewers recognized the wider significance of The Twelve for the contemporary American art world. J. Nilsen Laurvik's analysis is worth quoting at length:

> The fact that at first glance this heterogeneous assemblage of insistent individualists is more than apt to get on one's nerves, only confirms my belief in the ultimate good to be derived from such a demonstration. There is a wholesome absence of subservience to any standard. Only in one particular do these twelve men agree; their intention to be uncompromisingly themselves is the tie that unites them. And herein lies the importance of this exhibition to American art. It is a protest against the intolerance that recognizes nothing save its own kith and kin. Whether as a whole or taken separately, the work shown here possesses any great intrinsic value is of little importance besides the idea promulgated, that art shall be free and untrammeled. That is what lends unusual significance to this exhibition.[74]

Frederick Gregg in the *Sun* further extolled the more anarchic art world that was emerging: "Art groups are breaking up in this town at present.... An excellent sign of life. Those who hate 'authority' will rejoice greatly.... The more 'insurrection' we have the better. Every man for himself and may the critics catch the hindmost!"[75]

Despite the positive press coverage lavished on The Twelve, only two works sold: Davies's *Refluent Season* (Fig. 115) and a Maurer still life (Fig. 110) to John Quinn.[76] The status of the American modernists and more practically their sources of income, were never secure.

END GAME

After 1911 the exhibition game continued to produce new formats at ad hoc venues that often made for strange bedfellows. The most significant event to follow on the heels of The Twelve was undoubtedly the famous Armory Show, where Henri and his concerns about the

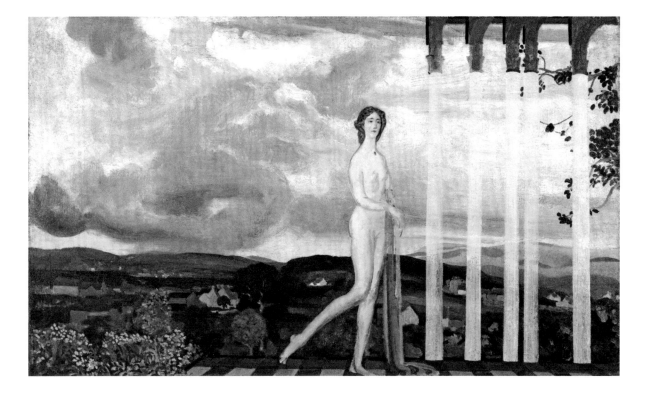

Fig. 115
Arthur B. Davies
Refluent Season, 1911
Oil on canvas
18 × 30 in. (45.7 × 76.2 cm)
Munson-Williams-Proctor Arts Institute,
Utica, NY; Museum Purchase 58.39

emphasis on European modernism—quite warranted, as it turned out—were kept at bay.[77] Stieglitz reveled in Henri's marginalization: "Sometimes the dead don't know they're dead...here's the point: What's the use of going on breeding little Chases [and] little Henris?"[78] Soon Stieglitz's younger, more daring associates Agnes Meyer, Marius de Zayas, and Francis Picabia were ridiculing his own acuity. They appropriated the 291 moniker for their experimental, large-format magazine where Picabia's famous portrait of Stieglitz as a camera with a broken bellows was published in 1915. That fall, de Zayas opened his own exhibition space as a rival to 291 and emphatically titled it the Modern Gallery. In 1916 the Forum Exhibition, a show devoted solely to American modernists, promoted the Synchromists led by their champion, Willard Huntington Wright, the brother of Stanton Macdonald-Wright. In 1917 the Independents realized their dream of an open, no jury/no prizes exhibition when the first Society of Independent Artists show was held. It was now the turn of Duchamp and the show's main sponsor, Walter Arensberg, to direct events. Just as Kent had struck directly at Henri's open-door policy with the Academy in 1911, so Duchamp and his co-conspirators, by submitting a urinal dubbed *Fountain* under the pseudonym R. Mutt, took advantage of the occasion to illuminate the limits of the central premise that lay at the core of the Independents movement, namely the right of anyone to show whatever they wanted. Kent was on the hanging committee with Bellows and Duchamp. He recalled: "And what a show it was! Good work, bad work, works of genius, trash.... The physical incarnation of the spirit of cultural independence, in its totality as a spectacle it showed itself a victim of the principle which it proudly fostered, innocently proclaiming by the all-over hideousness of its walls the incompatibility of individualism with social and aesthetic order."[79] After the show, Kent claimed to have "quit the independent movement."[80] Yet in June 1927 we still find him attacking the National Academy of Design, again because of their exclusionary policies, with a quixotic proposal for a permanent democratic institution devoted to living artists to be called the National Gallery of Contemporary Art.[81] Museums of contemporary art soon arose in New York under the directorship of Juliana Force and Alfred Barr. But neither Force nor Barr, although they both embarked on eclectic, wide-ranging exhibition programs, would ever be able to fully satisfy the demands of a growing army of contemporary artists who, even if they were shown at Force's Whitney or Barr's MoMA, would, as true modernists, still often feel aggrieved and excluded.

Two of the last attempts to conclude the American exhibition game came at mid-century in the guise of Clement Greenberg's art criticism and Milton Brown's art history. Both men produced remarkably authoritative intellectual frameworks that brought order to the chaos and fluidity of American modernism. Brown did this by deval-

uing American modernism and, indeed, American art in general by characterizing it as decidedly second-rate and derivative of European models.[82] Subordinating everything that had come before, including the efforts of the early American modernists, Greenberg created a teleological model that culminated with American abstraction and what Irving Sandler would later dub the triumph of American painting.[83] These efforts, however, proved to be just temporary gambits in the never-ending American modernist game, simply the latest in a long line of claims for attention and primacy that bear comparison to the ploys of Kent, Stieglitz, Duchamp, and even to the role of the National Academy itself early in the century. Throughout the twentieth century various attempts to "return to order" always met with resistance. In the case of Clement Greenberg, Willem de Kooning protested, "Order to me, is to be ordered about and that is a limitation."[84] Later Philip Guston, an artist who was constantly negotiating the numerous byways and dead ends of the treacherous modernist terrain, became cognizant of "something ridiculous and miserly in the myth we inherit from abstract art" and declared himself "sick and tired of all that purity."[85]

The logic of Greenberg's theory and Brown's historical analysis effectively cut the history of American modernism off from the messy contentiousness and humanity and the fleeting contingencies that for better and worse defined it. Kent, Henri, Stieglitz, and Duchamp, and later Benton and many others, giving no quarter, were constantly clashing over what was modernist, what was American. These questions, by design and tacit consent, were never to be resolved and always left open for debate. If there were profound disagreements among the various players, there was also a shared understanding that everyone has a right to get and stay in the game, and that, at all costs, the game must go on. The price of participation was to live with the ambiguities and disarray that the exhibition game unleashed. Along with the exhilaration of the freedom of expression afforded by open democratic forums came pervasive doubts about personal identity and status—where exactly one stood in relation to one's peers. This was especially true as the rules of the game shifted and notions of what was and was not modernist became more and more elusive. These uncertainties could at times overwhelm individuals and lead to alienation and estrangement. Buffeted by modernism's contradictory impulses, insecurities ran deep. For every artist who made it through intact, like Kent, Marin, Davies, or O'Keeffe, there were others like Luks, Maurer, or Patrick Henry Bruce, and even Stieglitz himself who met troubling ends. American modernism was as much about failure as success, as much tragedy as triumph.

Studying events like Rockwell Kent's The Twelve teaches us that while recognizing the early twentieth century as a time when art groups were coalescing, as JoAnne Mancini has argued, it is equally important to understand it as a time when art groups were "breaking

up," a moment tenuously oscillating between a tentative new social reordering and the vociferous claims of independent individuals; an era when every new order proved to be no order at all.[86] If we begin with Virginia Woolf's famous claim that "on or about December 1910 human character changed," then, as the constant give and take of the American exhibition game demonstrates, it can be asserted that it has never stopped changing.[87] Or alternately, to assume a contemporary critic's proposition as our starting point, we might take up Jerry Saltz's provocative suggestion that modernism "never really happened in America" by considering whether something that never truly ended can be said to have actually occurred.[88] From the early twentieth century into the early twenty-first century, with every round, every inning, every throw of the dice, the American art world has continuously formed and reformed itself into new provisional configurations. From The Eight, to The Fifteen, to The Twelve, to Stieglitz's Seven Americans "Six plus X," to the Regionalist Triumvirate, to the Abstract Expressionists and beyond, the exhibition game has played on.

I would like to thank Frank Buscaglia and Jorge Santis of the Sansom Foundation for the invitation to deliver the 2015 C. Richard Hilker lecture at the New-York Historical Society. Thank you also to my colleagues Avis Berman, Carol Troyen, Nancy Anderson, and Frank Kelly for their support. Finally, a special thanks to Rockwell Kent scholar Scott R. Ferris for generously sharing his research file of contemporary reviews of Kent's Tent with me.

NOTES

1. Sloan used the phrase on a number of occasions. In his March 9, 1910, diary entry he wrote of how the National Academy of Design jury had "cut me off from the exhibition game" and in his January 12, 1911, entry used the term in relation to Kent's upcoming Independent exhibition. See Bruce St. John, ed., *John Sloan's New York Scene: From the Diaries, Notes and Correspondence 1906–1913* (New York: Harper and Row, 1965), 396, 496.

2. *Exhibition of Paintings by Arthur B. Davies, William J. Glackens, Robert Henri, Ernest Lawson, George Luks, Maurice B. Prendergast, Everett Shinn, John Sloan* (New York: Macbeth Galleries, February 3–15, 1908); Judith Zilczer, "The Eight on Tour, 1908–1909," *American Art Journal* 16, no. 3 (Summer 1984), 20–48; William Innes Homer, *Alfred Stieglitz and the American Avant-Garde* (Boston: New York Graphic Society, 1977); Sarah Greenough et al., *Modern Art and America: Alfred Stieglitz and His New York Galleries* (Washington, DC: National Gallery of Art; Boston: Bulfinch, 2001).

3. Allan Antliff, *Anarchist Modernism: Art, Politics, and the First American Avant-garde* (Chicago: University of Chicago Press, 2001).

4. Quoted in Avis Berman, *Rebels on Eighth Street: Juliana Force and the Whitney Museum of American Art* (New York: Atheneum, 1990), 5, citing *Juliana Force and American Art: A Memorial Exhibition* (New York: Whitney Museum of American Art, 1949), 34.

5. Quoted in Greenough et al., *Modern Art and America*, 15.

6. The composition of The Fifteen is recorded in "The Fifteen," *American Art Annual* 8 (1911), 185: "A group of fifteen young painters, who held their first exhibition during the winter of 1907, meet on Thursday evenings at the studio of Homer Boss, 1947 Broadway. The sixteen men who exhibited as "The Fifteen" are: Rockwell Kent, Julius Golz, John Koopman, Arnold Friedman, Karl [Carl] Sprinchorn, L. T. Dresser, George Bellows, Prosper Inverniggi [Invernizzi], Edward Hopper, Glen [Glenn] O. Coleman, Edward Keef [Keefe], G. L. Williams, Harry R. Dougherty, Walter Pach, Guy du Bois, and Homer Boss." The Twelfth exhibitor was John McPherson.

7. On Henri see William Innes Homer, with the assistance of Violet Organ, *Robert Henri and His Circle* (Ithaca, NY, and London: Cornell University Press, 1969); Bennard B. Perlman, *Robert Henri: His Life and Art* (New York: Dover, 1991). Also see Kimberly Orcutt, *Painterly Controversy: William Merritt Chase and Robert Henri* (Greenwich, CT: Bruce Museum, 2007).

8. On Sloan see John Sloan, *Gist of Art: Principles and Practise Expounded in the Classroom and Studio* (New York: American Artists Group, 1939); John Loughery, *John Sloan: Painter and Rebel* (New York: Henry Holt, 1995). In *Gist of Art* (32), Sloan commented: "I am keenly alive to the importance of ultra-modern art. . . . through Picasso and Braque."

9. On Davies see Bennard B. Perlman, *The Lives, Loves, and Art of Arthur B. Davies* (Albany: State University of New York Press, 1998). For a recent insightful study of Davies, also see Robin Veder, *The Living Line: Modern Art and the Economy of Energy* (Hanover, NH: Dartmouth College Press, 2015).

10. On Kent see Richard V. West, Fridolf Johnson, and Dan Burne Jones, *"An Enkindled Eye": The Paintings of Rockwell* Kent (Santa Barbara, CA: Santa Barbara Museum of Art, 1985); Jake Milgram Wien, *Rockwell Kent: The Mythic and the Modern* (Manchester, VT, and New York: Hudson Hills, 2005).

11. *Catalogue, Exhibition of Independent Artists, From April 1st to 27th 1910, Galleries, 29–31 West Thirty-Fifth St., N.Y; The Fiftieth Anniversary of the Exhibition of Independent Artists in 1910* (Wilmington: Delaware Art Center, 1960).

12. Robert Henri, "The New York Exhibition of Independent Artists," *Craftsman* 18, no. 2 (May 1910): 160.

13. Ibid., 160, 161, 170.

14. Ibid., 162.

15. Rockwell Kent, *It's Me O Lord: The Autobiography of Rockwell Kent* (New York: Dodd, Mead, 1955), 219, 226.

16. Ibid., 227.

17. Ibid., 226.

18. Ibid., 227.

19. Ibid.

20. As Perlman, *Lives, Loves, and Art of Arthur B. Davies* (195–97) recounts, Henri did in fact respond by organizing an exhibition at the conservative Union League Club with the surprising support of the chairman of the League, Harry W. Watrous, from April 13 to 15. In addition to The Eight, the participants included Walt Kuhn, Max Weber, George Bellows, James and May Wilson Preston, Edith Glackens, and Kent himself, who exhibited a painting with the rather pointed title *Burial of a Young Man* to wide acclaim. One commentator in "Around the Galleries," *New York Sun*, April 18, 1911, remarked: "This is the third and last of the series of League exhibitions this season; otherwise there would be nothing left but to fetch uptown from Mr. Stieglitz's Little Photo-Secession Galleries the appalling Senor Pablo Picasso."

21. Kent, *It's Me O Lord*, 227.

22. Ibid.

23. Ibid.

24. Ibid., 227–28.

25. Ibid., 228.

26. Ibid.

27. Ibid.

28. On the letters and diaries see St. John, *Sloan's New York Scene*; Bennard B. Perlman, ed., *Revolutionaries of Realism: The Letters of John Sloan and Robert Henri* (Princeton, NJ: Princeton University Press, 1997).

29. On Davies's travels in Europe see Perlman, *Lives, Loves, and Art of Arthur B. Davies*, 186–88.

30. Sloan, diary entry, in St. John, *Sloan's New York Scene*, 496.

31. Ibid., 506.

32. Rockwell Kent Papers, Archives of American Art, Smithsonian Institution, Alphabetical Files: Gallery of the Society of Beaux-Arts Architects, microfilm reel 5185, frames 41–43.

33. Quoted in Perlman, *Revolutionaries of Realism*, 205.

34. Quoted in Perlman, *Lives, Loves, and Art of Arthur B. Davies*, 193.

35. Kent, *It's Me O Lord*, 232.

36. Quoted in Loughery, *Sloan: Painter and Rebel*, 189.

37. See Peter Hastings Falk, ed., *The Annual Exhibition Record of the National Academy of Design, 1901–1950: Incorporating the Annual Exhibitions, 1901–1950, and the Winter Exhibitions, 1906–1932* (Madison, CT: Sound View, 1990).

38. Conspicuously missing from Kent's exhibition of "Twelve Men" were, of course,

women artists. This was in stark contrast to Henri's much larger first *Exhibition of Independent Artists* in 1910, where almost one third of the exhibitors were women. See Marian Wardle, ed., *American Women Artists: The Legacy of Robert Henri, 1910–1945* (New Brunswick, NJ, and London: Rutgers University Press, 2005).

39. "Paintings Shown by 'Insurgents,'" *New York Herald*, undated clipping [March/April 1911].

40. "The Independent Exhibition," *Lotus Magazine* 2, no. 4 (April 1911), 117. The show received an enormous amount of press coverage in New York and elsewhere. In addition to the *New York Herald* and *Lotus Magazine*, reviews and notices appeared in the *New York Evening Post*, *Boston Evening Transcript*, *New York Times*, *Philadelphia Inquirer*, *Brooklyn Standard Union*, *Vogue*, *New York World*, *Providence Journal*, *Arts and Decoration*, and *New York Evening Mail*.

41. On Marin see Ruth Fine, *John Marin* (Washington, DC: National Gallery of Art; New York: Abbeville, 1990); Martha Tedeschi with Kristi Dahm et al., *John Marin's Watercolors: A Medium for Modernism* (Chicago: The Art Institute of Chicago; New Haven and London: Yale University Press, 2010). The two works reproduced here represent the type of works shown by Marin. It is not possible to identify the exact watercolors on view based solely on the titles.

42. On Prendergast see Carol Clark, Nancy Mowll Mathews, and Gwendolyn Owens, *Maurice Brazil Prendergast, Charles Prendergast: A Catalogue Raisonné* (Williamstown, MA: Williams College Museum of Art; Munich: Prestel, 1990).

43. Although there are many possibilities based on titles and other evidence, *Opal Sea*, c. 1907–10, in the Daniel J. Terra Collection, Terra Foundation for American Art, Chicago, is the only work that has been positively identified and documented as having been exhibited in Kent's Tent. See cat. nos. 120, 1950, 1996, and 2193, Clark, Mathews, and Owens, *Maurice Brazil Prendergast, Charles Prendergast*, 238, 653, 655, 664.

44. On Luks see Elisabeth Luther Cary, *George Luks* (New York: Whitney Museum of American Art, 1931); *Catalog of an Exhibition of the Work of George Benjamin Luks: Newark, New Jersey, October 30 to January 6, 1934* (Newark, NJ: The Newark Museum, 1934); *George Luks, 1866–1933: An Exhibition of Paintings and Drawings Dating from 1889–1931* (Utica, NY: Munson-Williams-Proctor Institute, 1973). A number of the works shown by Luks and now in private collections have been identified as having been on view, including *Cats* (cat. 2), *The Guitar* (cat. 7), *Little Milliner* (cat. 11), and *Little Grey Girl* (cat. 14).

45. [Frank Jewett Mather], "Art Notes," *New York Evening Post*, March 25, 1911.

46. This is recounted at length in Kent, *It's Me O Lord*, 229–32.

47. On Boss see Susan Udell, *Homer Boss: The Figure and the Land* (Madison, WI: Elvehjem Museum of Art, 1994). Also Carol Lowrey's discussion of Boss in *A Legacy of Art: Paintings and Sculptures by Artist Life Members of the National Arts Club* (New York and Manchester, VT: Hudson Hills, 2007), 56–57.

48. Udell, *Homer Boss*, 12, 37.

49. Ibid., 16.

50. *Prosper Invernizzi* (cat. 3) is reproduced in Udell, *Homer Boss*, 11.

51. Compare for instance *Young Woman in Pink Shawl* (private collection), by Boss, reproduced in Udell, *Homer Boss*, 46, and Robert Henri's *Indian Girl in White Blanket* (National Gallery of Art, Washington, DC; Corcoran Collection).

52. Quoted in Udell, *Homer Boss*, 18.

53. Udell, *Homer Boss*, 21–24.

54. "Quoted in "An Artist of the New York Underworld," *Current Literature* 48 (March 1910): 330.

55. Many of the c. 1910 works by Coleman now in the collection of the Whitney Museum of American Art may have been on view. Their subjects, if not their

exact titles, correspond with the range of works referenced in the 1911 catalogue. *Street Scene, Chinatown* (Philadelphia Museum of Art) is another possibility.

56. On Coleman see C. Adolph Glassgold, *Glenn O. Coleman* (New York: Whitney Museum of American Art, 1932); Douglas A. Fairfield, "Forces of Modernism in the Work of Glenn O. Coleman" (PhD diss., University of New Mexico, 1997).

57. On Pène du Bois see Betsy Fahlman, *Guy Pène du Bois: Artist about Town* (Washington, DC: Corcoran Gallery of Art, 1980); Betsy Fahlman, *Guy Pène du Bois: Painter of Modern Life* (New York: James Graham & Sons, 2004).

58. In addition to *The Seamstress*, another possibility for the work on view titled *Girl Sewing* is *Interior* (private collection).

59. Guy Pène du Bois, *Artists Say the Silliest Things* (New York: American Artists Group, 1940).

60. [Mather], "Art Notes."

61. On Hartley see Townsend Ludington, *Marsden Hartley: The Biography of an American Artist* (Boston: Little, Brown, 1992); Gail R. Scott, *Marsden Hartley* (New York: Abbeville, 1988). Also see Marsden Hartley, *Somehow a Past: The Autobiography of Marsden Hartley*, ed. Susan Elizabeth Ryan (Cambridge, MA: MIT Press, 1997).

62. Other works that were likely on view include two works at the Frederick R. Weismann Art Museum, University of Minnesota, Minneapolis, both titled *Autumn* (1908).

63. See James Timothy Voorhies, ed., *My Dear Stieglitz: Letters of Marsden Hartley and Alfred Stieglitz, 1912–1915* (Columbia: University of South Carolina Press, 2002). The Hartley-Kent letters are in the Rockwell Kent Papers, Archives of American Art, Smithsonian Institution, Alphabetical Files: Hartley, Marsden, microfilm reel 5189, frames 1235–83.

64. See the entry on the Hartley painting in Erika D. Passantino, ed., *The Eye of Duncan Phillips: A Collection in the Making* (Washington, DC: The Phillips Collection; New Haven: Yale University Press, 1999), 389–90.

65. On Maurer see Stacey B. Epstein, *Alfred Maurer: At the Vanguard of Modernism* (Andover, MA: Addison Gallery of American Art; New Haven and London: Yale University Press, 2015).

66. [J. Nilsen Laurvik], "An Independent Exhibition," *Boston Evening Transcript*, undated clipping [March/April 1911]. *The Iron Table* has been documented as being on view in Epstein, *Alfred Maurer*. Epstein reproduces as well several c. 1910 still lifes that may also have been shown.

67. For example, see the comments on Maurer in "Interesting Examples of the Work of Twelve Painters in the Independent Exhibition at the Beaux Arts Gallery," *New York Times*, April 2, 1911, 59: "Alfred Maurer . . . obeys an intellectual formula which in itself and as a matter of theory is extremely interesting. . . . In one instance only does Mr. Maurer seem to have worked with adequate freedom of personal vision. A group of flowers in which may be distinguished pale hydrangeas and vivid bleeding-hearts is a beautiful generalization of flower forms and color which stops this side of pure abstraction and stirs the imagination with memories of particular blossoms. Maurer, who goes back to Matisse, who goes back to Cezanne, who goes back to Diogenes, searching for an honest thing in a world of subterfuge, is working along lines that have ample psychological and scientific explanation. . . . A rose so painted that it may be recognized by one person who has seen that particular rose by idiosyncrasies of its shape and color does not represent as a development of art as a rose painted synthetically in such a way as to make the rose form and rose color appeal to a wide public who may see in it the essential character of myriads of blossoms. To impose details that restrict the abstract impression is, theoretically, to limit and minimize the aesthetic effect."

68. Epstein, *Alfred Maurer*, 123. Also see Judith Zilczer, "Arthur B. Davies: The Artist as Patron," *American Art Journal* 19 (Summer 1987), 54–83.

69. This earlier version of the catalogue is reproduced in Kent, *It's Me O Lord*, 233.

70. "Interesting Examples of the Work of Twelve Painters," 59.

71. Among the works on view by Kent were *The Seiners* (cat. 2; Hirshhorn Museum and Sculpture Garden, Washington, DC), *Down to the Sea* (cat. 3; Brooklyn Museum), *Snow Fields* (cat. 6; Smithsonian Museum of American Art, Washington, DC), and *Men and Mountains* (cat 8; Columbus Museum).

72. [James G. Huneker], *New York Sun*, undated clipping [March/April 1911].

73. The painting by Golz was described in detail in "The Independent Exhibition," *Lotus Magazine*, 119: "The White Horse by Julius Goltz [*sic*] is a good picture. You see the head and part of the body of the animal over the edge of the hill up which it struggles with its load. The houses beyond are those of a harbor. The canvas would smack of the sea even without the tops of the tall masts in perspective."

74. [Laurvik], "An Independent Exhibition."

75. F.J.G. [Frederick James Gregg], "The Boss in Art," *New York Evening Sun*, March 23, 1911, quoted in Perlman, *Lives, Loves, and Art of Arthur B. Davies*, 201.

76. See Perlman, *Lives, Loves, and Art of Arthur B. Davies*, 195.

77. For a recent study of the Armory Show, see Marilyn Satin Kushner and Kimberly Orcutt, eds., *The Armory Show at 100: Modernism and Revolution* (New York: New-York Historical Society, 2013).

78. Alfred Stieglitz, "The First Great 'Clinic to Revitalize Art,'" *New York American*, January 26, 1913, 5CE.

79. Kent, *It's Me O Lord*, 315–16.

80. Ibid., 316.

81. This episode is discussed in Wien, *Rockwell Kent*, 21. See also "The National Gallery of Contemporary Art," in Rockwell Kent and Carl Zigrosser, *Rockwellkentiana* (New York: Harcourt, Brace, 1933), 37–38.

82. See Milton W. Brown, *American Painting from the Armory Show to the Depression* (Princeton, NJ: Princeton University Press, 1955).

83. The literature on Greenberg is voluminous. Among recent studies are Thierry de Duve, *Clement Greenberg between the Lines* (Chicago: University of Chicago Press, 2010); Alice Goldfarb Marquis, *Art Czar: The Rise and Fall of Clement Greenberg* (Boston: MFA Publications, 2006); Caroline Jones, *Eyesight Alone: Clement Greenberg's Modernism and the Bureaucratization of the Senses* (Chicago: University of Chicago Press, 2005).

84. Willem de Kooning, "A Desperate View," talk delivered at the Subjects of the Artist School, New York, February 18, 1949, published in Thomas B. Hess, *Willem de Kooning* (New York: Museum of Modern Art, 1968), 15.

85. Transcript of the panel held at the Philadelphia Museum School of Art, March 1960, as quoted in Clifford Ross, ed., *Abstract Expressionism: Creators and Critics* (New York: Abrams, 1990), 61; and David Anfam, *Abstract Expressionism* (London: Thames and Hudson, 1990), 207.

86. JoAnne Marie Mancini, *Pre-modernism: Art-world Change and American Culture from the Civil War to the Armory Show* (Princeton, NJ: Princeton University Press, 2005).

87. Virginia Woolf, *Mr. Bennett and Mrs. Brown* (London: L. and Virginia Woolf, 1924).

88. Jerry Saltz and David Wallace-Wells, "Jerry Saltz: Does the New Whitney Show That Modernism Never Really Happened in America?" *Vulture*, May 4, 2015, http://www.vulture.com/2015/05/saltz-did-modernism-even-happen-in-america.html.

NEW PERSPECTIVES ON WILLIAM GLACKENS

Exploring the career and legacy of the artist

A symposium held on

November 8, 2014

The Barnes Foundation

Philadelphia

Introduction

William Glackens, the first major survey of the artist's work in nearly fifty years, opened at the Nova Southeastern University's Museum of Art | Fort Lauderdale (now NSU Art Museum Fort Lauderdale) in February 2014. It then traveled to the Parrish Art Museum in Water Mill, New York, and the Barnes Foundation in Philadelphia. As curator of *William Glackens*, I had always intended to schedule a scholarly symposium organized as a public event during the tour of the exhibition. We could then celebrate the artist's achievements through a thoughtful exchange of ideas, made possible only after all the paintings, drawings, prints, and other works on paper assembled for the show had been seen and enjoyed as a whole.

My colleagues at the Parrish Art Museum and the Barnes Foundation and I decided that the best place to host this event would be the Barnes Foundation, home to an incomparable collection of American and European art that Glackens himself was instrumental in forming and that had recently relocated to Philadelphia, the city of his birth. The tireless Barnes staff and I began to plan "New Perspectives on William Glackens," for which participants would be invited to explore lesser-known aspects of this important American modernist's milieu.

It was my great pleasure to organize the symposium "New Perspectives on William Glackens," which took place on November 8, 2014. The eminent art historians who spoke that day gave authoritative presentations supplementing the research and insights introduced in the catalogue that accompanied the Glackens exhibition. Sylvia Yount detailed the cultural environment of late-nineteenth-century Philadelphia, and Carol Troyen analyzed Glackens's development as a modern artist, especially during his *annus mirabilis* of 1910. I am especially gratified that their expansion of their lectures into these essays resulted in even more rigorous meditations on Glackens's life and career. Moreover, the occasion gave me the opportunity to focus on the life, work, and influence of Glackens's extraordinary spouse, the artist Edith Dimock.

The symposium would not have become a reality without the generosity of the Sansom Foundation, which sponsored the event with unstinting enthusiasm. Their participation has its roots in the lifelong friendship between Albert C. Barnes and Glackens, whose son, Ira, and his wife, Nancy, created the Sansom Foundation. The Barnes Foundation kindly agreed with the Sansom Foundation that the symposium contributions to Glackens studies should be published and made available to scholars in this second volume of *The World of William Glackens*. Ira Glackens, whose own writings provide invaluable information about his father, would have welcomed these additions to the canon.

Avis Berman

Brotherly Love and Fellowship: Glackens's Formative Years

SYLVIA YOUNT

The city of Philadelphia offered a richly creative and nurturing environment for the young, ambitious artist William Glackens to develop a distinctive modernist sensibility. Born in West Philadelphia in 1870, Glackens was just six years old when the City of Brotherly Love experienced a cultural renaissance of sorts, occasioned by the advent of America's first world's fair—the Centennial International Exhibition—held in Fairmount Park from May 10 to November 10, 1876. In the lead-up to this transformative event commemorating the one hundredth anniversary of America's independence, the city's elders embarked on various infrastructure projects to prepare for the visiting millions, taking advantage of the international attention to also improve some of its historic sites and institutions.

The Pennsylvania Academy of the Fine Arts, founded in 1805 as the young nation's first art school and museum, was one such organization to benefit from this increased cultural activity. After a closure of six years, the Academy inaugurated its spectacularly modern new building—designed by Philadelphia's own idiosyncratic architect Frank Furness and his partner George Hewitt—in April 1876, just a few weeks before the opening of the exposition.[1]

As the nation's first capital, Philadelphia became an important center of enlightenment thinking in late eighteenth-century America, and continued to be celebrated internationally for its prestigious institutions of learning. That Glackens attended two of the city's finest—Central High School and the Pennsylvania Academy—speaks to his precocious talents and good fortune. Clever, affable, handsome, with a sociable nature that easily drew friends and admirers, Glackens (nicknamed "Butts") developed close, lifelong ties at Central, where his classmates included Albert C. Barnes as well as his future Ashcan colleague John Sloan. A preparatory school with a rigorous curriculum in math and science, Central, among the oldest continuing public schools in America and the only one with the authority to confer bachelor of arts degrees, also required four years of drawing. This core requirement—

Fig. 116
Pennsylvania Academy of the Fine Arts Composition Class, c. 1893
Archival photograph
Collection of Alma Gilbert, courtesy of the Pennsylvania Academy of the Fine Arts, Philadelphia

inaugurated by the school's first drawing instructor, the illustrious Rembrandt Peale, second son of the renaissance figure Charles Willson Peale and official painter of George Washington—helped shape the drafting talents and techniques of later nineteenth-century painters who would also establish deep roots at the Academy, among them Thomas Eakins and William Trost Richards.[2] Similarly, Central nurtured the more progressive approaches of Glackens and Sloan decades on.

By all accounts, Glackens thrived at Central, which he attended from 1884 to 1890, and where he actively participated in a wide range of student activities—playing baseball (an early passion he shared with Barnes) and contributing caricatures to the school's magazine. Sloan later recounted how Glackens and his elder brother Louis, also skilled at drawing, would entertain classmates for hours with their humorous and spontaneous sketching. Calling William "certainly the greatest draughtsman who lived this side of the ocean," Sloan particularly admired his "ability to bring back mentally what was an emotional state," a key feature of the exaggerated art of caricature.[3]

Such accolades call to mind another native Philadelphian with a precocious wit, infectious personality, and preternatural drawing talent, one who would later be a part of Glackens's social circle at the Pennsylvania Academy—Maxfield Parrish.[4] Both men developed their artistic talents through caricature and illustration as students: Parrish decorated his Haverford College chemistry notebook and produced an illustrated perspective manual at the Academy, while Glackens apparently illustrated a mathematics textbook and contributed drawings to a dictionary at Central. And both began their professional careers as successful illustrators before turning to easel painting. Different mentors and influences—Howard Pyle's historical fantasies for Parrish, Robert Henri's scenes of modern urban life for Glackens—eventually set them on divergent paths, but the fertile ground of the Pennsylvania Academy in the 1890s nourished and inspired them both.

Due to its venerable history and national profile, the Academy served as the locus of activity in late nineteenth-century Philadelphia's dynamic art world. The demanding curriculum initiated in the mid-1870s by Thomas Eakins (the institution's most infamous son) following his return from France, where he trained at the École des Beaux-Arts, was expanded by his successors in the late 1880s and 1890s.

As assistant professor of painting and instructor in anatomy, Eakins offered his pupils what was then a radical course of study. The "revolutionary" nature of his method, as William C. Brownell termed it in an important 1879 *Scribner's Monthly* article on "The Art Schools of Philadelphia," resided in Eakins's insistence on an early introduction to painting from the nude model and his discouragement of prolonged study of the antique.[5] This approach inverted the standard academic practice that required students to master drawing from plaster casts—to perfect the line—before advancing to life class and its attendant

exploration of form and color. Instead, Eakins wanted his students to learn to "draw with color." His teaching method was further distinguished by its so-called scientific study of the human figure, which mandated dissection classes for advanced students and anatomy lectures for all. Many students admired the artist's dedication to a realist aesthetic, but found his scientific approach too rigid and sought a more diversified form of instruction. In 1886, Eakins's emphasis on anatomical expertise and fearless dedication to nude studies would contribute to his dismissal from his Academy position, suggesting that the moral and aesthetic climate in Philadelphia was still evolving.

Under the succeeding direction of artists such as Thomas Hovenden and Thomas Anshutz, Eakins's method was tempered with a more conservative adherence to traditional academic practice. Glackens would attend classes at the Academy from 1891 through 1894, studying with, among others, Anshutz, whose work reveals how American artists in the 1890s were selectively absorbing the lessons of French Impressionism as well as tonalism. This approach would prove critical to Glackens's developing aesthetic.

Indeed, by the end of the decade the Academy's faculty was wholly composed of European-trained artists, from Eakins's contemporary William Merritt Chase to younger painters such as Robert Vonnoh and Cecilia Beaux, each of whom encouraged students to explore new stylistic techniques and subject matter—in genres from portraiture and figure painting, still life and plein-air landscapes, to illustration and "decoration," that is, mural painting.

Besides teaching Glackens and Sloan, Anshutz encouraged the early work of avant-garde modernists such as Arthur B. Carles, Charles Demuth, John Marin, Morton Schamberg, and Charles Sheeler, many of whom also studied with Chase.[6] Parrish and Glackens took classes with Anshutz and Vonnoh, as well as with Carl Newman, a budding modernist known for his experimentation with color, and with Henry Thouron, the Academy's beloved composition instructor. This eclectic group of teachers gave the two young men a solid foundation in both traditional and more progressive approaches to artmaking that shaped their future production. They likely also benefited from the many special lectures offered by the Academy—especially those on the history and current practice of illustration by W. Lewis Fraser, former art director of the *Century* magazine.

Even more than their studies, however, the rich social network of Academy classmates and the myriad experiences this fellowship inspired made a lasting impression on Parrish and Glackens. Their circle at the Academy (Fig. 116) included a number of women and men who went on to excel as artist-illustrators in turn-of-the-century America, including Florence Scovel, who would subsequently marry Everett Shinn, and James Preston, later associated with the Pennsylvania Post-Impressionists.

There is no question that Glackens's future as a "fine" artist was considerably influenced by his concurrent experiences on Philadelphia newspapers, where he, Sloan, Shinn, and George Luks worked as artist-reporters before the advent of staff photographers. This professional training—with its emphasis on human interest, topicality, spontaneity, and quickness of perception and production—determined his particular mode of realism in both style and subject matter. Throughout Glackens's career, he retained the speedy execution required of a sketch-reporter, and continued to employ what Shinn called his amazing memory in his illustrations as well as paintings.[7] That this on-the-job practice was sometimes at odds with the more traditional cast and life-drawing classes he attended at the Academy was among the factors that helped direct Glackens away from formal artistic training. Another was a life-changing encounter with an older Academy alumnus, Robert Henri.

Glackens's 1892 introduction to Henri, freshly returned from Paris with exciting news of modern art by the likes of Édouard Manet and James McNeill Whistler, led him to question rigid academic practice as Henri encouraged the young sketch artists to experiment with painting and embrace an untutored "art spirit."[8] Glackens's first known oil on canvas, *Philadelphia Landscape* of 1893 (Fig. 117), dates from soon after he met Henri, and reveals not only his mentor's influence in its direct painting and tonal palette, but also the larger shadows of Manet and Whistler—two touchstones for Glackens in his growth as a painter.[9]

Glackens and Sloan met the charismatic Henri at a studio party given by Academy alumnus and teacher of sculpture Charles Grafly to mark Henri's return from France. Soon they were attending Henri's weekly open houses, held at his Walnut Street studio, signaling a migration of male artistic fellowship from the Academy's classrooms to private spaces and club life. Both Glackens and Sloan were members of the short-lived, student-run Charcoal Club, and at various times shared studio space with Henri.[10]

The cross-fertilization between the academic establishment and its alternatives continued through spirited conversations, art appreciation, amateur theatrics, and other amusements. Henri's legendary studio burlesques, for example, prompted the Academy's 1894 student theatrical presentation of *Twillbe*, a parody of George du Maurier's wildly popular novel of Parisian bohemia, *Trilby*, which was being published serially in *Harper's Monthly*. Henri, Glackens, Shinn, and Sloan all had leading roles in the inspired Academy production, with Sloan creating the cover image for the program and playing the heroine, "Twillbe," in full drag.

The figure that connected these playful spectacles with Glackens's budding artistic practice was James McNeill Whistler, who, as the painter "James McNails Whiskers," was a prominently featured character

Fig. 117
William Glackens
Philadelphia Landscape, 1893
Oil on canvas
17¾ × 24 in. (45.1 × 61 cm)
NSU Art Museum Fort Lauderdale, FL;
Gift of the Sansom Foundation 92.41

in *Twillbe*. The controversial expatriate had established his trend-setting reputation in the 1860s with images of family members, friends, and lovers—construed, if not intended, as provocative expressions of his art-for-art's-sake philosophy. And his best-known work, *Arrangement in Grey and Black, No. 1: Portrait of the Artist's Mother* (1871; Musée d'Orsay, Paris), has its own Philadelphia story. This iconic painting— the first referred to by Whistler as an "arrangement" of colors—had debuted in America in a special group exhibition titled *American Artists at Home and Abroad*, held in the Academy's galleries in the late fall of 1881. While the soon-to-be-popularly-titled "Whistler's Mother" had already attained a modicum of fame in its ten-year existence, the Academy show represented one of the first opportunities for Americans to view a major picture by the artist, equally celebrated and ridiculed for his eccentric paintings and public persona. The portrait was viewed as radical due to its minimalist composition and palette, and its effect on artists—particularly those affiliated with the Academy—was profound, directly influencing the work of then-students such as Cecilia Beaux and Henry Ossawa Tanner while also casting a spell on the older artist-teachers Thomas Eakins and William Merritt Chase.[11]

The year 1881 also marked the exhibition of Whistler's challenging portrait of his mistress and model, Joanna Hiffernan, at New York's Metropolitan Museum of Art. *Symphony in White, No. 1: The White Girl* (1862; National Gallery of Art, Washington, DC) was arguably even more influential than the portrait of his mother on a generation of artists, inspiring a spate of "women in white" pictures throughout the country, a condition one critic termed the "Whistler rash."[12]

Glackens did not experience the 1881 showings of Whistler's art in America, and it was not until his 1895 visit to Paris's Musée du Luxembourg that he saw "Whistler's Mother" in person. However, he was greatly affected by two extensive encounters with the expatriate's work

Fig. 119
William Glackens
Girl in White, 1894
Oil on canvas
28¼ × 35 in. (71.8 × 88.9 cm)
Private collection

in the early 1890s. A visit with Henri to the Metropolitan Museum in November 1894, where *The White Girl* was once again hanging, led Glackens to draw parallels between it and two equally beloved paintings by Manet in the museum's collection—*Boy with a Sword* (1861) and *Woman with a Parrot* (*Young Lady in 1866*) of 1866. As he wrote to a friend, "The intention of both men is identical, and their theory of drawing the same." Revealing his intoxication with these progressive works, Glackens continued: "We gloated over these three pictures all afternoon, and we came back the next day and gloated over them until it grew dark, and then we went back home to Philadelphia."[13]

In the following days, it is probable that Glackens began to formulate his own painterly response to Whistler's white subjects (Fig. 118), though not specifically to the one he had viewed in New York. Glackens's *Girl in White* (Fig. 119), completed in 1894, suggests a creative evocation of Whistler's last portrait of Jo Hiffernan, posed once

Symphony in White. N° III. _ Whistler. 1867_

Fig. 120
James McNeill Whistler
Symphony in White, No. 3, 1865–67
Oil on canvas
20¼ × 30¼ in. (51.4 × 76.9 cm)
The Barber Institute of Fine Arts,
University of Birmingham, UK

again in a white muslin "artistic" gown—*Symphony in White, No. 3* (Fig. 120)—a painting that may have been seen by Henri in London in 1892, and shared in some form with his younger friend. Glackens's self-conscious homage to Whistler depicts a languorous model in a white dress reclining on a white-draped couch and holding a Japanese fan. The diagonal arrangement of the figure is extended by the nearby placement of two sprays of red flowers, plucked from a still-life arrangement (the first to appear in Glackens's work) set on an Asian-styled stool atop an oriental carpet—compositional devices suggestive of Whistler's *japonisme*. Around the same time, Glackens produced a little-known related watercolor study (Fig. 121) featuring an even more Whistlerian/Pre-Raphaelite-like model with a prominently placed Japanese fan dangling from her hand. This unfinished drawing, along with the *Girl in White* oil, anticipates his later and more overtly sensuous studio picture, *Girl with Apple* (1909–10; Fig. 55). All three works suggest how Whistler (as well as Manet, in particular his controversial nude, *Olympia*; Fig. 62) continued to inform Glackens's increasingly modern aesthetic.[14]

A more consequential display of Whistler's art had taken place on Glackens's front door in 1893, at the sixty-third annual exhibition of the Pennsylvania Academy. This was the inaugural undertaking of the

Fig. 121
William Glackens
Seated Woman with a Japanese Fan, 1894
Watercolor and graphite on cream
textured wove paper
14¼ × 16¾ in. (36.2 × 42.5 cm)
Philadelphia Museum of Art; Gift
of Mr. and Mrs. John Sloan, 1945
(1945–81–29)

recently appointed managing director, Harrison Morris, arguably the most enlightened leader in the institution's venerable history. The exhibition featured ninety-four examples of what Morris called "the best American art," a selection of works that had recently been on view at the 1893 Columbian Exposition in Chicago. Paintings by such American "old masters" as Whistler, John Singer Sargent, Winslow Homer, and Frank Duveneck represented the cosmopolitan eclecticism that characterized advanced American painting at the time. The Academy exhibition, like the Chicago show, proved to be a public sensation.[15]

Morris had been especially enchanted by the six Whistlers displayed at the world's fair, and succeeded in securing five of them for Philadelphia. *Portrait of Lady Archibald Campbell* (also known as *The Yellow Buskin* or *Arrangement in Black* [Fig. 122]) was Morris's favorite; he called it "nearly the most brilliant of all Whistler's full-sized figures— one of the greatest works of art in the world."[16] A contemporary image of Glackens, seated in front of an echo of the large, moody Campbell portrait on an easel in his Chestnut Street studio (Fig. 123), reveals that this Whistler was also of interest to the young artist. The Campbell portrait received the prestigious Temple Gold Medal (awarded by artist jurors) for the best figure painting in the Annual, yet Morris was unsuccessful in his campaign to persuade the Academy's board to acquire it for the museum's permanent collection. Eventually, he was able to convince the Philadelphia collector John G. Johnson to purchase the work at a greatly reduced price for the W.P. Wilstach Collection, which formed the core of the city's municipal art museum (the predecessor of the Philadelphia Museum of Art), then housed in Memorial Hall. In this way, the Campbell portrait became the first major painting by Whistler to enter an American public collection.

Fig. 124
James McNeill Whistler
The Chelsea Girl, 1884
Oil on canvas
65 × 35 in. (165.1 × 88.9 cm)
Crystal Bridges Museum of
American Art, Bentonville, AR;
2014.41

Another influential Whistler in the same Academy annual, the 1884 full-length oil *The Chelsea Girl*, also had a Philadelphia pedigree (Fig. 124). Apparently, it was not a work that Whistler had favored sending to the Chicago fair (he rarely arranged his own loans, but left them to dealers). The artist had originally given the work to Alexander Cassatt, president of the Pennsylvania Railroad and brother of Impressionist artist Mary Cassatt, by way of an apology for the delayed completion of a commissioned portrait of his wife. Calling it the "sketch of *one afternoon*—or rather the first statement or the beginning of a painting—I am not excusing it mind... for of course it is a damn fine thing," Whistler protested that it was not a "*representative* finished picture!" and, thus, not something he wanted to be judged by in America. "I ought to have been consulted," he added.[17]

Despite the artist's concerns, the painting struck a particular chord with Henri and his realist comrades, who greatly admired Whistler's uncompromising aesthetic principles and responded directly to his unsentimental depictions of working-class subjects. In the end, it was Whistler's dual standing as both old master and American modernist that defined his appeal in Philadelphia in general and at the Academy in particular—providing a bridge between traditional and avant-garde impulses for Glackens and other acolytes.

The admiration of Sloan, Glackens, Shinn, and Luks for Whistler's dramatic flair and distinctive artistry extended to their playful activities—from *Twillbe*, in which Shinn took on the character of James McNails Whiskers, to Luks's caricature of Glackens on the eve of his departure for Europe (Fig. 125)—an image that recalls the plethora of cartoons lampooning Whistler as a curly-haired dandy and aesthete.

Fig. 125
George Luks
William Glackens, 1895
Ink and graphite on bristol board
26⁵⁄₁₆ × 21½ in. (66.8 × 54.6 cm)
Delaware Art Museum, Wilmington;
Gift of Helen Farr Sloan, 1978

The art school tradition known as the caricature exhibition also provided Glackens with an opportunity to revel in his love of comic drawing while paying homage to the famous expatriate. In the 1894 offering, which spoofed some of the more notable works in the sixty-third annual, Whistler's five entries generated the greatest student response, including Glackens's recasting of *The Chelsea Girl* as *Jimmie*. While no image exists of this caricature, one may assume that it turned Whistler's defiant ragamuffin into a portrait of the strong-willed artist himself.

Whistler's artistic impact on Glackens persisted through his 1895–96 European sojourn. The painting *La Villette* (c. 1895; Fig. 127) has echoes of *Nocturne: Blue and Gold—Old Battersea Bridge* (1872–75; Tate Britain, London)—both moody evocations of picturesque bridges bathed in twilight. This and one of Glackens's rare etchings, *Untitled (By the River)* (1895; Fig. 126), may be considered "Whistler souvenirs" from this period. It was Sloan who taught Glackens to etch, and he produced the print in Philadelphia, along the Schuylkill, for publication in Sloan's short-lived art journal, *Moods*.

Toward the end of his time in Europe, Glackens began to move away from Whistler's quietism in favor of the art of two other influential modern painters, both French. The lively *In the Luxembourg* of c. 1896 (Fig. 129) reveals a new painterly ease and animation missing from Glackens's more muted Whistlerian compositions. Its vivid assurance drew the attention of the French Société nationale des beaux-arts, and in the spring of 1896 it was accepted into the Salon du Champ de Mars, an alternative to the Paris Salon that often featured younger, more progressive, and international artists. The luscious painting of a contemporary park scene, with its rapidly applied swirls of pigment

Fig. 126
William Glackens
Untitled (By the River), 1895
Etching
5 × 7 in. (12.7 × 17.8 cm)
NSU Art Museum Fort Lauderdale, FL:
Bequest of Ira D. Glackens 91.40.161

Fig. 127
William Glackens
La Villette, c. 1895
Oil on canvas
24 × 29 in. (61 × 73.7 cm)
Carnegie Museum of Art, Pittsburgh;
Patrons Art Fund 56.13

and keen observation of leisure activity, suggests a melding of Glackens's newspaper-sketch aesthetic with his devotion to Manet as a painter of modern life (Fig. 128)—a heady combination that would shape his future New York imagery.[18]

But before he would make the move to New York, Glackens returned from Europe to Philadelphia in October 1896, and commenced a project for the Pennsylvania Academy—the commission of mural paintings for the institution's newly renovated and electrified auditorium. Since the 1893 World's Columbian Exposition, mural painting in America had established itself as a legitimate and lucrative form of artistic production, and the Academy was alert to the opportunities it offered art students.

Winners of the Academy's 1896 mural painting class competition, directed by composition teacher Henry Thouron, executed a series of decorations for the upper walls of the auditorium. Sloan and Glackens were among thirteen alumni to participate (Henri and Parrish declined the invitation). Sloan produced a canvas he titled *Dramatic Music* (1896–97; Pennsylvania Academy of the Fine Arts), one of his earliest experiments in oil that stylistically echoes his other concurrent practice—art posters in a vaguely Art Nouveau style. Glackens, for his part, painted two large-scale works: *Calliope*, which has not survived, and *Science* (Fig. 130). Glackens's extant composition, so unlike anything

Fig. 128
Édouard Manet
Music in the Tuileries Gardens, 1862
Oil on canvas
30 × 46½ in. (76.2 × 118.1 cm)
National Gallery, London; Sir Hugh Lane Bequest, 1917 (NG3260)

Fig. 129
William Glackens
In the Luxembourg, c. 1896
Oil on canvas
16 × 19 in. (40.6 × 48.3 cm)
NSU Art Museum Fort Lauderdale, FL;
Bequest of Ira D. Glackens 91.40.66

Fig. 130
William Glackens
Science, 1896–97
Oil on canvas
77½ × 127½ in. (196.9 × 323.9 cm)
Pennsylvania Academy of the Fine Arts,
Philadelphia; Commissioned by the
Pennsylvania Academy 1897.9.3

he had produced to date, reveals the seminal and topical influence of Puvis de Chavannes in its sculptural figures and allegorical theme.[19]

The foremost French muralist of the period, Puvis was especially celebrated in America for his central mural cycle at the Boston Public Library, installed between 1895 and 1896. This near-symbolist work would inspire a few easel paintings by Glackens (Fig. 131) and would inform the rarefied aesthetic of his future New York colleague Arthur B. Davies, another important figure in that city's emerging modernist culture.

By December 1896, drawn by Luks's offer of employment as a cartoonist for the *New York World*, Glackens was ready to trade Philadelphia for Manhattan, but it is arguable that he never really shed his hometown identity—the place where his passion for modern painting and modern life first took root. Glackens went on to become an advanced painter—shaping the development and reception of modern art through his participation in both the landmark 1908 exhibition of The Eight at the Macbeth Galleries and the 1913 Armory Show, and playing a critical role in the creation of the Barnes Foundation, especially through his 1912 purchase trip to Paris on collector Albert Barnes's behalf. Glackens continued to advance the cause of modernism through influential surveys of avant-garde painting in New York and Philadelphia during the teens and twenties, and led such modernist organizations as the Society of Independent Artists. All of this would

Fig. 131
William Glackens
Untitled (The Garden Party), 1895
Oil on canvas
24 × 18 in. (61 × 45.7 cm)
New Mexico Museum of Art, Santa Fe;
Gift of Mrs. Lois Field in memory of
Miss Margaret Field and Mrs. Graham
Shaw, 1954 (24.23P)

unlikely have occurred without the benefit of his early experiences of social fellowship and cultural experimentation in a city where both deeply mattered.

On the artist's death in 1938, Barnes sorrowfully wrote to Edith Dimock Glackens of her cherished husband and his lifelong Philadelphia friend's profound influence: "I loved Butts as I never loved but half a dozen people in my lifetime. He was so *real*, and so gentle and of a character that I would have given millions to possess. And as an artist, I don't need to tell you I esteemed him.... He will live forever in the Foundation collection among the great painters of the past who, could they speak, would say he was of the elect."[20] And so he does, and so he will.

NOTES

1. For a historical overview of the institution, see *In This Academy: The Pennsylvania Academy of the Fine Arts, 1805–1976; A Special Bicentennial Exhibition* (Philadelphia: Pennsylvania Academy of the Fine Arts, 1976).

2. Franklin Spencer Edmonds, *History of the Central High School of Philadelphia* (Philadelphia: J. B. Lippincott, 1902), https://archive.org/stream/cu31924030635 340/cu31924030635340_djvu.txt.

3. For more on Glackens's Central High School experience, see Avis Berman, "Philadelphia Landscape: William Glackens's Early Years," in *William Glackens*, ed. Berman (New York: Skira Rizzoli in association with the Barnes Foundation, 2014), 28. For Glackens's remarkable recall, see also Bennard B. Perlman, *The Immortal Eight: American Painting from Eakins to the Armory Show, 1870–1913* (Westport, CT: North Light, 1979), 82.

4. See Sylvia Yount, *Maxfield Parrish, 1870–1966* (New York: Harry N. Abrams, 1999).

5. William C. Brownell, "The Art Schools of Philadelphia," *Scribner's Monthly* 18 (September 1879): 737–50.

6. On this consequential generation of American modernists, see William C. Agee, *Modern Art in America, 1908–68* (London and New York: Phaidon, 2016), 21–37.

7. Writing in 1900, Regina Armstrong described Glackens as "an illustrator, who is above all a painter"; see "The New Leaders in American Illustration, IV: The Typists: McCarter, Yohn, Glackens, Shinn and Luks," *Bookman* 11 (May 1900): 247, quoted in Michael Lobel, *John Sloan: Drawing on Illustration* (New Haven and London: Yale University Press, 2014), 28.

8. Henri's inspirational musings about art and life were collected by his former student Margery Ryerson and published as *The Art Spirit* in 1923 (Philadelphia: J.B. Lippincott).

9. See *William Glackens: The Formative Years* (New York: Kraushaar Galleries, 1991).

10. Ira Glackens, *William Glackens and The Eight: The Artists Who Freed American Art* (New York: Writers and Readers Publishing in association with Tenth Avenue Editions, 1990), 6–8. See also Perlman, *Immortal Eight*, 53–59.

11. See Sylvia Yount, "Whistler and Philadelphia: A Question of Character," in Linda Merrill et al., *After Whistler: The Artist and His Influence on American Painting* (Atlanta: High Museum of Art, 2003), 50–52.

12. See Linda Merrill, cat. entry 1, *Symphony in White, No. 1: The White Girl*, in *After Whistler*, 100–101.

13. Glackens to Miss Smith, November [1894], quoted in Berman, "Philadelphia Landscape," 33.

14. Avis Berman, "Glackens and Whistler: A Young Man's Attraction," *The Magazine Antiques* 181 (January/February 2014): 206–15; *William Glackens: The Formative Years*, cat. entry 1.

15. See Yount, "Whistler and Philadelphia," 55.

16. Harrison Morris, *Confessions in Art* (New York: Sears Publishing, 1930), 46. The Philadelphia Museum of Art catalogues Whistler's Campbell portrait as *Arrangement in Black (The Lady in the Yellow Buskin)*.

17. Quoted in Yount, "Whistler and Philadelphia," 56.

18. A March 1895 exhibition at the New York branch of the Durand-Ruel Gallery of fifteen major paintings by Manet—including *A Bar at the Folies-Bergère, Masked Ball at the Opera,* and *Music in the Tuileries* (the artist's first major painting of modern Parisian life)—may have deepened Glackens's infatuation with the Frenchman's work even before his June departure for Paris. See Berman, "Philadelphia Landscape," 33.

19. Yount, *Maxfield Parrish*, 40–41.

20. Barnes to Edith Glackens, June 3,1938, quoted in Ira Glackens, *William Glackens and The Eight*, 260.

Modernity Begins at Home:
Edith Dimock Glackens

AVIS BERMAN

In his day, William Glackens was a modern artist, and he was wise enough to marry a thoroughly modern woman whose unconventionality he acknowledged from their earliest days together. Edith Dimock Glackens (Figs. 132, 133, 135) was a wife, lover, muse, willing partner in William Glackens's work, and a skilled artist in her own right. She was a significant determinant in her husband's life and career for many more reasons than the cardinal fact that she was his spouse. Other than in the indispensable personal writings of her son, Ira,[1] the literature on William Glackens has largely posited his wife as an heiress and a feminist, and left it at that. Both of these attributes are accurate, but they are insufficient. Her profound contributions to the social, economic, and professional conditions surrounding William Glackens's art are comparatively well documented, but her intelligence and creative spirit deserve wider acknowledgment.

Edith Dimock was born in Hartford, Connecticut, on February 16, 1876, the second of six children of Ira and Lenna Dimock.[2] Ira Dimock was a successful inventor and manufacturer, the president of the Nonotuck Silk Company, which manufactured Corticelli silk. His wife, Lenna Demont, whom he had met on a business trip to England, was British, and believed that women should have all the privileges of men, denouncing anyone who referred to "woman's frailties."[3] Her two daughters, Edith and Irene, absorbed her beliefs, and both were determined to lead independent lives.

The Dimocks moved to an enormous mansion in the prosperous suburb of West Hartford, but the family had no wish to shine in local society. Lenna Dimock was not interested in having her daughters make debuts; instead, she valued academic and cultural education. Edith attended several schools, including a local private girls' school, and then the Burnham School in Northampton, Massachusetts, which was a preparatory school for Smith College. After these two institutions, Edith was sent to Miss Brown's School in New York, a private boarding and day school, in 1895.[4]

Fig. 132
Robert Henri
Portrait of Edith Dimock Glackens,
1902–04
Oil on canvas
84 × 45 in. (213.4 × 114.3 cm)
Sheldon Museum of Art, Nebraska Art Association, Lincoln; Gift of Miss Alice Abel, Mr. and Mrs. Gene H. Tallman, The Abel Foundation, and Mrs. Olga N. Sheldon, N-245.1970

Fig. 133
Photographer unknown
Edith Dimock, c. 1902
Archival photograph
NSU Art Museum Fort Lauderdale, FL;
Bequest of Ira D. Glackens, photograph
collection

Fig. 134
Gertrude Käsebier
William Glackens, 1907
Platinum print
8⅛ × 6¼ in. (20.6 × 15.9 cm)
Delaware Art Museum, Wilmington;
Gift of Helen Farr Sloan, 1978

After she graduated from Miss Brown's School, Dimock[5] defied even her liberal parents' expectations and announced that she would become an artist. She enrolled in the Art Students League of New York in October 1895 and remained there through 1898, taking classes in drawing from casts, composition, anatomy, life classes, and painting from the well-known academic artists of the day: J. Carroll Beckwith, Kenyon Cox, Frederick Dielman, Douglas Volk, and others.[6] She then returned home to Connecticut and studied painting with the renowned American Impressionist William Merritt Chase, who started giving weekly classes in Hartford in 1900. Dimock realized that one class a week was insufficient, and she knew she had to return to New York to continue her studies with him there.[7] She flamboyantly argued her case to her mother and father by singing the passage from Charles Gounod's *Faust* wherein Faust begs Mephistopheles,

> I want my youth! Give me youthful pleasure, a maiden's caress and desires. Give me the glowing strength of youth...! Ardent youth! Give me its desires, its intoxication, and its pleasures![8]

The senior Dimocks acquiesced. Anyone who could declare that she wanted to traipse off to the fleshpots of New York and win her adversaries to her vocational choice by invoking those forbidden pleasures was obviously someone of remarkable force. By then Dimock was twenty-five years old and primed for equal rights.

At the Chase School, Dimock met fellow student May Wilson Watkins, an illustrator who had studied with Whistler in Paris. They decided to room together and were joined by Louise Seyms, a friend of Dimock's from Hartford. The three moved into the Sherwood Studios, at 58 West Fifty-seventh Street, directly across the street from the New York School of Art (the formal name for Chase's school) at 57 West Fifty-seventh. The building was the first apartment house constructed specifically for artists, and with elevators, modern bathrooms, and one or two bedrooms per apartment,[9] the accommodations were sybaritic compared to the lodgings most artists and art students occupied, even for three women sharing a space.

In early 1901, Watkins was being courted by the illustrator James Preston, who had known William Glackens since high school, and one evening he brought Glackens (Fig. 134) along with him. Dimock was attracted to the handsome artist, but he was quiet and distant, and she later confessed in an unpublished memoir that she had chased him.[10] Their relationship was probably given a further push that September, when Robert Henri, Glackens's earliest artistic mentor, moved into the Sherwood Studios, and Glackens had more occasion to turn up there. Dimock formed her own friendship with Henri, who recorded visiting the three women's apartment on various occasions in his diary. In 1902, when Dimock was staying at her family's summer house in New London, Connecticut, she also saw Henri when she helped

engineer a portrait commission for him in the New London area. In late November 1902, in the Sherwood building, Henri briefly began a portrait of Dimock, which he took up again in January of 1903. He didn't finish it until May 1904 (Fig. 132), when the title—"Portrait of Miss Edith Dimock"—had to be changed, because she had become Edith Dimock Glackens when she married on February 16, 1904, her twenty-eighth birthday.

In an essay about Henri, the art historian Bennard Perlman condescendingly described the subject of the portrait as "a demure socialite from Hartford."[11] This jab infuriated Ira Glackens, who stated that his mother was never "demure," and not a "socialite."[12] Indeed, even Henri, regarding the liberated and exuberant Dimock, said to her a little later about the picture, "It's an antique, isn't it?"[13] Henri must have seen that the image and approach were too reticent to convey the main facets of Dimock's personality: informal, vigorous, emancipated, and gregarious. In contrast, John Sloan got it right when he characterized Dimock as "gracious and used her very unique, clever wits to good purpose."[14] Glackens was the shy, retiring one of the pair, and Dimock was resolved to break down his reserve. In a very early letter to her before they married, he wrote of his "miserable shyness" and envied her "delightful way of carrying off things in a quasi-light style . . . that I like so much. One never becomes embarrassed."[15] Nevertheless, Glackens continued to call her "Miss Dimock" until she threatened, "If you call me that again, I will kiss you in front of everyone."[16]

Dimock later remarked that it took "years to entice William Glackens to put on the ball and chain,"[17] and there is a hint or two in some of his letters from 1903 that the two had been intimate. Thus Dimock was far from "demure," although she was a denizen of artistic circles in which premarital sex was not unknown. Edith Dimock seamlessly fit into the haut-bohemian world of Henri, Glackens, Sloan, Everett Shinn, and their friends, and she was included in the party when they went to restaurants, cafés, and other nightspots that more straitlaced women would have avoided. In Glackens's *At Mouquin's* (Fig. 136), Dimock, reflected in the mirror in between the two main figures, is portrayed as a comfortable habitué of this sophisticated French restaurant. Adding her to the scene and having her sit with the art critic Charles FitzGerald, whose portrait Glackens had painted two years before, indicates her ease in navigating what was then a risqué environment.

Glackens's portrait of his wife (Fig. 137), painted in spring 1904, is far more true to the spirit and appearance of the woman before him than Henri's canvas. Dimock wears an elaborate outfit, redolent of wealth and status. Her amused expression as she eyes her new husband and watches him paint, affectionately taking his measure, suggests that her costume did not overwhelm her in the least. She revels in the opportunity to see him work—indeed, the hint of iconoclastic humor and sense of will gives the portrait its contemporary sensibility. Glackens

Fig. 135
William Glackens
Edith Glackens Walking, c. 1905–10
Black chalk on dark brown paper
6½ × 3³⁄₁₆ in. (16.5 × 8.1 cm)
The Metropolitan Museum of Art,
New York; Robert Lehman Collection,
1975 (1975.1909)

Fig. 136
William Glackens
At Mouquin's, 1905
Oil on canvas
48⅛ × 36¼ in. (122.4 × 92.1 cm)
The Art Institute of Chicago;
Friends of American Art Collection
1925.295

included a still life in the painting. The ripe fruit may symbolize the couple's abundant marital joy, but the spots and discoloration that naturally developed during the days Glackens worked are a nod to his commitment to address the facts of visual appearance—which extended to refraining from idealizing the image of his wife. Edith Dimock Glackens is rendered realistically and inhabits a believable space; her expression is what piques the viewer's interest and imbues the portrait, despite its formal conservatism, with its enduring magnetism.

Portrait of the Artist's Wife signals the beginning of a union that was happy, saucy, and real. Glackens made the most stable and lasting marriage among his immediate peers. Sloan was married to an alcoholic manic-depressive who was the source of much misery in his life. Shinn was wed four times and died divorced. George Luks married five times, and although Ernest Lawson and his wife stayed together, they did not get along. Maurice Prendergast was a lifelong bachelor, and Arthur B. Davies was a bigamist, leading a clandestine double life. Henri, who warned all of his friends not to get married because its demands would undermine their ambition, married twice. His first wife died young, but after a few years of despondency he remarried successfully.

As opposed to the background role that she played in *At Mouquin's*, Edith Dimock Glackens takes center stage in *The Shoppers* (Fig. 138), the painting that is the summation of William Glackens's early career and trumpets Dimock's essentiality to his life and work. In a letter he writes from New York while she is visiting her parents in West Hartford, Glackens reports his frustration—he's "spoiled" *The Shoppers*, he can't fix it, and he misses her; her absence and his frustration are entwined.[18] Their marriage infused him with confidence: within months after his wedding, Glackens began working with bigger canvases. The two largest paintings in Glackens's oeuvre, *The Shoppers* and *Family Group* (Fig. 139), are multifigural compositions with Dimock front and center. Slightly smaller but equally ambitious is *Artist's Wife and Son* (Fig. 140). Romance and domesticity supported Glackens's artistic project. Dimock provided him not only companionship and sexual satisfaction, but the constancy of an accomplished and understanding model. Rather than a passive placeholder, she was a sentient participant in Glackens's act of painting, and in *The Shoppers* she carries a secret. Her costume and pose are emblems of a vital event in the couple's lives: when Dimock first modeled for the painting, she was pregnant, and would give birth to their first child, Ira Dimock Glackens, on July 4, 1907. The loose, slightly flared fur coat hides her shape, and she is standing in such a way that makes ambiguous any swelling of her body.

But what of Edith Dimock the artist? This aspect of her biography must remain speculative on account of a sad fact. After Glackens died, Dimock was so grief-stricken that she destroyed as much of her own

Fig. 137
William Glackens
Portrait of the Artist's Wife, 1904
Oil on canvas
74¾ × 40 in. (189.9 × 101.6 cm)
Wadsworth Atheneum Museum of Art, Hartford, CT; Gift of Ira Glackens in memory of his mother, the former Edith Dimock of Hartford, 1876–1955 (1956.27)

Fig. 138
William Glackens
The Shoppers, 1907
Oil on canvas
60 × 60 in. (152.4 × 152.4 cm)
Chrysler Museum of Art, Norfolk, VA:
Gift of Walter P. Chrysler, Jr. 71.651

Fig. 139
William Glackens
Family Group, 1910–11
Oil on canvas
71¹⁵⁄₁₆ × 84 in. (182.8 × 213.3 cm)
National Gallery of Art, Washington, DC;
Gift of Mr. and Mrs. Ira Glackens 1971.12.1

work as she could. The surviving pieces were only what she had sold, overlooked, or given to other people.[19] It is impossible, therefore, to discuss with authority a body of work based roughly on one painting, about fifty known watercolors, and reproductions of forty-eight book illustrations. However, with such limitations in mind, one can analyze the scope of Dimock's art.

The one extant painting by Edith Dimock is a self-portrait (Fig. 141), presumably painted at the Chase school, where she worked directly from life. The painting, a mere nine by seven inches in size, has the look of student work; it shows someone learning to model forms and blend paint. Yet, given that Dimock had been painting for several years and in art school for at least five, it is not a particularly assured picture. Dimock must have known her strengths, because she decided by 1904, the first year that she is known to have exhibited profession-ally and when a reviewer called her a "newcomer,"[20] that her métier

Fig. 142
Edith Dimock
Country Girls, c. 1905–12
Watercolor, gouache, and black crayon
on wove paper
7¹⁵⁄₁₆ × 9³⁄₁₆ in. (20.2 × 23.3 cm)
The Barnes Foundation, Philadelphia;
BF352

was watercolor. She would work in watercolor, enhanced by touches of gouache and black crayon, for the rest of her life.

Dimock used the medium as a vehicle for genre vignettes and character studies. Satirical and sharply observed, her watercolors depict women and children of the lower and middle classes, usually seen in motion–shopping, talking, and walking. Men make rare appearances, and then no more than as figures of fun. Dimock excelled at the quickly noted impression—the images are fresh, the simplifications of modern art are embraced, and the chosen media are adeptly handled. A talent is apparent, as affirmed by two works (Figs. 142, 143) purchased in January 1913 by the collector and patron Albert C. Barnes, who bought four watercolors from Dimock over the years.

In April 1904, a few weeks after her wedding, Dimock, who exhibited as "E. Dimock" rather than Edith Glackens, submitted three works to the American Water Color Society's annual spring show.

Fig. 143
Edith Dimock
Country Girls Carrying Flowers,
c. 1905–12
Watercolor and black crayon with
graphite on thick wove paper
9½ × 10⅜ in. (24.1 × 26.4 cm)
The Barnes Foundation, Philadelphia;
BF353

According to the Society's register, they were titled *Circus Day*, *A Widow*, and *Village Girls*.[21] However, the published catalogue lists only one watercolor by Dimock, called *Rain*.[22] In a rave review in the *New York Evening Sun*, *Rain* (Fig. 144) was acclaimed as distinct from the 344 other works on view, which the critic scorned as a sea of "friendly nothings" chosen by a "decorous" jury. The writer expressed surprise that Dimock's contribution had escaped rejection because

> it has no business in an exhibition that ranges in orthodox order from the flimsy sketch of vague sentimental possibilities to the carefully niggled ideal of the Christmas supplement. Miss Dimock is not orthodox at all. She comes to her world very unconventionally, free from pictorial prejudice.... Here is an artist with a definite aim, a keen fresh vision readily interested in the humorous, whimsical aspect of her neighbors: the impish brats of the street, the village gossip, the plain countryman, the citizen, pathetically self-conscious in his Sunday clothes. And these little fragments are picked out with an astonishing eye to the essential features of the business in hand: the blobs of color distributed artfully and with a frugal recognition of form, no more nor less than sufficient to enclose and intensify the curiosity, oddity or quaint charm of the characters. It is a wonderful art. How futile are the many careful, conscientious studies on the walls here in comparison with this slight sketch that goes so infallibly to the point![23]

The critic's extensive remarks are clearly based on a more comprehensive understanding of the artist's work than the one watercolor under discussion: he possessed personal knowledge of them. The review rings true because the analysis is so vividly and cogently argued and because Dimock showed genuine ability, but the extravagance of the praise is somewhat undercut by the fact that the unsigned author was the couple's friend Charles FitzGerald. However, FitzGerald was generally known as a defender of the livelier currents of American realism—the movement with which Dimock was allied—and the accuracy of his observations about the quality of the rest of the Water Color Society's offerings was confirmed by the *New York Times*' reviewer, who wrote, "No brilliant achievements of hitherto neglected or unknown artists, no pictures defiant of tradition and decorum, none over which the war of tastes is ever likely to wage can be reported from these walls."[24]

Contrary to assertions in previous publications,[25] Edith Dimock did not give up her artistic career after she was married. (Indeed, if that were true, there would have been precious little career to give up, because her first known professional activity was her 1904 debut with the American Water Color Society.) In 1905, Dimock created the cover and fourteen color illustrations for the children's book *The Yellow Cat and Some Friends*. The author was Grace Van Rensselaer Dwight, a friend of Dimock's who was also from the Hartford elite.[26]

Fig. 144
Edith Dimock
Rain, c. 1904
Watercolor on paper
6½ × 8 in. (16.5 × 20.3 cm)
NSU Art Museum Fort Lauderdale, FL;
Bequest of Ira D. Glackens 91.40.95

Yet there were competing claims on Dimock's time, especially after the couple's second child, Lenna, was born in December 1913. Although the Glackens family had servants and everything was cushioned by her money, Dimock had a busier establishment to manage.

It is a truth universally acknowledged that an artist not in possession of a fortune is usually destined for a ragtag life. Such was William Glackens's existence for the first thirty-three years of his life. But his marriage to Dimock changed his financial circumstances, and thus shaped the trajectory of his art, from parlous to secure. Although Dimock did not yet have the fortune that she would inherit when both parents died in 1917, she did receive regular payments from her family's business, and her parents often gave her cash presents. Her income made it possible for the couple to live in far greater comfort than they would have on Glackens's earnings alone, and he was free of the financial pressures that plagued his friends. Yet Glackens continued to illustrate and did not exploit his wife's money for the purpose of his art. His income supported his studio and exhibition expenses

and her wealth made a bourgeois household possible. That household included children. Most artists in the Glackenses' circle could not afford to support a family, and those who did struggled with poverty. Dimock and Glackens had two children without anxiety about their upbringing, and they resided in the commodious and lavishly furnished apartments that are seen as backgrounds in *Family Group* and *Artist's Wife and Son*. In 1919 the Glackenses bought a town house at 10 West Ninth Street, and the following year they purchased a farm in New Hampshire.

Money made extensive travel possible. And because a change in scene invigorated Glackens, Dimock often took it upon herself to plan the couple's holidays and make sure that they would be fruitful for his painting. For example, their Christmas at her parents' house in 1907 resulted in *View of West Hartford* (1907; Wadsworth Atheneum Museum of Art, Hartford, Connecticut). Dimock then initiated a vacation on Cape Cod during the summer of 1908. During that time, Glackens painted side by side with Maurice Prendergast, whose example encouraged him to intensify his palette and embrace nonlocal color. In 1910, Dimock chose the family's summer vacation spot in Nova Scotia, where Glackens produced several beach scenes that rank among his finest achievements, including *Mahone Bay* (1910; Sheldon Museum of Art, Lincoln, Nebraska) and *The Bathing Hour, Chester, Nova Scotia* (Fig. 157). In addition, after Glackens joined the C. W. Kraushaar Galleries in 1925, Dimock handled the bulk of his business correspondence. Therefore, the record of Dimock's exhibition history that follows is a testament to the considerable energies she invested in sustaining a career.

In April 1910 both Dimock and Glackens took part in the *Exhibition of Independent Artists*, the first large-scale invitational show for progressive artists. With 103 painters and sculptors participating free of juries and prizes, it was a landmark in American art. Glackens made a splashy appearance with *Race Track* (Fig. 166) and *Girl with Apple* (Fig. 55), and Dimock was represented by twelve watercolors of New York life.[27] They depict women and children from the Lower East Side and Greenwich Village, and many of the latter group were drawn from the immigrant Italian neighborhood a few blocks south of the Glackenses' apartment off Washington Square. Ira Glackens wrote that when he was growing up, the Square was "full of Italian mothers and children. . . . The mothers in shawls perambulating their broods through the walks of the square, or chatting . . . with their neighbors on the benches."[28] Dimock remained a disciple of the Ashcan school long after Glackens had jettisoned it, specializing in urban incidents and studies of people on the margins of life. (See, for example, Figs. 145, 146.) The 1910 annual of the American Water Color Society, held from April 28 to May 22, overlapped the Independents show, and six of Dimock's pieces were accepted there.[29] They too hint of Ashcan roots:

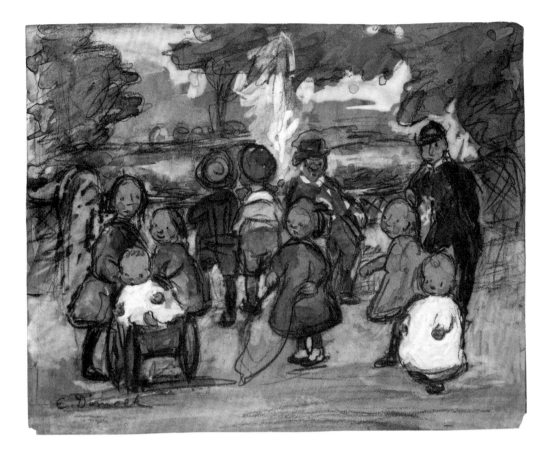

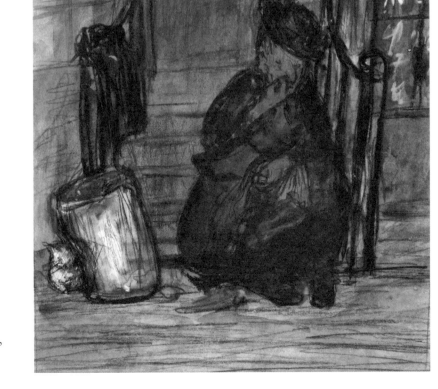

Fig. 145
Edith Dimock
In the Park, n.d.
Opaque and translucent
watercolor and black crayon
on brown wove paper
6⁹⁄₁₆ × 8³⁄₁₆ in. (16.6 × 20.8 cm)
Philadelphia Museum of Art;
Gift of Carl Zigrosser, 1953

Fig. 146
Edith Dimock
Old Snuff-Taker, 1912
Watercolor on paper
7 × 7 in. (17.8 × 17.8 cm)
NSU Art Museum Fort Lauderdale,
FL; Bequest of Ira D. Glackens
91.40.3

they are all titled "Street Group," and probably sketch the Italian-American community and its customs.[30] A year later, Dimock had two watercolors in the Society's 1911 annual, which traveled to Detroit and Chicago.[31] She then illustrated *Stories Grandmother Told*, a book of fairy tales compiled by Kate Forrest Oswell, a prolific children's book author, that was published in 1912 (Figs. 147, 148).

In February 1913, Dimock, like her husband, was included in the epochal *International Exhibition of Modern Art*, known as the Armory Show. Dimock had eight watercolors accepted, and all sold. *Sweat Shop Girls in the Country* and *Mother and Daughter* (Figs. 149, 150) were purchased by John Quinn, then the leading collector of modern art in America. The other six, all originally titled "Group," were sold to a George E. Marcus, who has not been identified.[32] Two of those six watercolors have disappeared, but four have emerged with new titles: *Fine Fruits*, *Three Women*, *Florist*, and *Bridal Shop* (Figs. 151–154).[33] Following on the Armory Show, in May 1913, Dimock was invited to be in a group exhibition at the MacDowell Club, along with Glackens, Sloan, Henri, James and May Wilson Preston, Mahonri Young, and John White Alexander.[34] In April 1915, Dimock was in the first exhibition of the American Salon of Humorists,[35] and in early 1918 both she and Glackens became charter members of the Whitney

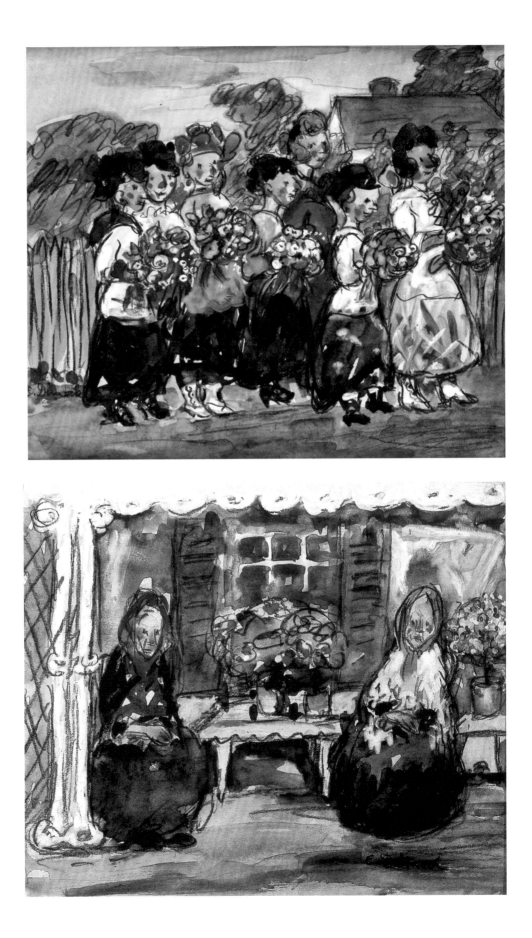

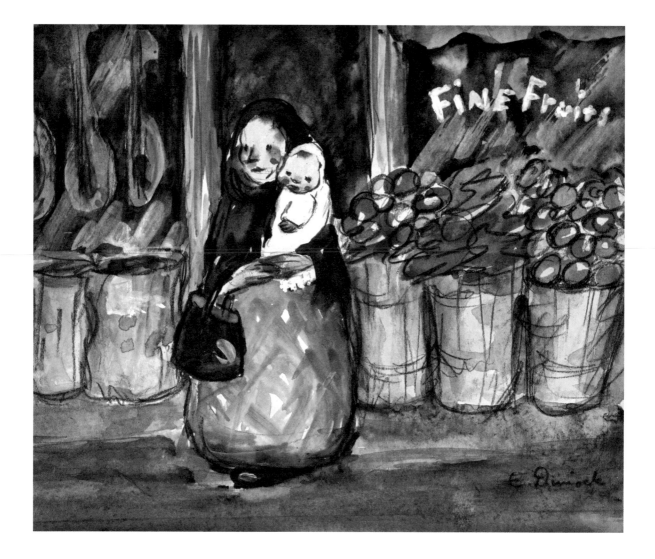

Fig. 151
Edith Dimock
Fine Fruits, n.d.
Watercolor, gouache, and charcoal on
paper
8 × 9¼ in. (20.3 × 23.5 cm)
Bernard Goldberg Fine Arts, LLC, NY

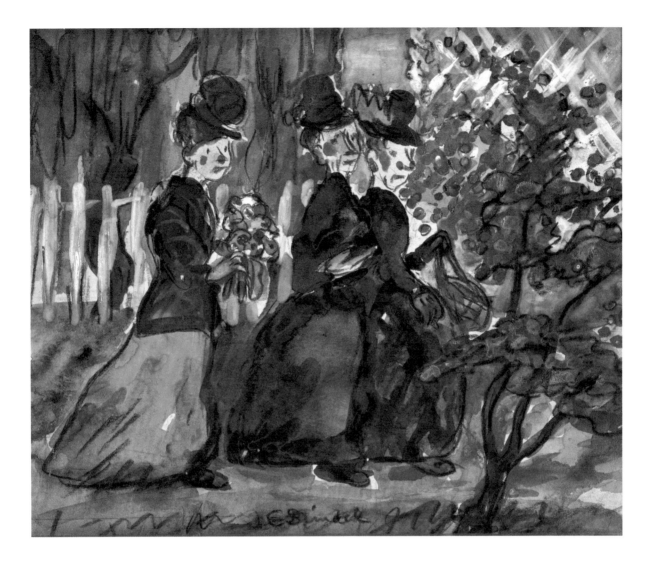

Fig. 152
Edith Dimock
Three Women, n.d.
Watercolor, gouache, and charcoal on
paper
8 × 9¼ in. (20.3 × 23.5 cm)
Bernard Goldberg Fine Arts, LLC, NY

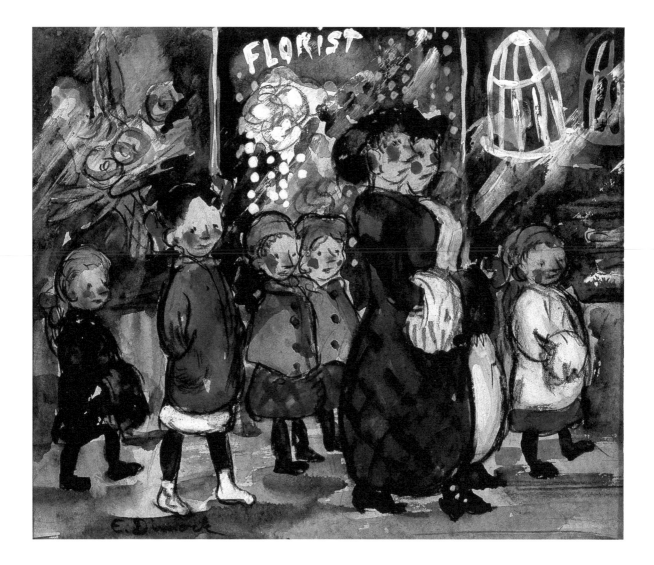

Fig. 153
Edith Dimock
Florist, n.d.
Watercolor, gouache, and charcoal on
paper
8 × 9¼ in. (20.3 × 23.5 cm)
Bernard Goldberg Fine Arts, LLC, NY

Fig. 154
Edith Dimock
Bridal Shop, n.d.
Watercolor, gouache, and charcoal on
paper
8 × 9¼ in. (20.3 × 23.5 cm)
Bernard Goldberg Fine Arts, LLC, NY

Studio Club,[36] the principal predecessor of the Whitney Museum of American Art. Dimock also exhibited intermittently with the Society of Independent Artists, an artist-run cooperative that dispensed with juries and prizes; she showed in that organization's annuals in 1920, 1924, 1925, 1928, and 1929.[37] Reviews in the *New York Times* document that she was in a group show of artists' wives in 1933 and had a solo exhibition in March 1934; in the latter, she presented two watercolors of scenes from *Four Saints in Three Acts*, meaning that Dimock was still *au courant* enough to have seen and responded to this legendary opera by Virgil Thomson and Gertrude Stein, which had opened on Broadway barely a month before, and was proclaimed the avant-garde wonder of the season.[38]

There are no records of Dimock in the Whitney Studio Club's extant annual exhibition catalogues from 1918 to 1928, but in February 1928 she and the artist Beulah Stevenson each had one-person shows in the Whitney galleries at the same time. Dimock's exhibition comprised fifty-two watercolors produced while the Glackenses lived in France in the mid-1920s, which again disproves the canard that she had given up painting. Barnes bought *Women with Eggs* (Fig. 155) in January 1928, perhaps in advance of the exhibition, which earned admiring notices from the *New York Times* and *The Art News*.

Dimock's watercolors became more solid and less sprightly in the 1920s. Once again, while it is possible to commend these later works for their nimble line and lack of pretension, none of them display much evolution from the watercolors of three decades before. That sameness is the intractable problem of Dimock's oeuvre. Keeping her focus eternally comic, Dimock did not stray from her formula nor challenge herself to make changes in size, format, theme, style, or media, which remained static for thirty years. Perhaps the parameters that she set herself—the quasi-caricatural presentation of types from rural and working-class backgrounds, rendered in amusing shapes, poses, and attitudes—never allowed her to surmount the emotional and physical distance she had introduced early on in her compositions. FitzGerald's review of Dimock's "slight sketch" from 1904 could have passed for a write-up of her exhibition of 1928.

In 1911 the millionaire chemist Albert C. Barnes looked up Glackens, a high school classmate with whom he had lost touch. Wanting to collect masterpieces of modern French art, Barnes sent Glackens on a buying trip to Paris in February 1912 with $20,000. The thirty-three paintings and works on paper that Glackens brought back from France would form the nucleus of Barnes's unparalleled collection, and the two men became best friends for life. Dimock also benefited from a unique relationship with Barnes. In 1913, as we have seen, he bought two watercolors from her, and in mid-1914 the two were discussing potential authors for a book on Glackens that she had initiated.[39] Later that year, Barnes and his wife, Laura Leggett Barnes (Fig. 156), earned

Fig. 155
Edith Dimock
Women with Eggs, 1928
Watercolor, gouache, and black crayon
on thick wove paper
9⅛ × 12½ in. (23.2 × 31.8 cm)
The Barnes Foundation, Philadelphia;
BF784

Dimock's gratitude for taking charge when Glackens had to have an appendectomy. They insisted that he undergo surgery in Philadelphia so that Barnes could monitor the procedure in the operating theater. Dimock stayed with the Barneses at their house in Merion, Pennsylvania, and Glackens recuperated there. From then on, Dimock consulted Barnes on any medical matter. In turn, Barnes often recruited Dimock to help right some perceived insult to Glackens's reputation or to ascertain that the artist was properly compensated for his work.[40] She and Barnes savored a bumpy camaraderie in their letters. When they saw eye to eye, Dimock addressed Barnes as "Albertus," which alluded to Albertus Magnus, the medieval philosopher and scientist, and was shorthand for "Albert the Great." In halcyon interludes, she might also append "Yours to command"—an offer so improbable in real life that it was laughable—before she signed off.

Fig. 156
Albert C. Barnes with Laura Barnes and Fidèle at Ker-Feal, 1942
Photograph by Gottscho-Schleisner
Violette de Mazia Collection, The Barnes Foundation Archives, Merion, PA

For all her appreciation of Barnes, Dimock could not countenance his domination of his self-effacing wife, and she was legendary in her set for being the only human being ever known to have told Barnes to shut up. The Glackenses were out with the Barneses in Pennsylvania. Laura Barnes had only lately learned to drive, and she was at the wheel. Dimock was in the front with her, and the two men were in the back. A dog ran into the road, and Laura Barnes swerved to avoid it. Everyone in the car was slightly jolted but unhurt, and the excursion continued. Barnes began criticizing his wife's driving, and growled that she could have killed them all. Dimock saw that Laura Barnes was becoming more and more nervous, so she turned around and barked, "Shut up!" in Barnes's face. Silence followed, and no one spoke for the rest of the evening. The Glackenses left the next day, and for some time Barnes did not communicate with Dimock; he only visited Glackens when she was away.[41] But inevitably the two reconciled. Barnes once remarked to Glackens that his wife was "so interesting and so funny,"[42] and as Ira Glackens would conclude:

> It is miraculous that Albert Barnes put up with my irrepressible mother. Nobody else ever got away with what she got away with . . . Yet I think . . . [he] liked my mother in some odd way, and that her affronts were all forgiven was not entirely due to the fact that he did not want his long serene friendship with my father ruptured. Mother was apparently the only one who ever did, and survived. Besides, there was no way he could fire her.[43]

Edith Dimock's solidarity with women went well beyond defending a friend from bullying. In 1909, Sloan noted that "Mrs. G. is for women's suffrage which is growing nearer and nearer each year."[44] A committed feminist, she participated in political activities that also took time away from her art. Both she and Glackens, along with several other artists' wives, marched in the Woman Suffrage Procession in March 1913. In 1911 and 1915 she was appointed honorary secretary of the National Union of Women's Suffrage Societies, which was the umbrella organization for more than one hundred British groups dedicated to attaining the vote for women.[45] A 1913 article in the *New York Times* records that Dimock, a member of New York state branch of the Woman Suffrage Study Club, gave a report on the social conditions of young working women in the city, including their lack of protection from sexual harassment.[46]

What bonded Dimock and Barnes was their mutual devotion to William Glackens. And since most of the time during their epistolary spats, Dimock was standing up for her husband, he tolerated her "affronts." As Barnes reassured her in 1915, "I know no man that I admire more than Glack, and I am not in the habit either of flattering or bestowing my likings except where a discriminating analysis of character justifies them."[47] In 1923, when an article Barnes wrote

about the history of his collection was about to be published in *The New Republic*, Dimock was alarmed that her husband's contribution would not be sufficiently acknowledged and upbraided Barnes about it. Although Glackens had been enlisted by Barnes to make the critical first art-buying foray, Barnes stated in his manuscript, "No dealer, expert, or similar person has been consulted in the choice of any of the works in the collection."[48] Barnes sent a long, informative, paranoia-laced, and somewhat disingenuous reply to Dimock citing his reasons for omitting Glackens. But ultimately he relented, writing, "If you wish me to modify the statement about Glack's function in the service of the thing developed up to its present point, I wish you would send me your ideas."[49] Perhaps because Barnes had done her the courtesy of allowing her to make a change and Glackens did not care about being credited for his role, Dimock backed down. "Of course I don't want you to change it & neither does Glack," she answered. "If anyone says you take advice it is probably hoping to get your goat by some one to whom you have handed some of those bouquets. You are the only one who ever gave Willie's pictures a chance to speak for themselves, collectively. That is appreciation enough to suit me."[50]

On May 22, 1938, Glackens died of a cerebral hemorrhage, and Dimock dedicated herself to preserving his legacy. In the early 1950s, after being diagnosed with cerebral arteriosclerosis, she moved from New York to Hartford. She suffered from vascular dementia, whose signs mimic those of Alzheimer's disease—disorientation, anger, loss of memory, and confusion. Yet even when she no longer recognized anyone, she would tell visitors that the one painting she had on the wall was by "my Willie." Dimock kept the 1904 portrait of her until her death on October 28, 1955. It is no wonder that she refused to be parted from it. The painting immortalized her inextinguishable self—"diverting, unpredictable, determined, vigorous, and full of will."[51]

I thank the Sansom Foundation, particularly Frank Buscaglia, for the opportunity to expand the text of my original symposium lecture on Edith Dimock Glackens into a more thorough exploration of her life and art. I am also extremely grateful to Barbara Anne Beaucar and Amanda McKnight of the Barnes Foundation Archives, Merion, Pennsylvania, for their invaluable help in locating and pointing out correspondence that illuminated connections between Albert C. Barnes and William and Edith Dimock Glackens.

NOTES

1. Most notably, *William Glackens and the Ashcan Group* (Grosset & Dunlap, 1957), re-released in 1983 by Horizon Press as *William Glackens and The Eight: The Artists Who Freed American Art*, and in 1990 by Writers and Readers Publishing in association with Tenth Avenue Editions; "A Garden of Cucumbers" (unpublished manuscript, 1970s–1980s, William J. Glackens Research Collection and Study Center, NSU Art Museum Fort Lauderdale, FL [hereafter WJG/NSU]); and *Ira on Ira: A Memoir* (New York: Tenth Avenue Editions; distributed by Writers and Readers Publishing, 1992).

2. Ira and Lenna Dimock's children were Irving Dimock (1873–1898); Edith L. Dimock (1876–1955); Stanley K. Dimock (1878–1969); Arthur Wright Dimock (1881–1887); Harold Edwin Dimock (1884–1967); and Florence I. Dimock (1889–1962). Harold Dimock was always called "Edwin," and Florence was always called "Irene."

3. Ira Glackens (hereafter IG), *William Glackens and the Ashcan Group*, 34.

4. "Mrs. Glackens, 79, Widely Known in Art Circles, Dies," *Hartford Courant*, October 29, 1955; "Mrs. W. J. Glackens Passes in Hartford," *The Villager*, date unknown [1955]. Clippings, WJG/NSU.

5. To avoid confusion with her husband, Edith Dimock Glackens will henceforth be referred to in this essay as "Dimock," the name she used professionally.

6. Art Students League of New York, records for Edith Dimock, courtesy of Stephanie Cassidy, Art Students League of New York Archives.

7. D. Frederick Baker, email to the author, December 7, 2012.

8. IG, "A Garden of Cucumbers," 52.

9. Christopher Gray, "Streetscapes: The 1880 Sherwood Studios, Once at 57th and Sixth; Building That Was 'the Uptown Headquarters of Art,'" *New York Times*, August 9, 1998.

10. Edith Dimock Glackens (hereafter EDG), "To Whom It May Concern," undated, unpaginated, unpublished memoir, WJG/NSU.

11. Bennard B. Perlman, *Robert Henri, Painter* (Wilmington: Delaware Art Museum, 1984), 81.

12. IG, conversation with the author, mid-1980s.

13. IG, "The So-called Ash Can School," unpublished lecture, WJG/NSU, 20; IG, *William Glackens and the Ashcan Group*, 62.

14. John Sloan, diary entry, November 30, 1908, quoted in Bruce St. John, ed., *John Sloan's New York Scene: From the Diaries, Notes and Correspondence 1906–1913* (New York: Harper and Row, 1965) (hereafter *JSNYS*), 267.

15. Quoted in IG, *William Glackens and the Ashcan Group*, 44.

16. Ibid.

17. EDG, "To Whom It May Concern."

18. William Glackens (hereafter WG) to EDG, January 17, 1908, quoted in IG, *William Glackens and the Ashcan Group*, 84–85.

19. IG, *Ira on Ira*, 3.

20. [Charles FitzGerald], "The American Water Color Society," *New York Evening Sun*, May 3, [1904], Charles FitzGerald scrapbooks, Archives of American Art, Smithsonian Institution (hereafter AAA).

21. Records of the American Water Color Society 37th Annual Exhibition, microfilm reel 497, AAA.

22. *Illustrated Catalogue of the Thirty-Seventh Annual Exhibition of the American Water Color Society* (New York: American Water Color Society, 1904), 11. I thank John Patt of the American Watercolor Society, New York City, for allowing me to examine several decades of exhibition catalogues in the Society's archives.

23. [FitzGerald], "The American Water Color Society," AAA.

24. "The American Water Color Society. Figures, Seafights, Landscapes in Pastel and Washers [*sic*] at the American Art Galleries," *New York Times*, April 30, 1904, 8.

25. See, for instance, Laura R. Prieto, *At Home in the Studio: The Professionalization of Women Artists in America* (Cambridge, MA: Harvard University Press, 2001), 260n46.

26. Dwight became even friendlier with Dimock and Glackens after she married Daniel H. Morgan, moved into the Glackenses' apartment building, and posed for *Family Group*.

27. The exhibition catalogue lists the watercolors as *A Sidewalk Shop (No. 2)*; *The East Side*; *At Noon on 9th Street*; *A Fat Girl*; *At Noon on 9th Street (No. 2)*; *Women on Bleecker Street*; *Village Girls*; *Woman and Child*; *Child in Red*; *A Small Fruit Stand*; *A Sidewalk Shop (No. 1)*; and *A Family*. See *The Fiftieth Anniversary of the Exhibition of Independent Artists in 1910* (Wilmington: Delaware Art Center, 1960), 10, for the facsimile catalogue page.

28. IG, "A Garden of Cucumbers," 5.

29. *Illustrated Catalogue of the Forty-Third Annual Exhibition of the American Water Color Society* (New York: American Water Color Society, 1910), 27–28.

30. William Glackens also documented the Italian-American presence in Washington Square in several paintings of this period.

31. *Illustrated Catalogue of the Forty-Fourth Annual Exhibition of the American Water Color Society* (New York: American Water Color Society, 1911), 11–12; Elizabeth Thompson Colleary, *The William J. Glackens Collection in the Museum of Art / Fort Lauderdale* (Fort Lauderdale, FL: Museum of Art / Fort Lauderdale, Nova Southeastern University, 2014), 100. Colleary also discovered that Dimock was in a group exhibition at the Thumb Box Gallery in New York City in March 1916. Her watercolors were of "east side life," and her co-exhibitors included George Bellows, Maurice Prendergast, and Glackens. See "Group Exhibits at Thumb Box Gallery," *American Art News* 14, no. 22 (March 4, 1916): 2.

32. See Milton W. Brown, *The Story of the Armory Show* (New York: Abbeville; Washington, DC: Joseph H. Hirshhorn Foundation, 1988), 262. Dimock also bought a drawing by Walt Kuhn from the Armory Show.

33. Marilyn Satin Kushner and Kimberly Orcutt, eds., *The Armory Show at 100: Modernism and Revolution* (New York: New-York Historical Society, 2013), 440–41.

34. "Art at Home and Abroad: An Exhibition of Drawings, &c., Which Shows Present-Day Tendencies of American Art," *New York Times*, May 11, 1913, 70.

35. Emanuel Julius, "Humor in American Art," *New York Call*, May 2, 1915, 1. Besides Dimock, among the other artists participating were Stuart Davis, Sloan, Bellows, Guy Pène du Bois, Boardman Robinson, Glackens, Henri, Luks, Marjorie Organ, and Art Young.

36. "Charter Members Whitney Studio Club," Archives, Frances Mulhall Achilles Library, Whitney Museum of American Art, New York. Dimock is listed as "Mrs. William Glackens."

37. Clark S. Marlor, *The Society of Independent Artists: The Exhibition Record, 1917–1944* (Park Ridge, NJ: Noyes, 1984), 210. Marlor also gives the titles of the works shown.

38. Edward Alden Jewell, "In the Realm of Art: September Activities: Wives Without Husbands," *New York Times,* September 24, 1933, 181; "Art: Dimock Water-Colors Shown," *New York Times*, March 29, 1934, 21.

39. Albert C. Barnes (hereafter ACB) to Guy Pène du Bois, September 1 and September 24, 1914, ACB Correspondence, 1914.33, The Barnes Foundation Archives, Merion, PA, reprinted with permission (hereafter BFA). Dimock wanted Charles FitzGerald as the author, but Barnes was pressing her to choose Pène du Bois. Nothing came of this project, although Pène du Bois later wrote a small book on Glackens for the Whitney Museum of American Art (*William J. Glackens*) in 1931.

40. See, for example, ACB to EDG, February 21, 1916, ACB Correspondence, 1916.93; ACB to EDG, May 6, 1918, ACB Correspondence, 1918.36; and ACB to EDG, January 17, 1921, ACB Correspondence, 1921.29, BFA.

41. IG, *William Glackens and the Ashcan Group*, 163–64.

42. ACB to WG, December 3, 1915, ACB Correspondence, 1915.44, BFA.

43. IG, "A Garden of Cucumbers, 105.

44. Sloan, diary entry, November 15, 1909, *JSNYS*, 352.

45. Space does not permit an investigation of Dimock's involvement with the women's suffrage movement in England, but the connection may well have started with her mother, a native Briton who crusaded for women's rights. Furthermore, activism for women's suffrage was more organized, more advanced, and more militant in England. Dimock could not have exercised much personal influence on the British movement when she was on this side of the Atlantic, so she must have donated generous sums of money to the cause to have been elected honorary secretary *twice*. Even at long distance, she took the appointment seriously. A letter to Miss Edith Dimock dated June 6, 1911, from Sir Maurice Bonham Carter, the principal private secretary to Herbert Asquith, then prime minister of the United Kingdom, acknowledges the receipt of her letter to Asquith about the issue of women's suffrage. The letter is in the Women's Library Archives of the London School of Economics, London University.

46. "Mothers Get Girls' Pay. One Reason Young Workers Get Into Bad Company, Suffragists Hear," *New York Times*, April 8, 1913, 5.

47. ACB to EDG, October 8, 1915, ACB Correspondence, 1915.19, BFA.

48. ACB, "The Barnes Foundation," *The New Republic*, March 14, 1923, 65–66.

49. ACB to EDG, February 19, 1923, ACB Correspondence, 1923.104, BFA.

50. EDG to ACB, n.d. [February 19, 1923], ACB Correspondence, 1923.104, BFA.

51. IG, "A Garden of Cucumbers," 414.

"Wonderful Color Palpitating about Us": William Glackens and the Independents Exhibition of 1910

CAROL TROYEN

In the years following the landmark exhibition of The Eight in 1908, William Glackens was an increasingly busy man. His personal life was active and happy. He was married to Edith Dimock, a delightful, talented, independent, and, not insignificantly, wealthy woman, and was the father of a three-year-old son, Ira. (A second child, Lenna, would be born in 1913.) He had recently moved into a handsome and comfortable apartment at 23 Fifth Avenue, with a studio nearby on Washington Square South (Fig. 158). This appealing-looking residence was temporary, as it turned out—by 1911, the Glackenses had moved again, to even more luxurious quarters on Washington Square West. During these years, William and Edith entertained frequently and took pleasant vacations, often with friends. His long-time colleague John Sloan described this idyllic period a little wistfully: "A splendid dinner at Glackens', very good cooking and things so nice. He should be happy, a wife, a baby, money in the family, genius."[1]

As a manifestation of his genius, or in any case his ambition, Glackens would participate in twelve exhibitions in 1910—more than in any previous year. These included two foreign venues (an international exposition in Buenos Aires and a large show of contemporary American painting in Berlin), seven institutional annuals in major American cities, and group shows featuring landscape painting at several New York arts clubs.[2] At the National Academy of Design's annual show, he was represented by *The Green Car* (1910; The Metropolitan Museum of Art, New York), and subsequently at the Academy's winter annual by *The Bathing Hour, Chester, Nova Scotia* (Fig. 157). To the latter work, painted in eye-popping lime green, orange, and blue, the progressive critic James Huneker responded, "Glackens's color grows more harmonious, tho' it often shocks by its brilliant dissonances. He is pulling up the key year after year."[3]

At some point during this period, Glackens began conversations with his friends George Bellows, Arthur B. Davies, Everett Shinn, and a few others about organizing an association to promote pastel.

Fig. 157
William Glackens
The Bathing Hour, Chester, Nova Scotia,
1910
Oil on canvas
26 × 32 in. (66 × 81.3 cm)
The Barnes Foundation, Philadelphia;
BF149

The intention of the group was to "exhibit intimate studies or pictures which the artists themselves have enjoyed the performance of . . . as far as possible from the trammels imposed by commercial aspects."[4] They would call themselves "The Pastellists"; by January of the next year, the group presented its *Initial Exhibition* at Folsom Galleries, which was quite well received. The critic for the *New York Times* admired Glackens's contribution, *Summer House* (present location unknown), calling it "a mosaic of brilliant color."[5]

In 1910, Glackens was also in the midst of overhauling his style. As Guy Pène du Bois noted a few years later, "The Glackens of these two shows [the 1904 exhibition at the National Arts Club and the celebrated show of The Eight at the Macbeth Galleries in 1908] was different . . . [from] the Glackens of today."[6] Huneker's reference to "pulling up the key" and the characterization of Glackens's pastel by the *Times* critic as "a mosaic of brilliant color" indicate how the artist's evolution was perceived in his own day. In recent commentaries, the shift from black as the foundation of his palette in favor of high-keyed, expressive color has been attributed to a move away from Manet and Degas to the Impressionism of Renoir and to the intense color, compressed space, and compositional simplification of Matisse and the Fauves.[7]

Glackens's rethinking of his style took place over a period of several years, but first became evident shortly after The Eight exhibition in early 1908. At the end of that year, Glackens submitted *Beach Scene: Cape Cod* to the winter exhibition of the National Academy of Design. He had presumably painted it the summer before while vacationing on the Cape with his family and Maurice Prendergast. *Beach Scene* has not yet been securely identified with any painting known today, but it may well have been similar to *Cape Cod Pier* (Fig. 159). In that work, Glackens revisited a subject he had explored in France in 1906 (Fig. 160), but replaced the naturalistic palette of the earlier picture—grays, smoky greens, and acidic whites—with a triad of secondary hues—lime green, burnt orange, lavender—and used tactile, sensuous brushwork to evoke, rather than describe, a holiday at the shore. Critics were quick to notice that Glackens was moving in a new direction. Arthur Hoeber, writing in *International Studio*, observed that "the painter was striving to get away from the conventional rendering of his confreres."[8] Subsequently, newer works such as *Wickford, Low Tide* (Fig. 161) and *Italian Parade* (1909; Whitney Museum of American Art, New York), both of which were shown in the Academy's 1909 winter exhibition, would demonstrate his increasingly brightly colored and richly textured style.

Although Glackens would continue to send paintings to the National Academy's annuals for the next several years, his new direction was most apparent in the work he displayed at a show organized in defiance of the Academy: the gargantuan *Exhibition of Independent*

Fig. 158
William Glackens
Twenty-Three Fifth Avenue, Interior, 1910
Oil on canvas
19½ × 24 in. (49.5 × 61 cm)
NSU Art Museum Fort Lauderdale, FL;
Bequest of Ira D. Glackens 91.40.135

Artists. Conceived in the early weeks of 1910 by Sloan, Robert Henri, Walt Kuhn, and a few others,[9] the Independents exhibition was triggered, at least in part, by the Academy's rejection of Henri's *Salome Dancer* (Fig. 82), and Sloan's *Pigeons* (1910; Museum of Fine Arts, Boston) and *Three A. M.* (Fig. 162) from that year's annual. The Independents show reflected the organizers' belief that "there are a great many good pictures painted in New York which are never exhibited. We aim to place these pictures before the public."[10] It was an artist-run, cooperative effort, based on the premise "no jury, no prizes." Admission was guaranteed to any artist willing to pay the entry fee. The show, which opened on April 1, 1910, and ran for four weeks, was staged in a rented house on West Thirty-fifth Street. Glackens served on the hanging committee, which turned out to be a daunting task as the exhibition grew to include some six hundred works by more than one hundred artists.[11]

As it took shape in the makeshift galleries, the *Exhibition of Independent Artists* was promoted as revolutionary by Robert Henri, who

Fig. 159
William Glackens
Cape Cod Pier, 1908
Oil on canvas
26 × 32 in. (66 × 81.3 cm)
NSU Art Museum Fort Lauderdale, FL;
Gift of an anonymous donor 1985.74

Fig. 160
William Glackens
Chateau Thierry, 1906
Oil on canvas
24 × 32 in. (61 × 81.3 cm)
The Huntington Library, Art
Collections, and Botanical Gardens,
San Marino, CA; Courtesy of the
Virginia Steele Scott Foundation

Fig. 161
William Glackens
Wickford, Low Tide, 1909
Oil on canvas
25 × 30 in. (63.5 × 76.2 cm)
NSU Art Museum Fort Lauderdale, FL;
Gift of the Sansom Foundation 94.69

called it "an opportunity for individuality, an opportunity for experimenters."[12] Guy Pène du Bois (who contributed four paintings to the show while working as an art critic for the *New York American*[13]) predicted that the works in the exhibition would have far more energy and integrity than those shown at the Academy. It would be, he said, "a vital, manly—if artistically vulgar—record of a living, seeing, breathing set of human beings whose hands and visions are not warped into inefficiency by the conventional aesthetics or the philistinism of art." Furthermore, he promised a display "entirely independent of all that is accepted and practically all that is conventional in art.... [The show will include] the realists, the impressionists, the men who, with Matisse followed the theories of Cézanne, the followers of the geometrical art of Picasso and by men whose art [is] purely personal [and] directly connected with no concerted movement."[14]

More than two thousand visitors came on opening day, causing an uproar. According to Sloan, "A small squad of police came on

the run. It was terrible but wonderful to think an art show could be so jammed."[15] Publicity was good, even though sales were not, and while critics admired many of the works on view, they were divided on the issue of whether anything momentous had occurred there. While Joseph E. Chamberlain in the *Evening Mail* enthused about the presentation of "artists now unknown whose work some day may be famous," conservative critic Royal Cortissoz characterized the display as "curiously mild," and the critic for the *Times* spoke of "vigor and sincerity rather than novelty."[16]

Scholars of our own day have for the most part shared the latter viewpoint, asserting that, unlike the Armory Show three years later, the primary contribution of the Independents exhibition was not the introduction of any stylistic breakthrough, but rather its democratic, even utopian, organizing principle of "no jury, no prizes."[17] Because the doors were open to all comers, quite a few younger artists were able to participate. Most of those have long since been forgotten, but the show did give early visibility to Morton Schamberg, Edward Hopper, and Stuart Davis.[18] In addition, an unusually large number of women were represented. These included Glackens's wife, Edith Dimock, their friend May Preston, and several Henri students. Though some stylistic diversity was evident among the works on view, there was little that revealed the promised influence of Cézanne, Matisse, or Picasso. The show included many sketches for illustrations, and most of the works

Fig. 162
John Sloan
Three A.M., 1909
Oil on canvas
32⅛ × 26¼ in. (81.6 × 66.7 cm)
Philadelphia Museum of Art,
Gift of Mrs. Cyrus McCormick, 1946
(1946-10-1)

in the paintings section had a decidedly realist bent—not surprising since many of the organizers were members of the Henri circle.

In fact, by many measures the show was The Eight exhibition recapitulated and expanded. Except for George Luks (who declined to participate, perhaps because his solo show at the Macbeth Galleries coincided with the exhibition[19]), all members of the original group took part, and all but Glackens showed paintings similar to those they had exhibited two years earlier. Ernest Lawson contributed soft blond landscapes, and Davies showed romantic fantasies.[20] Maurice Prendergast offered three paintings titled *Seashore*; a critic welcomed the return of his "tapestry effects."[21] The artists more directly in Henri's orbit likewise displayed works that resembled their submissions to the earlier show. Both Henri and Sloan included the paintings the National Academy had rejected. Henri also presented a number of his character studies, and among Sloan's pictures were street scenes and images of working-class life. Shinn once again showed theater subjects.[22]

Even beyond the contributions of The Eight, their gritty, muscular brand of realism dominated the display, in scale and energy if not necessarily in quality. Many of the works were—at least in the opinion of some critics—poorly crafted and derivative ("the worse they smear, the more they tug at the coat tails of painters like Henri, Davies, Lawson, Glackens . . . and a few others for support"[23]). However, there were also some remarkable paintings on view by up-and-coming realists. There were brutal boxing pictures and construction scenes by Bellows: *Stag at Sharkey's* (Fig. 163) and *Blue Morning* (1909; National Gallery of Art, Washington, DC); powerful landscapes and scenes of working men by Rockwell Kent (*The Road Roller*; Fig. 98); a tough, if sympathetic, view of immigrants sleeping on a park bench by Jerome Myers (*End of the Walk* [1907; Greenville County Museum of Art, South Carolina]); and, representing the next generation, a group of dark, wintry landscapes by Stuart Davis (*Sunlight and Steam* [*Newark*] [1910; Smithsonian American Art Museum, Washington, DC]), who was then studying at the Henri School of Art.

Discussing these paintings, critics tended to use words like "dynamic," "manly," "brut[al]," and "courage[ous]." They also emphasized the essentially *American* spirit of the works on view.[24] Similar language had greeted the exhibition of The Eight two years earlier. The Independents show, dominated by vigorous, brawny, true-to-life pictures constructed with strong, dark colors and slashing brushwork, asserted the triumph of realism as an American style.

The organizers were so confident of the groundbreaking nature of their endeavor that they offered their democratic process as a "substitute . . . for the Academy idea"[25] and described another of their perceived competitors—Alfred Stieglitz—as quaking in his boots. Sloan wrote in his diary, "Stieglitz of Photo Secession is hot under the collar about our show. The whole curious bunch of 'Matisses' seem to hang

about him and I imagine he thinks we have stolen his thunder in exhibiting 'independent' artists."[26]

In reality, Stieglitz was unlikely to have felt serious competition from the Independents. His radical exhibition *Younger American Painters* had just closed at 291 (it ran from March 9 to 21); in it he promoted, among others, Arthur B. Carles, Arthur G. Dove, Marsden Hartley, and Alfred Maurer, who exhibited work in a style inspired by the Fauves, or, as A. Harrington of the *New York Herald* defined it, by the "new school of color for color's sake." There was widespread enthusiasm for the "ultra-modern art" and "earnest experiment" on view. Harrington suggested that "some day this strange school will be recognized as the beginning of an important evolution in art"[27]—the very status to which the Independents aspired. More telling, while James Huneker of the *Sun* credited the Independents show with avoiding "the insipidity and conventionality of the Academy," he noted that "the majority of the Independents" seemed "mere offshoots of the now moribund impressionists" when compared with the "grouping of the minor spirits of the Matisse movement that were actually [presenting something] new" at 291.[28]

Fig. 163
George Bellows
Stag at Sharkey's, 1909
Oil on canvas
36³⁄₁₆ × 48¼ in. (92 × 122.6 cm)
The Cleveland Museum of Art;
Hinman B. Hurlbut Collection
1133.1922

So while the Independents had the satisfaction of exhibiting works that were more modern than those that were shown at the National Academy, their triumphs were triumphs of naturalistic painting. The show presented a perspective that, while exhilarating in individual example, was by this time familiar and not especially innovative or "independent." Although a headline in the *New York World* proclaimed, "The 'Art Rebels' of America Are Shocking the Older Schools by... Picturing Up-To-Date Life as It Really Is Here and Now,"[29] most critics argued that neither the older schools nor the public was particularly shocked any longer. "A few years ago we should have been startled by... the spotted harmonies of Maurice Prendergast," said the critic for the *New York Times*. "Now they are classic."[30] Furthermore, according to Huneker, "There is nothing new.... The best things have been shown here time and time again; the bad stuff we hope never to encounter any more."[31]

If Sloan and other organizers of the Independents exhibition underestimated the impact of Stieglitz's show, *Younger American Painters* was probably not much of a revelation to Glackens. He had recently befriended Marsden Hartley, arranging in early 1909 a private viewing of Hartley's paintings in his studio for some of his colleagues from The Eight. Davies, responding to their mystical qualities (the display at Glackens's included such paintings as *Carnival of Autumn* [Fig. 164] and *Cosmos* [1908–09; Columbus Museum of Art, Ohio]), saw a kindred spirit, but Sloan found them perplexing and Shinn didn't like them at all.[32] Glackens did, taking note of Hartley's richly textured paint, his simplification of landscape elements into visual patterns, and especially his juxtapositions of passages of intense, contrasting, expressive color.

Glackens surely knew Alfred Maurer's radically colored and abstracted landscapes (Fig. 165); they had been shown (along with watercolors by John Marin) in an exhibition at 291 in March 1909. Maurer was an old friend; he and Glackens had exhibited together in 1901. He had been Glackens's host, guide, and painting companion in France in 1906, and undoubtedly introduced him to the work of the Fauves at that time. Although Glackens probably arrived in Paris too late to see the Salon des Indépendants, or the Matisse exhibition at the Galerie Druet, the French artist was still the talk of the town. Glackens renewed his friendship with Maurer in 1912, when he traveled to Paris to buy paintings for Albert C. Barnes. On that visit, Maurer introduced him to Gertrude and Leo Stein and their extraordinary collection of works by Cézanne, Matisse, and Picasso.[33]

Glackens's relation to the Independents (and thus to what had until very recently been considered the avant-garde) was complex. With the exception of *Girl with Apple* (Fig. 55), a nude,[34] his own submissions were representative of the range of subjects that had long interested him: a scene of outdoor recreation (*Race Track*; Fig. 166), a figure

Fig. 164
Marsden Hartley
Carnival of Autumn, 1908
Oil on canvas
30⅛ × 30⅛ in. (76.5 × 76.5 cm)
Museum of Fine Arts, Boston;
The Hayden Collection—Charles Henry
Hayden Fund 68.296

study (*Russian Girl* [*Russian Lady*]; Fig. 167), and a landscape (*Winter*; present location unknown).[35] The three works identifiable today all contain strong elements of fantasy, abstraction, and sensuality, and exhibit an experimental approach to color. Developing the ideas he was exploring in *Cape Cod Pier* and other works of 1908–09, Glackens clearly no longer placed supreme value on representing "up-to-date life as it really is here and now"; that is, he had ceased to be what would come to be called an "Ashcan school" painter. In addition, he had renounced his commitment to the somber grays, browns, and blacks of Henri-esque naturalism. Unlike his old friends from The Eight,

Fig. 165
Alfred Maurer
Landscape, c. 1907–10
Oil on gessoed panel
8½ × 10½ in. (20 × 25 cm)
Collection of Tommy and Gill LaPuma

Glackens used the Independents show as a forum for announcing a new, brilliant style, illustrated most dramatically by the return of *Race Track*, which he had first displayed at Macbeth's in 1908 but which he had completely repainted by this time.[36] In color, in technique, but, more important, in artistic philosophy, he now had more in common with those "minor spirits" working in the Fauve style who had just shown a few blocks away at 291. By the time of the Independents, it is clear, Glackens had gone over to the bright side.

Critics had already begun to recognize his new set of "confreres." In a review of a landscape show at the National Arts Club earlier that year, one reporter credited Glackens with displaying "a brand-new manner," and another grouped him with Prendergast, Hartley, and Maurer as "followers of the presumably crazy French painter Matisse."[37] But the press also acknowledged his ability to make this unconventional approach palatable—unlike some of the other "followers," he could embrace the avant-garde while managing not to offend. For example, while noting that "E. Middleton Manigault is the most direct follower of Matisse among the exhibitors [at the Independents]," James B. Townsend of *American Art News* complained that "his 'Rocket' (Fig. 168) is still too advanced for the present writer"; on the other hand, he admired Glackens for his "strong brush." "'The Race Track,'" said another critic, "impresses one with the Matisse effect."[38]

Glackens used the occasion of the Independents to debut his *Girl with Apple* (Fig. 55).[39] Its scale—at forty by fifty-six inches, it was considerably larger than his other contributions—and its placement at the base of the staircase (which as a member of the hanging committee

Fig. 166
William Glackens
Race Track, 1908–09
Oil on canvas
26⅛ × 32¼ in. (66.4 × 81.9 cm)
The Barnes Foundation, Philadelphia;
BF138

Fig. 167
William Glackens
Russian Girl (Russian Lady), 1910
Oil on linen
24¼ × 18⅛ in. (61.6 × 46 cm)
Patricia and Phillip Frost Art Museum,
Florida International University,
Miami, Gift of Mr. and Mrs. Herman
Cutler, MET 77.45.1

he undoubtedly engineered) was designed to attract attention to his new manner. He was successful: *Girl with Apple* was one of the most discussed and admired pictures in the show. A number of reviewers connected it with Renoir, whose work by this time was already well known in New York.[40] According to the *Sun*'s Huneker, "Mr. Glackens's big nude is surprisingly brilliant, though reminiscent of Renoir, particularly in the color scheme."[41] (In fact, Glackens's color scheme here—and in later works exhibiting his newly adopted Impressionist manner—does owe a debt to Renoir, but the reddish-oranges and deep blues beloved by the French painter are far hotter, and the brushwork more heavily textured.) Pène du Bois noted that the Independents show, and this painting in particular, marked Glackens's debut as a colorist,[42] a claim borne out by the brilliance of those colors, as well as by the vivid contrasts. For example, the bright red of the couch, glowing with flecks of yellow, is juxtaposed with the chalky white of the drape (itself animated by soft tinges of blue) and with the hat, a massive oval of midnight blue. The model's white dress, flung over the back of the sofa, is punctuated by thickly brushed triangles of gold. Such dazzling adjacencies, as well as Glackens's obvious delight in texture and pattern, are characteristic of the artist's evolving approach.

Girl with Apple has been discussed in relation to the great paintings of reclining nudes from the past—works by Titian and Cranach and especially Manet's *Olympia* (Fig. 62). Like Manet's figure in particular, Glackens's nude is meant to be perceived both as a real woman and as a studio construct, a model and—with the apple in her hand and the ribbon around her neck—a sensuous, even erotic, ideal. Yet while paying homage to his artistic predecessors, Glackens also claims the subject for his own. He does this by domesticating it, by locating the scene in his studio (the sofa appears in several of his paintings; on the wall is a Glackens-like beach scene), by integrating the familiar with a seductive type. The flirtatiousness of the model's gesture and the boldness of her expression—she seems to be addressing the viewer, drawing him into the scene—are an acknowledgment of Glackens's roots in "picturing up-to-date-life." As Teresa Carbone points out, this directness, as well as her fashionable and outlandish hat, defines her as a modern woman.[43] At the same time, with decorative pattern and saturated color, Glackens transforms her factuality into a sensate vision. The allure of *Girl with Apple* comes less from the preciseness of its description than from its pictorial qualities.

The intensification of a pleasurable world made accessible through art is the cornerstone of Glackens's stylistic and philosophical overhaul. These changes were first visible in paintings such as *Cape Cod Pier* and the repainted *Race Track*. And as Glackens's radiant style developed into the Impressionist-inflected manner of *Girl with Apple* and *Russian Girl*, his work continued to exhibit the "revolutionary accomplishments in the domain of color" with which writer Sadakichi Hartmann

Fig. 168
Edward Middleton Manigault
The Rocket, 1909
Oil on canvas
20 × 24 in. (50.8 × 61 cm)
Columbus Museum of Art, OH;
Museum Purchase, Howald Fund II
(1981.009)

credited the Fauves, both French and American. According to Hart-mann, the most sensitive critic of the age, this sumptuous and original vision derived from color that was not merely decorative or atmospheric, but "endowed with some sensuous or emotional magnificence."[44]

It is tempting to attribute Glackens's conversion from dark-toned, descriptive, illustrative art to a style of torrid colors and patterned sur-faces solely to the influence of his progressive American colleagues, and behind them the coloristic revolution inaugurated by Matisse. Richard Wattenmaker describes Glackens's reworking of *Race Track* as depen-dent upon "the brushwork of Ernest Lawson, the dense impasto of the Maine mountain scenes of Marsden Hartley, and the dramatically brighter palette and the overall color intensity of Maurice Prender-gast's open-air compositions."[45] Wattenmaker also mentions Maurer.[46] And indeed the connections to Maurer and to Hartley's landscapes of 1909 suggest themselves in the bold contrast of intense hues, the "riot of tone" that so captivated critic Arthur Hoeber and excited Albert

Barnes when he bought *Race Track*. [47] It is also clear that in paintings of the period such as *Wickford, Low Tide*, Glackens was thinking about what Avis Berman has called Hartley's "tweedy" brushwork as well as the dry-brush manner of Prendergast.[48] Like Maurer, Prendergast was an old friend. He and Glackens painted together on Cape Cod in 1908, when the latter was working on *Cape Cod Pier*—and in fact the subject of that canvas, women promenading on a boardwalk, was one Prendergast treated frequently, beginning in the 1890s (Fig. 169).

But Glackens's new approach was more than an accumulation of shared stylistic traits and adopted pictorial strategies. It was a radical shift of point of view, a complete revision of what being a painter meant to him. According to his friend Pène du Bois, before 1908 Glackens was "following the letter of realism" in a manner waggishly described as "darkest Henri"; by the time of the Independents exhibition, he had begun "feasting on color."[49] Glackens had evolved from a sketch artist and a journalistic painter—an extremely talented one, to be sure—into a modernist dedicated to pure painting. The Fauves reinforced that interest. Having set aside storytelling and social engagement as artistic agendas, Glackens at the Independents declared himself to be a sensualist, entirely dedicated to the pleasures of the visual and the satisfactions of paint. Already in 1909, Hartmann described the skin Glackens was shedding: "W. J. Glackens is painting away lustily and with good cheer. It is a hard struggle for him to eliminate his illustrative qualities, but I think he will win out in the end."[50] By the time of the Independents show, Glackens had prevailed. Soon after, his friend Sloan noted somewhat regretfully, "Even Glackens is in the obvious color class just now."[51]

Part of this transformation can be explained by Glackens's personality. With the influence of Henri now more distant, and given the pleasant events of his life (as Sloan said, "very good cooking and things so nice"), his natural proclivity for happiness would win out over the darker sensibilities of his teacher. He was clearly a congenial man and, while somewhat reserved, a natural leader—he was popular among his fellows, was entrusted with important positions in a number of art societies, and was generally well regarded by the press. As his own world became more comfortable, his circumstances allowed him to pursue his artistic hedonism. He became increasingly committed to creating work that provided pleasure, work that elicited the joy that came simply from looking.

In addition, Glackens increasingly saw himself as cosmopolitan, and enjoyed the company of painters with an equally sophisticated world view—well-traveled artists like Prendergast, Maurer, Davies, and even the notoriously difficult and needy Hartley. This cosmopolitanism was not just part of living the good life; for Glackens, it provided a path to modernism. By 1913, he had come to characterize as an "old idea" Henri's belief that "American art... is to become a fact by the

Fig. 169
Maurice Prendergast
South Boston Pier, 1896
Watercolor and graphite on white wove paper
18¼ × 14 in. (46.4 × 35.6 cm)
Smith College Museum of Art, Northampton, MA; Purchased with the Charles B. Hoyt Fund

Maurice B. Prendergast

reproduction of local subjects." He had been converted to an international outlook. "The early Americans were illustrative," he said. "It was France that showed them the error of their project."[52] What Glackens took from France, beyond the voluptuous palette, the interest in decorative patterning, and the taste for the exotic, was the license to pursue a radically different, and much more modern, concept of the art "project" than the one espoused by Henri and his circle.

Glackens's style was not nearly as radical as that of Matisse and the other Fauves, or even, for that matter, as Maurer's or Prendergast's. His idylls were, for the most part, completely familiar ones. And he remained bourgeois: in large measure his fantasies were scenes of ordinary contentment, of simple domestic joys elevated and enriched. But he was nonetheless dedicated to presenting visions of pleasure, even luxury, in formal terms that were as seductive as their subjects. And so, in *Race Track* and *Cape Cod Pier*, hot, jewel-like color, dazzling light, and sparkling brushwork transform a day at the races and a stroll on the beach into timeless, resonant interludes. In his 1910 portrait of his apartment, *Twenty-Three Fifth Avenue, Interior*, an everyday environment becomes a dreamscape. And, in works like *Russian Girl*, a painting of an ordinary ethnic "type" of the kind that was the mainstay of Henri and his followers, he creates a seductive, exotic figure, full of allure and mystery.

Glackens achieves this conversion of the quotidian into the Arcadian by what could be considered mildly Fauvist means: while his pictures tend to have a firm spatial structure, some of them contain deliberate and visually exciting eccentricities. The roller coaster–like rise and fall of the boardwalk in *Cape Cod Pier* leads to a high horizon, bisecting a space that flattens into planes of color. In *Race Track*, the roofs of the grandstand articulate movement into the distance—a logical procession countermanded by the flat triangle of blue that rivets the eye to the picture surface.

While many of Glackens's colleagues became enamored of the colors and theories of Hardesty Maratta at just this time, he had little use for them.[53] He continued to take his cues from Renoir and the Fauves, while consistently turning up the temperature with radiant colors more intense and dazzling than those of real life. In his works from 1908 and 1909, what his silhouetted color shapes represent—racehorses, strolling ladies, swaths of lawn—matters less than where they are relative to one another. The large, simplified blocks of color—an atoll of green lawn surrounded by an ocean of red-orange turf, a lavender boardwalk next to orange dunes—are slammed together with astonishing boldness. In the slightly later *Girl with Apple*, colors seem to jostle one another; the painting is both a representation of a languorous nude and a surface pattern of boldly colored passages radiating heat. Coloristic details delight: for example, the ruddy luminosity of the horses in *Race Track*, which seem to glow as though magically lit from

behind. And in *Cape Cod Pier*, the soft aqua used for the left foot of one of the women strolling on the pier wittily echoes the color of her parasol; her companion's feet, tinted orange and red, mimic her hair and the nape of her neck.

Another source of visual enjoyment is Glackens's brushwork: lively, vigorous, and often an end in itself. This is especially apparent in the scribble of multicolored strokes forming the background in *Russian Girl* and in the calligraphic swirls of red on her stole. Opalescent stripes of paint entertain the viewer's eye as it travels along the boardwalk in *Cape Cod Pier*, and, in *Race Track*, the tiny dabs of blue against red both define the crowd in the middle distance and become an entrancing, shimmering array of tonal contrasts. These are images of memory more than observation, created through an astute ordering of pictorial elements in the service of the "sensuous magnificence" noted by Hartmann.

Years later, shortly after he was included in the Whitney's 1937 show of *New York Realists, 1900–1914*, Glackens was the subject of a profile in *Esquire* magazine. Despite the fact that most of the work in the Whitney's show was in his "darkest Henri" mode, in the article he was described as being on perpetual holiday, as an artist for whom it was always high noon. Glackens apparently went along with this cheery characterization, and responded to an admiring remark about one of his dark, pre-1908, paintings by saying, "It's mud, life isn't like that."[54]

Glackens may have been blessed with a perpetually sunny temperament, as this article suggests, but his luminous visions should not be dismissed as lightweight or superficial. Rather, they are the product of a carefully developed artistic philosophy, one that was both personal and absolutely modern, absolutely of the moment. In his work, Glackens retained a constructive engagement with everyday life, while making his case for giving primacy to the visual and for painting as pleasure, for joy as a sufficient justification for art.

Beyond the high-keyed color, the sumptuous patterning, and the interiors appointed with exotic fabrics, this belief is what Glackens took from Matisse and the Fauves and from Renoir, and what he shared with his American colleagues like Prendergast. His new artistic approach was boldly on view at the Independents exhibition, and again in the Armory Show and at his solo exhibition at the Folsom Galleries in 1913. In these shows, which included almost nothing painted before the 1908 exhibition of The Eight, he demonstrated how art could maintain a connection with painting's traditional task, representation, while surpassing it. In paintings like *Family Group* (Fig. 139), his principal submission to the Armory Show, Glackens converted a scene of ordinary domestic interchange into a vision of sensate bliss. *The Bathing Hour, Chester, Nova Scotia*, also in the Armory Show, and *Street Cleaners, Washington Square* (Fig. 170), in his one-artist exhibition, are the orchestrated improvisations of a brilliant observer.

But all these images are heightened to a level of enjoyment beyond that occasioned by their subjects through Glackens's dynamic color harmonies and through brushwork that is articulate and yet pulses with autonomous pictorial energy. With texture, color, and facture, Glackens proselytizes the sheer gratification of looking. He is striving to paint—in a secular, even bourgeois way—an Arcadian dream at the seashore and on Washington Square. His scenes are idylls of the commonplace, linked to ordinary life but warmer, richer, and more transcendent.

The Armory Show is often considered the end of the Ashcan school. The power of the French avant-garde, and the eagerness of American artists to embrace the new styles, made Henri and his fellow travelers seem outmoded. The most gifted painters associated with that group—men like Bellows and Sloan—seem to have been unable to go beyond, or even equal, their brilliant, pre-1913 achievements, and would thereafter turn, with only modest success, to more formal considerations in an effort to keep their voices relevant.[55] Glackens, however, had already made the leap. Absorbing not only the stylistic traits, but also the philosophy, of at least one strain of the French avant-garde, he was ahead of many of his American "confreres." What he presented at the Independents and again at the Armory Show and at his one-artist exhibition was a declaration of his complete transformation from a narrative painter to one who found necessary and sufficient satisfaction in paint. By 1913, he was entirely at ease with the new spirit of the time, the brave new world ushered in by the Armory Show.

For the ambitious artists of this era, bravery seems to have been a defining trait. Mary Fanton Roberts, reviewing Glackens's 1913 Folsom Galleries show for the *Craftsman*, describes the "fearlessness in demarcation of color" of *Race Track*. But she also admits to a moment of hedonistic pleasure. Just as Arthur Hoeber had once said he wanted to "wallow in [the] vivid reds and greens" of *Race Track*,[56] Roberts confesses that Glackens's pictures have seduced her, enticing her to "stay indefinitely" in the galleries and luxuriate in the "wonderful color palpitating about us." She then comments on the newness, the timeliness, and the modernity of Glackens's achievement:

> We venture to believe that the same thing would not have happened a year ago, even with the same collection of pictures. Somehow in the last year the attitude of the public toward beauty seems to have freshened, we are less afraid of color, we are more sure of ourselves in our appreciation of the brilliant beauty of the world."[57]

Her words echo the prediction of A. E. Gallatin, who announced, in a profile of Glackens published shortly after the close of the Independents show: "He has gone far. He is going farther."[58]

Fig. 170
William Glackens
Street Cleaners, Washington Square,
c. 1910
Oil on canvas
25¼ × 30 in. (64.1 × 76.2 cm)
The Barnes Foundation, Philadelphia;
BF2035

NOTES

1. Sloan, diary entry, July 20, 1907, in Bruce St. John, ed., *John Sloan's New York Scene: From the Diaries, Notes and Correspondence 1906–1913* (New York: Harper and Row, 1965), 143.

2. For a complete list of 1910 exhibitions that included work by Glackens, see Emily C. Wood, "Exhibition History," in *William Glackens*, ed. Avis Berman (New York: Skira Rizzoli in association with the Barnes Foundation, 2014), 247.

3. [James G. Huneker], "Seen in the World of Art: William Glackens Shows His Versatility," *New York Sun*, December 18, 1910, 4.

4. "The Pastellists: A New Art Society," *Craftsman* 19, no. 6 (March 1911): 639. "The Pastellists" would sponsor four exhibitions in New York between 1911 and 1914. They ceased to operate in 1915 after the American Water Color Society revoked its policy of excluding pastels from its annual exhibitions. See Doreen Bolger et al., "American Pastels, 1880–1930: Revival & Revitalization," in *American Pastels in the Metropolitan Museum of Art*, ed. Doreen Bolger, with Marjorie Shelley (New York: Metropolitan Museum of Art, 1989), 20–21.

5. "First Exhibition of 'The Pastellists' Suggests the Revival of a Charming Form of Eighteenth-Century Art," *New York Times*, January 15, 1911, 15. See also Guy Pène du Bois's enthusiastic review, "Pastellists Hold Their First Exhibition: Grace and Charm Mark Delightful Show," *New York American*, January 16, 1911, 9.

6. Guy Pène du Bois, "William Glackens, Normal Man: The Best Eyes in American Art," *Arts and Decoration* 4 (September 1914): 406.

7. See Avis Berman, "Urban Arcadia: Glackens and the Metropolis," in Berman, *Glackens*, 83; William H. Gerdts, *William Glackens* (New York: Abbeville, 1996), 89; Martha Lucy, "Glackens, French Art, and the Language of Modernism," in Berman, *Glackens*, 202.

8. Arthur Hoeber, "The Winter Exhibition at the National Academy of Design," *International Studio* 36, no. 144 (February 1909): 136.

9. Glackens also intended to participate in the planning of the show but was ill for the inaugural meeting on January 10 and was unable to attend; see *The Fiftieth Anniversary of the Exhibition of Independent Artists in 1910* (Wilmington: Delaware Art Center, 1960), 6. John Sloan notes that Glackens "sent his excuses by Shinn." (Sloan, diary entry, January 10, 1910, in St. John, *Sloan's New York Scene*, 374). However, he was listed among the "artists who contributed interest, time and money to the organization of this exhibition" in Robert Henri, "The New York Exhibition of Independent Artists," *Craftsman* 18, no. 2 (May 1910): 172.

10. Robert Henri, as quoted in the *New York Evening Sun*, March 23, 1910, cited in William Innes Homer, *Robert Henri and His Circle* (Ithaca, NY, and London: Cornell University Press, 1969), 153.

11. According to the catalogue, the exhibition included 260 paintings, 22 sculptures, and 344 drawings. The catalogue is reproduced in *Fiftieth Anniversary*, 5–12

12. Henri, "New York Exhibition," 160.

13. Pène du Bois most likely destroyed these paintings. See Guy Pène du Bois, *Artists Say the Silliest Things* (New York: American Artists Group, 1940), 150–51, where he describes using old pictures for target practice.

14. Guy Pène du Bois, "Great Modern Art Display Here April 1," *New York American*, March 17, 1910.

15. Sloan, diary entry, April 1, 1910, in St. John, *Sloan's New York Scene*, 405–6.

16. Joseph E. Chamberlain, "With the Independent Artists," *New York Evening Mail*, April 4, 1910, cited in Homer, *Henri and His Circle*, 154; Royal Cortissoz, "Independent Art: Some Reflections on Its Claims and Obligations," *New York Daily Tribune*, April 10, 1910, sec. 2, 2; "Young Artists' Work Shown," *New York Times*, April 2, 1910, 9.

17. For a detailed and insightful discussion of the Independents exhibition and its political and artistic accomplishments, see Marianne Doezema, *George Bellows and Urban America* (New Haven and London: Yale University Press, 1992), 113–21.

18. Schamberg showed two figure studies, *Girl Reading* and *Lady in Yellow*. Hopper showed a work titled *Louvre*, presumably one of his Parisian landscapes, such as *Le Louvre et la Seine* (1907) or *Louvre in a Thunderstorm* (1909; both Whitney Museum of American Art, New York). For Davis, see below.

19. Luks's absence was a cause of resentment to some of the organizers. Sloan was annoyed enough to quote in his diary a conversation with Alden March, the Sunday editor of the *New York Times*, who said: "G. Luks in keeping out of the Independent Exhibition has shown that his self interest is stronger than his interest in an Idea. The rest of you have shown that you stood for an Idea." Sloan later wrote, "Luks was narrow enough and doubted the success of the Ex. Enough to refuse to exhibit with us." Sloan, diary entries, April 20 and June 5, 1910, in St. John, *Sloan's New York Scene*, 412, 431.

20. Among Lawson's submissions were *Old White Horse* (possibly *Watering the White Horse* [art market, 2006; present location unknown]); Davies sent *Valley's Brim* (1910; Hirshhorn Museum and Sculpture Garden, Smithsonian Institution, Washington, DC) and three other paintings.

21. James B. Townsend, "The Independent Artists," *American Art News* 8, no. 26 (April 9, 1910): 2.

22. Henri's entries included *Dancer, Lady in Black with Spanish Scarf*, and possibly *Dutch Joe* (1910; Milwaukee Art Museum). Sloan showed *Clown Making Up* (1910; Phillips Collection, Washington, DC) and *Recruiting in Union Square* (1909; Butler Institute of Art, Youngstown, OH), in addition to the rejected pictures. Shinn's titles included *The Stage, Talking to the Leader*, and *Stage, Yellow Dress* (present locations unknown).

23. James G. Huneker, "Around the Galleries," *New York Sun*, April 7, 1910, 6.

24. James B. Townsend, "The Independent Artists: Second Notice," *American Art News* 8, no. 27 (April 16, 1910), 2; Pène du Bois, "Great Modern Art Display Here April 1"; Arthur Hoeber, "Art and Artists," *New York Globe and Commercial Advertiser*, April 5, 1910, 10.

25. Henri, "New York Exhibition," 171.

26. Sloan, diary entry, March 22, 1910, in St. John, *Sloan's New York Scene*, 402.

27. A. Harrington, *New York Herald*, reprinted in "'The Younger American Painters' and the Press," *Camera Work* 31 (July 1910): 45.

28. Huneker, "Around the Galleries."

29. Henry Tyrell, "Battle of the Artists: How the 'Art Rebels' of America Are Shocking the Older Schools by Actually Putting Prize Fights on Canvas and Picturing Up-To-Date Life as It Really Is Here and Now," *New York World*, June 5, 1910, magazine sec., 6. Tyrell's article featured an illustration of Bellows's *Stag at Sharkey's*.

30. "Young Artists' Work Shown."

31. In his assertion that the show presented "nothing new," Huneker noted that many of the best works in the Independents had been seen previously: "The Bellows pugilists we admired at the Pennsylvania Academy." Huneker, "Around the Galleries."

32. See Barbara Haskell, *Marsden Hartley* (New York: Whitney Museum of American Art, 1980), 17; and Berman, "Urban Arcadia," 83. As Sloan reported, "Went to Glackens' studio to see Hartley's work. It is broken color 'Impressionism.' Some two or three canvases I liked—the more sincere, nervous sort. Some of them seem affectations—the clouds especially like tinted buckwheat cakes. The work had,

however, several good spots in it. Met Shinn at Glackens'. Everett doesn't like the Hartleys even a little bit." A few days later Sloan wrote, "His mysticism is a little too much for me." Sloan, diary entries, March 23 and March 27, 1909, in St. John, *Sloan's New York Scene*, 302–3.

33. Richard J. Wattenmaker, *American Paintings and Works on Paper in the Barnes Foundation* (New Haven and London: Yale University Press, 2010), 127. Glackens repaid the favor by advocating for Maurer with his patron. In addition to purchasing paintings by Van Gogh, Renoir, Cézanne, and Matisse, Glackens brought home to Barnes five landscapes by Maurer, who soon developed a strong relationship with the collector. When Barnes traveled to Paris later in 1912, Maurer introduced him to the Steins. Thereafter, Maurer would also advise Barnes on his collection.

34. According to Teresa Carbone, nudes were "highly unusual in his own oeuvre and in [that of] his American peers. . . . Even his comparatively progressive Realist peers rarely painted large, finished nudes for exhibition during the first decade of the century." Teresa A. Carbone, "Girl with Apple," in Carbone, Barbara Dayer Gallati, and Linda S. Ferber, *American Paintings in the Brooklyn Museum: Artists Born by 1876* (London: D. Giles, 2006), 1:558.

35. He also sent four drawings: *Along the Seine*, two works titled *Sketches from Window*, and *Study*.

36. *Race Track* made its public debut in The Eight exhibition in New York. Rather than sending it on tour with the rest of his pictures, Glackens withdrew it to rework it. A number of scholars believe that the painting was changed substantially before its next public appearance. See Berman, "Urban Arcadia," 81; and Wattenmaker, *American Paintings*, 66, 76–78.

37. Arthur Hoeber, "Art and Artists," *New York Globe and Commercial Advertiser*, February 7, 1910, 8; "Landscapes at Art Club," *American Art News* 8 (February 12, 1910): 6.

38. Townsend, "Independent Artists;" and "Independents Hold an Art Exhibit," *New York World*, April 3, 1910, sec. 2, 7, as quoted in Wattenmaker, *American Paintings*, 75. In her perceptive essay on the influence of contemporary French art on Glackens, Martha Lucy suggests that other Fauves may also have made an impression on Glackens. She cites André Derain's *Charing Cross Bridge* (c. 1906; Musée d'Orsay, Paris)—"one of the stars of the Salon d'Automne"—as perhaps affecting the design of *Race Track*. Although Glackens is not likely to have seen that exhibition—it opened on October 6, 1906, by which time Glackens was in London in anticipation of an early October departure for New York from Liverpool—he might have seen it beforehand. Whether or not this specific painting was relevant to Glackens's work, he surely would have known the Fauves through Maurer. See Martha Lucy, "Glackens, French Art," 202.

39. For a thorough discussion of *Girl with Apple*, see Carbone, "Girl with Apple," in *American Paintings in the Brooklyn Museum: Artists Born by 1876*, 1:558–60; and her essay "All About Eve? William Glackens's Audacious *Girl with Apple*" in this volume.

40. Renoir's work had been seen in America since at least 1883; the artist's representatives, Galeries Durand-Ruel, had presented exhibitions of his paintings in their New York branch in 1900 and 1908.

41. Huneker, "Around the Galleries."

42. Pène du Bois, "William Glackens, Normal Man," 406.

43. See Carbone, "All About Eve," p. 100–104

44. Sadakichi Hartmann, in "'The Younger American Painters' and the Press," *Camera Work* 31 (July 1910): 47, 48.

45. Wattenmaker, *American Paintings*, 76.

46. Ibid., 66.

47. Hoeber, "Art and Artists," April 5, 1910, 10. Wattenmaker comments on Barnes's devotion to *Race Track*: "When he bought *Race Track* from Folsom Galleries in March 1913, Barnes was expressing his need to possess the talisman that had initiated him into what he came to see as a new world of perception and meaning. *Race Track* was for Barnes always *primus inter pares*, the centerpiece of his collection, its indispensability a deeply personal touchstone and perpetual tribute to Glackens." Wattenmaker, *American Paintings*, 66–67.

48. Berman, "Urban Arcadia," 83.

49. Pène du Bois, "William Glackens, Normal Man," 406.

50. [Sadakichi Hartmann], "En Passant," *The Stylus* 1, no. 1 (December 1909): 31–32, reprinted in *Sadakichi Hartmann, Critical Modernist*, ed. Jane Calhoun Weaver (Berkeley: University of California Press, 1991), 315.

51. Sloan, diary entry, April 15, 1911, in St. John, *Sloan's New York Scene*, 526.

52. William J. Glackens, "The American Section: The National Art," *Arts and Decoration* 3, no. 5, special number (March 1913): 159, 160.

53. According to Sloan, "I was trying to persuade Glack of the excellence of the Maratta colors, but without much result." Sloan, diary entry, December 7, 1909, in St. John, *Sloan's New York Scene*, 358. See also Michael Quick, "Technique and Theory: The Evolution of George Bellows's Painting Style," in Quick et al., *The Paintings of George Bellows* (Fort Worth, TX: Amon Carter Museum of Art, 1992), 33.

54. Glackens, quoted in Harry Salpeter, "America's Sun Worshiper," *Esquire* 7, no. 5 (May 1937): 88.

55. Rebecca Zurier, "The Making of Six New York Artists," in Zurier, Robert W. Snyder, and Virginia M. Mecklenberg, *Metropolitan Lives: The Ashcan Artists and Their New York* (New York and London: National Museum of American Art in association with W. W. Norton, 1995), 83. See also Virginia Mecklenberg's comment, "When the Armory Show opened in 1913, it was clear that the Ashcan artists were not practitioners of artistic radicalism. Although flurries of debate related to both their art and their illustrations continued to erupt from time to time, by 1916 the artists were considered historians of their age." Mecklenberg, "Manufacturing Rebellion: The Ashcan Artists and the Press," in Zurier, Snyder, and Mecklenberg, *Metropolitan Lives*, 212.

56. Hoeber, "Art and Artists," April 5, 1910, 10.

57. Mary Fanton Roberts, "Notes of General Interest," *Craftsman* 24, no. 1 (April 1913): 135–36. See also Henri's comments in his article on the Independents, in which he calls Glackens, and in particular *Girl with Apple*, "intensely sincere and intensely brave" (Henri, "New York Exhibition," 162).

58. A. E. Gallatin, "The Art of William J. Glackens: A Note," *International Studio* 40 (May 1910): 68.

Contributors

JUDITH A. BARTER

AVIS BERMAN

CHARLES BROCK

TERESA A. CARBONE

MARC SIMPSON

CAROL TROYEN

SYLVIA YOUNT

JUDITH A. BARTER was the Field-McCormick Chair and Curator of American Art at the Art Institute of Chicago from 1993 to 2017, and is the author of many books and exhibitions, including *America after the Fall: Painting in the 1930s* (2016), *Art and Appetite: American Painting, Culture and Cuisine* (2013), *For Kith and Kin: The Folk Art Collection at the Art Institute of Chicago* (2012), *The Age of American Impressionism: Masterpieces from the Art Institute of Chicago* (2011), *Edward Hopper* (2007), and *Mary Cassatt: Modern Woman* (1998).

AVIS BERMAN is an independent writer and art historian. In 2014 she organized *William Glackens*, the first comprehensive survey of the artist's work in nearly fifty years, and is the author or co-author of numerous books, including *Rebels on Eighth Street: Juliana Force and the Whitney Museum of American Art* (1990), *Edward Hopper's New York* (2005), *My Love Affair with Modern Art: Behind the Scenes with a Legendary Curator* (2006), and *Roy Lichtenstein: Between Sea and Sky* (2015). She lives in New York City.

CHARLES BROCK is Associate Curator of American and British Paintings at the National Gallery of Art, Washington, D.C. His exhibitions there include the major retrospective *George Bellows* (2012), *Crosscurrents: American and European Masterpieces from the Permanent Collection* (2007), and *Charles Sheeler: Across Media* (2006). He has contributed to numerous publications on American modernism, and in 2014 he co-authored the catalogue *Andrew Wyeth: Looking Out, Looking In* with Nancy Anderson.

TERESA A. CARBONE is Program Director for American Art at the Henry Luce Foundation. She worked as a curator at the Brooklyn Museum from 1985 to 2015, overseeing the American Art collections from 2005 as Andrew W. Mellon Curator of American Art. Her curatorial projects have included *Eastman Johnson: Painting America* (1999), *Youth and*

Beauty: Art of the American Twenties (2011), *John Singer Sargent Watercolors* (2013), and *Witness: Art and Civil Rights in the Sixties* (2014).

MARC SIMPSON was the Associate Director of the Williams College Graduate Program in the History of Art from 2000 until 2013. He has also served as curator of American art at the Clark Art Institute and at the Fine Arts Museums of San Francisco. The exhibitions he has organized include *Winslow Homer: Paintings of the Civil War* (1988), *Eastman Johnson: The Cranberry Harvest, Island of Nantucket* (1990), *Uncanny Spectacle: The Public Career of the Young John Singer Sargent* (1997), *Like Breath on Glass: Whistler, Inness, and the Art of Painting Softly* (2008), and *Winslow Homer: Making Art, Making History* (2013).

CAROL TROYEN, Kristin and Roger Servison Curator Emerita of American Paintings at the Museum of Fine Arts, Boston, is an independent scholar. While at the museum she organized many exhibitions, including *Charles Sheeler, Paintings and Drawings* (1987), *Awash in Color: Homer, Sargent, and the Great American Watercolor* (1993), and *Edward Hopper* (2007). She has lectured at museums across the country and has served as interim chief curator at the Wadsworth Atheneum. Her recent publications include essays on American still life painting and on Charles Sheeler's last works.

SYLVIA YOUNT is the Lawrence A. Fleischman Curator in Charge of the American Wing at the Metropolitan Museum of Art. In addition to completing pivotal collection reinstallations at the Virginia Museum of Fine Arts, the High Museum of Art, and the Pennsylvania Academy of the Fine Arts, she has organized major exhibitions with accompanying publications, including *Cecilia Beaux: American Figure Painter* (2007), *Maxfield Parrish: 1870–1966* (1999), and *To Be Modern: American Encounters with Cezanne and Company* (1996).

Index